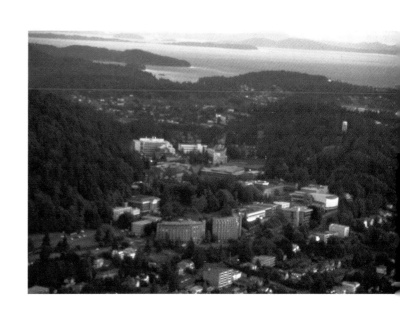

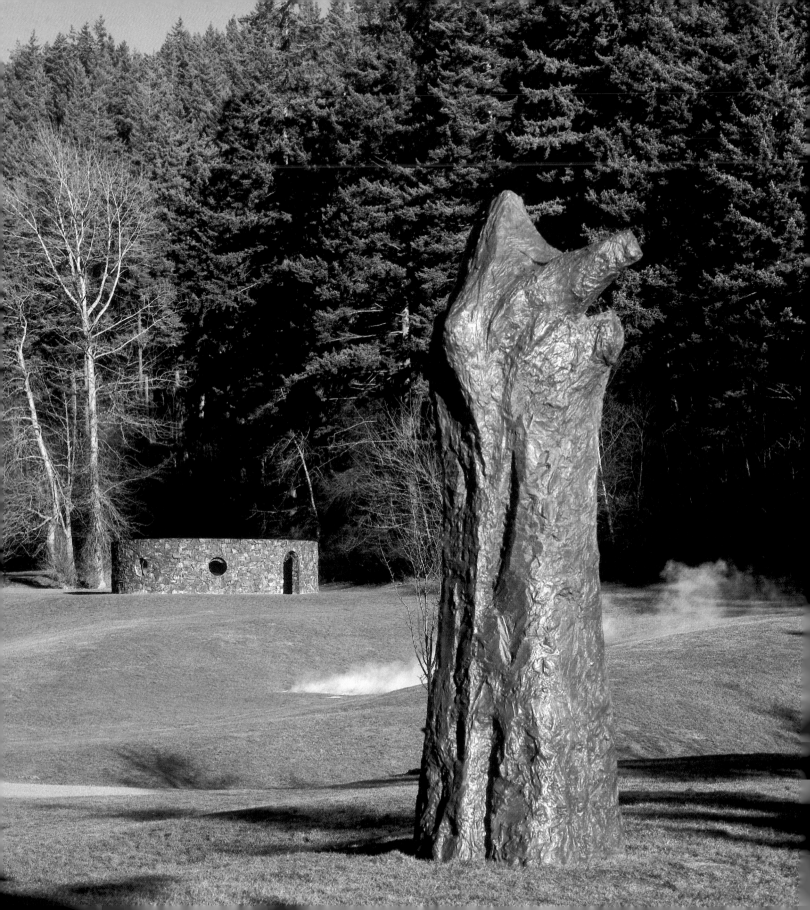

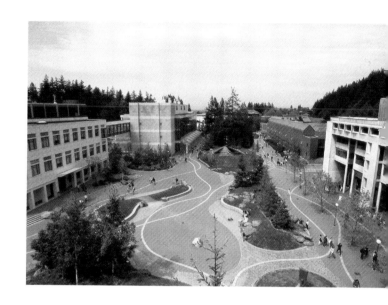

SCULPTURE in PLACE

a CAMPUS as SITE

WESTERN WASHINGTON UNIVERSITY, BELLINGHAM

Sarah Clark-Langager

This publication was initiated with a grant from the National Endowment for the Arts, a federal agency, and matched by the Gannett Foundation and the Elizabeth Firestone Graham Foundation. Additional major support came from Western Washington University's Office of the President, Friends of the Western Gallery, the Homer Bernard Mathes Exhibition Fund, the Elizabeth Firestone Graham Foundation, and the Spirit Action Fund of the Whatcom Community Foundation. Support also was provided by Marquand Books, Inc., the Department of Art of the College of Fine and Performing Arts, Associated Students, Dr. Bertil van Boer and Margaret Fast, and Sandra Lucke.

First published in the United States of America in 2002 by Western Washington University
516 High Street
Bellingham, WA 98225

Library of Congress Cataloging-in-Publication Data
Clark-Langager, Sarah A.
 Sculpture in place : a campus as site / Sarah Clark-Langager.
 p. cm.
 Includes bibliographical references and index.
 ISBN 1-878237-05-5 (hardcover : alk. paper)
 1. Sculpture, American—Washington—Bellingham—20th century—Catalogs. 2. Outdoor sculpture—Washington—Bellingham—Catalogs. 3. Site-specific sculpture—Washington—Bellingham—Catalogs. 4. Sculpture—Washington—Bellingham—Catalogs. 5. Western Washington University—Art collections—Catalogs. I. Title.
 NB235.B45 C58 2002
 730'.9797'73—dc21 2002014440

Distributed by
University of Washington Press
P.O. Box 50096
Seattle, WA 98145-5096

Edited by Gail Chamblin Fox
Proofread by Sharon Vonasch
Designed by Susan E. Kelly
Color separations by iocolor, Seattle
Produced by Marquand Books, Inc., Seattle
 www.marquand.com
Printed and bound by C&C Offset Printing Co., Ltd., Hong Kong

Page 1: Western Washington University campus, looking south to Fairhaven and the islands.
Page 2: (background) Nancy Holt, *Stone Enclosure: Rock Rings,* 1977–78 (see pp. 30–33); © Nancy Holt/Licensed by VAGA, New York, New York. (midground) Robert Morris, *Untitled (Steam Work for Bellingham),* 1971 (see pp. 68–72); © Robert Morris. (foreground) Magdalena Abakanowicz, *Manus, Hand-like Tree Series,* 1994 (see pp. 57–59); © Magdalena Abakanowicz.
Page 3: Western Washington University campus, Haskell Plaza.
Page 8: Richard Serra, *Wright's Triangle,* 1979–80 (see pp. 22–25). © Richard Serra.
Page 89: Western Washington University campus at sunset, with Mt. Baker in distance.

Photo Credits
Art on File: pp. 2, 8, 12 (bottom), 13, 15, 19, 22, 24 (top), 26–29, 31, 32 (top), 33 (top), 36, 37, 39 (right), 44, 45, 52, 53 (top), 56–58, 69–71, 72 (top), 78 (top), 79, 81; BJSS/Duarte Byrant, Seattle, and Opsis Architecture, Portland: p. 43 (bottom); Paul Brower: pp. 35, 42 (right), 64, 65 (top), 72 (bottom), 73 (top), 84 (bottom); Jon Brunk: p. 77; Nancy Holt: pp. 30, 32 (center, bottom); John W. Hubbard: p. 78 (bottom); Sandra Lucke: pp. 12 (top), 17, 24 (bottom), 34, 40, 60, 85 (both top); Robert Maki: p. 21 (top); Daydre Phillips: pp. 16, 21 (bottom), 33 (bottom), 38, 39 (left), 41, 42 (left), 43 (both top), 46, 49–51, 53 (bottom), 61, 62, 66, 67, 84 (top); Manuel R. del Pozo: pp. 23, 25, 55, 59, 63, 65 (bottom), 73 (bottom), 74–76, 85 (bottom), 86–88; Phil Schofield: pp. 1, 3, 89; Roger Schreiber: pp. 47, 48

Contents

Preface

Scholar Emory Lindquist has stated in the preface to his book on Swedish-American artist Birger Sandzen that "every civilization is seen through its art." This statement is proven time and time again by the historical past, from the monuments of ancient Egypt and Mesopotamia to the soaring cathedrals of Medieval Europe, the intricately decorated mosques of the Baghdad Caliphate and Ottoman Empire, and the rich variety of artworks from Japan to Africa, both decorative and functional. Indeed, in modern society art has played a vital role in the rule of politics, from works in service to the state to pieces that are controversial not only because of their form and structure, but because they force society to confront and discuss a myriad of issues that go to the heart of our global civilization. Much of this art is dependent upon the environment, taken both as a general and a specific statement, and the subject matter that is created by the artists is most often a direct result of interaction and reaction to it.

The Outdoor Sculpture Collection at Western Washington University is one of the few places that both allows a special, even unique interaction between the artist and his or her environment, as well as creates an opportunity that is funded in many instances by the state as public art. While the creation of art in this fashion is not new (or uncontroversial), the Collection offers an opportunity for an artist, chosen by jury, to use the various sites of this well-situated campus as a canvas or backdrop for a unique, specially created piece without more than the mundane constraints of available funding. Over the past years, this collection has grown and prospered, attaining a reputation as one of the leading places for outdoor sculpture in the nation. The artists who have been chosen by virtue of their reputation and creative talent have contributed works of international stature, which in turn have sparked both imitation and approbation. The latter is an ever-increasing part of the collection, ranging from critical acclaim in the national media to groups of students who take particular pride in "their" pieces. And the artists themselves have been inspired to contribute works that are both provocative and unique without fear of interference or constraint.

The Outdoor Sculpture Collection is truly one of America's living treasures, representing something that is growing and developing thanks to the support by both the Washington State Arts Commission and by the enhancement of private donors like the Virginia Wright Fund. I hope that you will find this catalogue of our work both enlightening and provocative; and that this will both inspire you to promote similar efforts in your own region and to see these unique and prescient works in person. It is our vision to continue to make the Outdoor Sculpture Collection a mirror of the complexities of our civilization.

Bertil van Boer
Former Dean, College of Fine and Performing Arts
Western Washington University

Acknowledgments

Since this is the first major catalogue of a collection that is almost fifty years old, the University wants to take this opportunity to express its immense gratitude to the artists not only for their highly creative endeavors, but also their willingness to work in this setting and their efforts which always far exceeded any remuneration they received. Without these artists' pivotal works, the early support of the Art in Public Places Program of the National Endowment for the Arts and the catalytic gifts of the Virginia Wright Fund, Seattle, Washington, this collection would not have the level of distinction it has today.

Special recognition is also due to individuals on campus: Barney Goltz, first director of the Office of Campus Planning, who in the mid seventies took our earlier Board of Trustees' proclamation and model for an art allowance on a residential campus all the way to the Senate Chambers for a state percent-for-art program; Larry Hanson, former Professor of Sculpture, who with a sense of adventure nominated some of the best artists of our time for workshops and potential commissions; Richard Francis, Professor Emeritus of English, who looked at the entire setting and reminded the campus community to think about excellent design in architecture and landscaping as well as art; all the Provosts and Presidents who have courageously championed the hard-fought, timely and wise decisions of the various art acquisition committees, now known as the Outdoor Sculpture Collection Advisory Board; and President Karen W. Morse, who continues to support our challenge of excellence in the visual arts. Finally, it is our University's maintenance crews and facility technicians who have worked with the artists over the years and who honor their works now through daily care, with the benefit of the Kreielsheimer Endowment Fund for Conservation.

For the production of the catalogue, Gail Fox was gracefully persistent in carefully editing my essay. Susan Kelly of Marquand Books responded with her dynamic design giving equal emphasis to artist and writer. Each of the photographers enhanced the art and campus under constraints of weather, construction, population, and remuneration; added on, were their in-kind services, especially those of Sandra Lucke. With a Western alumnus in his family, Pat Soden at University of Washington Press remained loyal throughout the long process of initial discussion to final distribution. Behind the scenes at the University many people, especially the Western Foundation, provided encouragement and dedicated time to pursue important details in the overall project.

Over the years students, faculty and alumni, art lovers and art skeptics, the presence of out-of-town visitors to this unique campus, and history itself have all demanded this publication. Without the flexible powers of David Bancroft, specialist in the visual arts at the NEA; the generous endorsement and trust of Ray A. Graham III, President of the Elizabeth Firestone Graham Foundation; the ever-expanding love for good books and art by Miriam Mathes, former director of Wilson Library; the civic spirit of Pam Meals, Publisher of the *Bellingham Herald,* in association with the Gannett Foundation; the strong belief in partnerships in behalf of art and nature by the Spirit Action Fund of the Whatcom Community Foundation; the timely gifts and loyalty of all the Friends of the Western Gallery; the magnanimous leadership of Ed Marquand at Marquand Books, Seattle; the resolution of Rosalie King, new chair of the Department of Art; and the enthusiasm of Allison Smith, President of the Associated Students' Board of Directors, this project would not have happened.

With deep respect and profound gratitude, I dedicate my essay on the Outdoor Sculpture Collection to Virginia Wright.

Sarah Clark-Langager
Curator, Outdoor Sculpture Collection
Director, Western Gallery

SCULPTURE in PLACE

a CAMPUS as SITE

Sarah Clark-Langager

THE PLACE

Whether heading north to Vancouver or south to Seattle, the traveler sees the snowcaps of Mt. Baker give way to a series of smaller mountains, lakes, and hills, all stepping down to the water. Farther out, north to the Haro Straits, are the San Juan Islands. In Bellingham, on a narrow shelf between Sehome Hill's protected arboretum and Bellingham Bay is the Western Washington University campus. From an architectural viewpoint, the campus has been described as a "classic sanctuary of learning" arranged in a "sequence of outdoor spaces"; as a series of "living rooms," an academic mall or residential, pedestrian village relating to rocks, trees, water, and sky. Even from a business perspective, Western's liberal arts education emphasizing real world practices has been characterized as something of a "human resources" manager's playground.[1]

When the traveler sees the landmark sign on I-5 announcing Western's Outdoor Sculpture, he might imagine it to be in an open-air museum sculpture garden, but in actuality he would find himself in a park-like setting. He would discover the traditional view of American campus architecture as a mixture of idealized rural simplicity and urbanity, yet he would find it in a spectacular landscape setting. As opposed to a group of sculptures on pedestals among the flowerbeds or sculptures deposited in plazas, he would come to see that this sculpture collection is closely integrated with the entire built and natural environment. Unlike a visitor, the Western student who lives on this playground has far more time to develop a wider curiosity, including self-exploration, by engaging with these works of the imagination. The many visiting artists who have contributed to this outdoor sculpture collection have, among other things, inspired the student to continue to learn to put ideas and experiences together in new ways.

THE DEVELOPMENT OF PUBLIC ART ON CAMPUS: ISSUES CONCURRENT WITH NATIONAL FOCUS

Art and Architecture as Public Symbols

As an institution, Western has followed national and regional patterns of architecture representing quality education. From the first arcadian lawn containing the earliest buildings, which recalled classical and European foundations of education, to the latest hi-tech influenced designs of the science complex in the expanded campus, the architecture has exemplified this range of educational goals. But architecture has not been the only public symbol reflecting our past and our future. During the period 1957–63, new members of Western's Board of Trustees made several crucial decisions to incorporate a variety of the best designs in art as well as architecture for this community of living and learning.

At the time that the National Endowment for the Arts and Humanities established its Art in Public Places Program (1967), Western had already begun to set its pace with its own internal art allowances in its capital projects' budget. In an early era of strong NEA support for artist workshops and exterior art, Western fast became a testing ground by commissioning such artists as Robert Morris (1971), Lloyd Hamrol (1974), and Nancy Holt (1978). By the early seventies, the University's public art program had not only become a model for the state but also the art itself was known at the national level.[2]

Evolutions

Since the percent-for-art program at the national level began with architecture, it was logical that the commissioning process was controlled by the architects. Such was the case with capital projects at Western until 1970 when the field of expertise was broadened. Regardless of what was happening in the most up-to-date contemporary art on the national scene, and the character of the NEA's first public art, and later, which artists would subsequently come to Western, it could be stated that Western's selections by architects throughout the sixties were mostly conservative choices. They selected, for example, Noel Osheroff's small-scale, animal garden sculpture at the Ridgeway Dormitories (1962), Norman Warsinske's decorative wall and lantern forms around the Humanities building (1962), and James FitzGerald's fountain (1959), created in an earlier fifties' abstraction. Only the recycled assemblage of Steve Tibbetts (1966 student competition award)[3] and the hard, abstract, technological cube of Noguchi (1969) could possibly be counted among the more avant-garde camp of the early sixties. By 1970 the new draft for an art committee restricted the architect's role. Decisions concerning potential artists, general concepts, and appropriate sites would be made by the committee of the whole.

Following the University's successful arts festivals, artist/student workshops, and early federal support, Larry Hanson, an influential member of the art acquisition advisory committee, in the late eighties proposed to the NEA a summer symposium where artists, students, and the community would focus on the issue of site-specific work. The choice of artists—the earthworks of Michael McCafferty, the architectural sculpture of Alice Aycock, and the hybrid sculpture/furniture of George Trakas—reflected the history of public sculpture, moving from the single object to sculpture related to site, and to the eighties' version of functional sculpture. Interestingly, the selection of artists who generally used architecture and landscape as their subject matter and who had a history of working in unusual places, flew in the face of one of the trends of the eighties—the collaboration of artists and architects on one design team. Actually, at Western, the artists as sole designers would perform a community service by solving the problems of some of the out-of-the-way areas of the campus.

The early artworks on the landscape at Western and elsewhere by Robert Morris, Lloyd Hamrol, Nancy Holt, and Richard Serra resonated in the 1979 national symposium *Earthworks: Land Reclamation as Sculpture,* held in Seattle, in which eight artists participated, including Robert Morris, Beverly Pepper, and Larry Hanson. Morris' keynote address elaborated on a new structural element: the references and conditions of a specific site, whether they be historical, economic, social, political, or

physical. One of the important results of the Seattle conference was a wake-up call to landscape architects that artists had been working in their bailiwick with a high degree of visibility.[4] The nature of earthworks in the late sixties and early seventies had led artists to consider their art as landscape architecture. Generally oriented to social utility and maintenance or reclamation, the landscape architect, in turn, began to aspire to that high degree of media attention cultivated by an artist. So while Western did not become involved with the issue of design teams or collaboration of artists and architects for urban design/public art in the eighties, it did immerse itself in the question of the nineties: is landscape architecture art?

To some, public art still manifests itself as a monument. In their minds the plaque and rock wall making up the Mt. Baker Memorial (1939) commemorating the deceased student mountain climbers should be included in the brochure on the sculpture collection. To others, outdoor sculpture is remembered as a part of large-scale landscape gardening, such as Frederick Law Olmsted's creation of Central Park in New York City or 18th-century landscapes. When Tom Otterness was commissioned in 1997 with percent-for-art funding from the last phase of the new science complex and the renovation of the old science building (Haggard Hall), the issue of architectural purview, including selection of artists, shifted to that of landscape architecture. The landscape architectural firm, Campbell & Campbell from California, had been hired to coordinate the flow of pedestrian traffic stemming from the final grouping of the older buildings and new science buildings (biology and chemistry) and to revitalize the residue of land in this area. Park-like settings of any scale can be successful spaces even if they do not include art. But the challenge here was to incorporate two existing sculptures already at this site: Beverly Pepper's *Normanno Wedge* and Lloyd Hamrol's *Log Ramps*. After several changes in their design, Campbell & Campbell utilized the "found" sandstone boulders excavated in the area and created a plaza replicating on a miniature scale the San Juan Islands and Bellingham Bay (completed 1994).

Inflecting the spiritual tone often associated with the Pacific Northwest—the "place soul of Western"—Campbell & Campbell felt that they had reached a symbolic level that was "difficult to achieve in modern times." In their prepared statement, they said they believed that "by recognizing the enormous significance and beauty of the regional landscape, this work transmits an authentic and profound environmental ethic." And to these modernist landscape architects "it is clear, therefore, that the integrity of the work can be easily lost in small intrusions over time." When Otterness proposed to work in this plaza three years later—alongside the large-scale Pepper and Hamrol works—the firm wanted no part of his design of 18-inch-high anthropomorphic bronze figures. To them the figures would be an intrusion on their symbolic work, their formal artwork or garden.[5] Campbell & Campbell had been successful working with other artists, but clearly Otterness' cartoon, cyborg, or Disney-like figures in *Feats of Strength* were too unusual. Interestingly, in its own way, Western had introduced a more up-to-date version of public art, which in this case provides questions, disrupts, and contemplates high culture with a touch of low culture. More importantly, it set an example as well as underscored the question of how the older and new art juxtaposed could renew the entire campus as an interdisciplinary field of operation.

THE ART

While the landscape architects Campbell & Campbell envisioned Haskell Plaza as another social center for campus similar to Red Square, they also hoped that they had a ready-made context: the "university's renowned art walk."[6] Yet this is not a fixed walkway. One of the things that sets Western apart from other institutions is the idea of allowing an artist to react creatively to diverse sites and environments on campus.

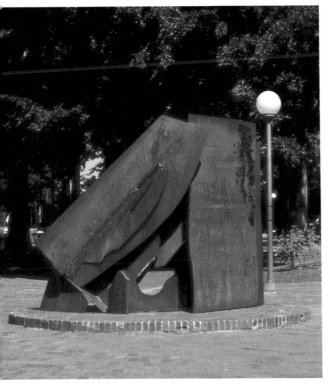

ANTHONY CARO

When the art committee took over the selection of artists from the architects, the visiting artists were permitted to find their own site or context. If Anthony Caro is one of the few who did not actually visit the campus, one might question if his piece is placed to its best advantage and whether his work responds to the architectural environment. Despite his not siting the work himself, Caro has said, "I am pleased to hear that *India* is in an enclosed area, surrounded on three sides by buildings, but with the buildings sufficiently far away not to compete with it or obstruct the view. It [seems] as if the siting has been very sensitive."[7]

Early in his career, Caro had been interested in representing the human figure in an expressive manner while still emphasizing the body's weight. While he was in the United States in the early sixties, he changed to a totally abstract mode using units of industrial preformed steel (I-beams, bars or railings, mesh screens, etc.) in his concern to more effectively imply an architectonic order. He continued to dispense with the conventional pedestal and oriented his sculpture horizontally along the floor or ground. One critic found that, instead of having an actual body, Caro's figuration had to do with its lively horizontal and vertical movement in its static, albeit abstract, frame. Also the critic felt he could say that Caro's internal forms—the different sizes of planar shapes—emerged gradually, as in music. While Caro himself has often stated that his relational mode of working is parallel to music, he and other critics today speak more openly about "architectural detail."[8]

Favoring a more human scale, Caro had disliked the type of public sculpture that was being forced to match the scale and meaning of a public building. Yet, he always has been attuned to the reinvention of sculpture in relation to architecture. He has stated that the adjectives "sculptural" and "bodily" are similar in that both imply a physicality—"a type of felt relation to our bodies' size [verticality] and stretch [horizontality]" as well as weight and gravity. Furthermore, he feels that both "sculptors and architects are necessarily conscious of the body."[9]

In the seventies Caro wanted a more monumental look to his sculptures, which earlier had been placed running in rectilinear directions along the top of the ground. Moving from the floor of his studio, he stepped outside to work with a crane operator in a steel yard. There, he chose large flat pieces of steel to lean against each other so that the work had a stronger vertical stance with a front and back view. The multi-layered planes gave a compressed sense of volume and, as in *India*, the small, open cut-out area joining the right and left sides even suggested the possibility of looking into something. Rather than scaling itself to a tall building, for example, the adjacent Old Main (1896 building on first quad), Caro's sculpture relates to human scale and to architectural detail. There is a strong frontality to *India*—like the vertical planes of a

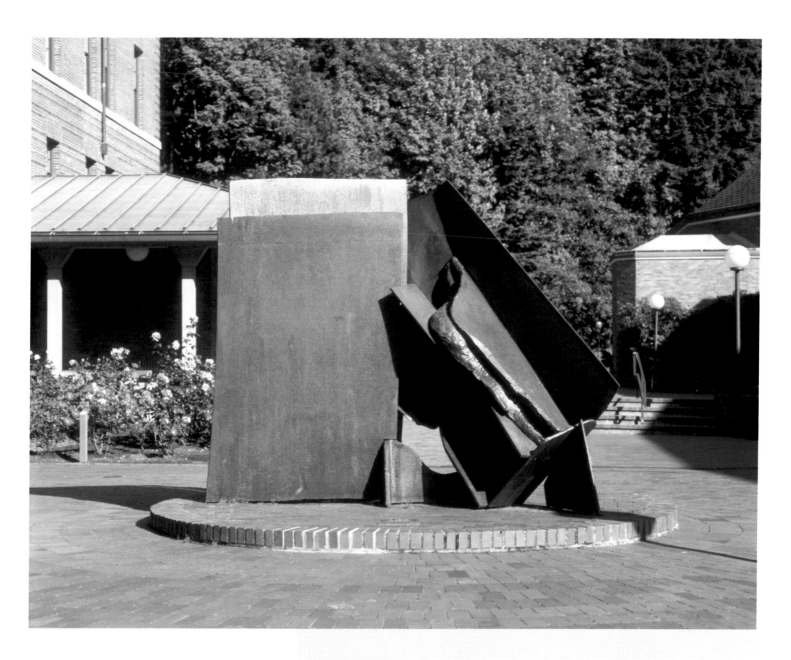

Anthony Caro

(BORN 1924)

India, 1976

Steel, rusted and varnished; approx. 7'9" h. × 9'9" w.
Gift of the Virginia Wright Fund, 1977.

© Anthony Caro

ANTHONY CARO artist statement

Virginia Wright saw *India* in an exhibition that I had at the André Emmerich Gallery in New York during spring 1977. There were several pieces, all of which had heavy elements in them, ingots of mild steel. I got them from Consett in Derbyshire, England, where I went to a big steel factory. The ingots would come into the rolling mills on rollers and be pressed down into much thinner pieces, rather like rolling out pastry. They would eventually come out a few millimeters thick. I had used quite a lot of pieces that had been rolled in that way. Some I used in the *Flats* series made at a big steel yard called York Steel in Toronto. Before that I had used some thinner slabs for the *Veduggio* series made at a small factory at Veduggio in Italy. The factory did not trim the pieces, but supplied them as they were, and then the workmen trimmed them themselves. The >>

>> seven or eight works shown at the Emmerich Gallery were done in a series; each had one or more of those great lumps, which were not easy to move about. They were put into position and then held there with other pieces of steel. The lumps are the key to this theme.

The title has a reference that not even I was aware of at the time. The titles always come after the sculptures. Your assumption that it relates to the ship from which the steel came is certainly not correct, for these parts came from a steel mill. However, I think the work probably had something of the feel of the enormous size or the shape of India on the map. I have subsequently been to India, and I do not think I would call the piece *India* now, mainly because India is so many other things for me now. But you have probably put your finger on it in suggesting that there is a reference to the lushness of the ancient Indian sculptures embedded in their architecture.

It was quite a surprise to me that the work had been given to Western Washington University. I have not seen it, as I have not been to your part of the world. I do not often get involved with the siting of a work after it has been purchased. I tend to leave that to the purchaser. It is like when you buy a picture—you put it on your wall and you are unlikely to ask the artist if he likes it there. You try to place it in good light in a fairly anonymous situation where it is going to look good. And I hope this has been done with *India* at Western Washington University. There are special problems when it comes to public work, but in fact I would not call *India* a public work. By and large, I have liked to see my work indoors. It is very difficult to put up sculpture outdoors, and it seldom looks good. It cannot compete in size or scale with a tree. If you are trying to make public art, you have to be very conscious where it is going to be sited and how the public will interact with it. The work helps them to identify where they are in the city. It should be a meeting place, like the fountain in the square used to be in the old days. It has to be user-friendly. All of these things are important aspects of the work. I do not think that is the case in private art or studio art.

I am pleased to hear that *India* is in an enclosed area, surrounded on three sides by buildings, but with the buildings sufficiently far away not to compete with it or obstruct the view. It sounds as if the siting has been very sensitive. If people are enjoying it and feel it is the right scale, and if it has that sense of containment, say within the plaza formed by the buildings, then it sounds perfect. <<

(Interview, July 3, 1991; revisions, November 7, 2001)

door, panel, or room divider. Each side gives dramatically different views; at the back, smaller, uneven shapes activate the unpainted, pitted, and corroded surfaces and at the front, organic lumps thrust diagonally against the large planes.

When *India* was completed, one critic commented on its combination of urban and pastoral imagery.[10] While he probably was specifically referring to a lingering figuration in the lumps reminding him of Caro's past apprenticeship with Henry Moore, he also suggested he saw an urban quality probably connected with Great Britain's industrialism, present and past. In the seventies, Caro worked in the steel yards in Veduggio, Italy, and York, Canada, and would travel in his own country to the County of Durham to find material. There the workers at Consett also sent steel along rollers to be flattened from a lump to a slab to a sheet for future boilers, ships, and car bodies, just like those auto parts in Steve Tibbetts' sculpture. Yet, another critic stated that these steel lumps in *India* "evoked outcroppings of prehistoric rock pushing through the earth's surface, the hidden recesses of cave formations. . . ." Another found that the upright planes "sheltered secret sculptures tucked under the overhanging planes. . . ." Perhaps, when Caro stated that "walking into a building and walking around a building are different," he was remembering the Indian ritual of circumambulating a temple but also the details of those temples.[11] Prevalent in India are rock caves with interior religious sculptures and/or towering architecture encrusted with ever moving body parts of various deities and attendants. Now we know that Caro has always wanted to cross the boundaries of sculpture and architecture, to address the same subject—the relation of form and space in a way that makes sense in human terms.

DONALD JUDD

In the seventies, Donald Judd had begun to think more about how his art had similar subject-object relations peculiar to architecture. Yet, if his "specific object" could be occupied, was it necessarily a building? By the time he moved from the streets of New York City to the plains of Texas in 1976, he had created a full range of work that had no other concept but the literal space within the hollow-like box itself. Any relationship would have to incorporate "virtually the whole room or area outdoors."[12] When he came to Western in 1981, he first proposed a series of architecturally scaled, concrete boxes set one after the other on a knoll parallel to the walkway adjacent to the field track in south campus. He finally decided on one large Cor-ten box with open ends and with interior planes set on the diagonal to the box's perpendicular sides. He sited his *Untitled* (1982) work on the lawn of Old Main.[13]

The fact that this new type of object was a hybrid—not painting, not traditional, solid sculpture, not functional architecture—does not contradict Judd's insistence on the independence of things. Conversely, he also sought a feeling of wholeness in his work. He felt that his procedure of making different hollow-like boxes provided a

Donald Judd
(1928–1994)

Untitled, **1982**

Cor-ten steel, 7'4" h. × 7'4" w. × 14'8" d.
Gift of the Virginia Wright Fund.
© Donald Judd Foundation/Licensed by VAGA, New York, New York

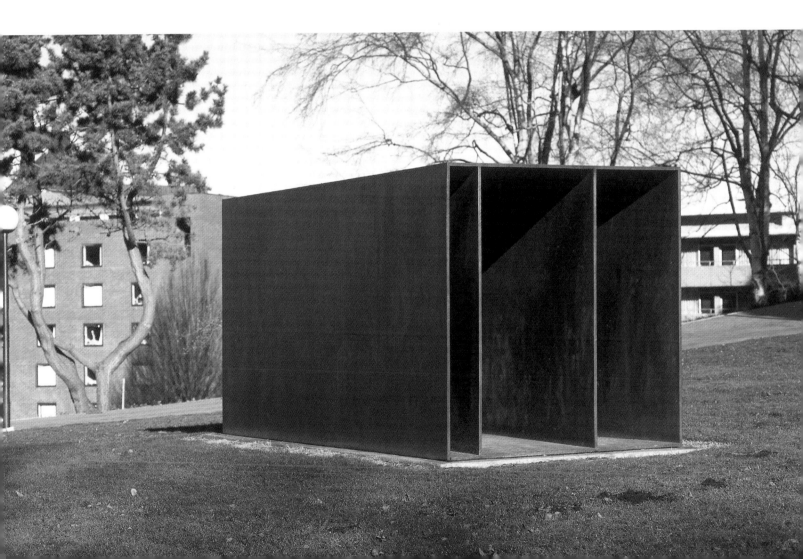

structuring experience for the viewer. His attention to a material structure would create the greatest intensity between the viewer and the immediate space of the specific object. His new architecturally scaled work could provide the core of a larger, complex underlying structure.

Inside Western's "box" there is an earlier method of using perspectival lines or planes to depict space. However, Judd was opposed to the western idea of fixing space, so he also opened up the ends of the boxes to allow occupancy and a greater "ambient situation." His concept of order countered hierarchical relationships, particularly those of European rationalism, because he was against any grand, immutable scheme or composition of knowledge that excluded information gathered by the senses. He believed that Cartesian rationalism failed to reflect the disparate conditions of the 20th century. He saw "an existential universe in which parallel lines meet, in which interior and exterior (subjectivity and objectivity) are co-extensive and finally interchangeable, in which order and disorder (symmetry and asymmetry)

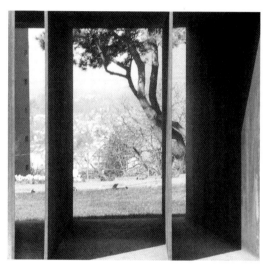

have equal value. . . ." Furthermore, as one critic has stated, he realized that ". . . all rationalism [is] the same, whether that of a higher, purer harmonic, or that of capital and labor."[14]

Another artist, Robert Smithson, described Judd's work as "uncanny," a strange adjective for what was supposed to be rigorous, right-angled work. What Smithson meant was for all Judd's repetition of this defining box structure in various permutations and materials, Judd's space is "elusive" in what it captures, holds, or "misses." As Smithson said: "Time has many anthropomorphic representations, such as Father Time, but space has none. There is no Father Space or Mother

Space. Space is *nothing*, yet we all have a vague faith in it." Suggesting an analogy between abstract space, mineral deposits, and Judd's boxes, Smithson still found Judd's space "elusive."[15]

In retrospect, perhaps what Judd was thinking about was his situation in Marfa when he first proposed the concrete boxes one after the other for this campus. In Texas he was working out specific spaces for his artwork, where each object contains space and is contained in space; where windows and doors, rooms, courtyard, and sheds would frame the expanse of the fields, plains and mountains in the distance; where the concrete boxes in those outer fields would take this underlying unity one step further. However, Judd's mental process also incorporated feeling and particular experience. That experience of the University was more like a series of smaller rooms—architecturally enclosed spaces—on a fortified hill that was part of a larger natural landscape. In the end, he placed his Cor-ten work beside the Greek columned porch of Edens Hall (a vintage 1919 women's residence hall on first quad), which looks across to the Canadian Coastal mountains. One open end of his work looks up the sloping lawn to Old Main, framed by the towering trees of Sehome Arboretum, and the other end measures the exact interval between the newer dormitories of Mathes and Nash Halls, which allows a distant view of these mountains. In a statement for a catalogue in 1993, Judd actually referred to his *Untitled* (1982) work at Western as a piece where "space in the work and outside the work is important." In general, he felt that the "vocabulary of space of the past should be reconsidered" because, as in Greek civilization, there was a wholeness in a relationship not just made up of parts of a box or room but rather consisting of art, architecture,

Any work of art, old or new, is harmed or helped by where it is placed. This can almost be considered objectively, that is, spatially. Further, any work of art is harmed or helped, almost always harmed, by the meaning of the situation in which it is placed. There is no neutral space, since space is made, indifferently or intentionally, and since meaning is made, ignorantly or knowledgeably. This is the beginning of my concern for the surroundings of my work. These are the simplest circumstances that all art must confront. Even the smallest single works of mine are affected.

My work, whether indoors or outdoors, ranges from that which can be placed on any flat surface, floor, wall, ceiling, or ground, with no intention of space other than that implied by the work, to work that articulates part of a room or some of an area outdoors, to work which is virtually the whole room or an area outdoors. The smallest, simplest work creates space around it, since there is so much space within. This is new in art, not in architecture of course. All old sculpture, great as it is, from any civilization, is monolithic; it is the stone that Dr. Johnson kicked at Harwich and not the glass that you pick up. . . . A Greek sculpture is the stone; the building that it was in is space.

. . . The space around the work is only somewhere from which to look toward the continuous solids. Very generally as to meaning, all earlier sculpture, East or West, is totemic, from the altered stone to *David*. (The installation of Michelangelo's sculpture in the *Accademia* is harmful, the least to *David*.) A god is in the stone, the stone is a god, the sculpture is a god, the sculpture is a representation of a god, the sculpture is a man as a god, it is a representation of a man as a god, it is a representation of a man as a power. God dominates or man dominates; god is man-made and man is self-made. Everything is man-made. At the least, this is out of proportion. When I look up a night nothing is man-made. Man as a god was fortunately never made of the highest quality: Alexander was too late and Augustus remained a Roman, in art still Republican. Stalin tried but art history was against him. When art history is forgotten the new powers can have new totems.

I found that if I placed a work on a wall or on the ground, I wondered where it was. I found that if I placed a work on a wall in relation to a corner or to both corners, or similarly on the floor, or outdoors near a change in the surface of the ground, that by adjusting the distance the space in between became much more clear than before, definite, like the work. If the space in one or two directions can become clear, it's logical to desire the space in all directions to become clear. This usually requires more than a unit or it requires a space built around a unit or it requires the amplification of a unit to an enclosure containing a great deal of space. This is so of some large indoor works and of most large outdoor ones.

Works outdoors, then, are either freestanding on a level surface, containing space within, or they incorporate a level or a sloped surface or relate to an existing wall or demarcation. Some of the freestanding works are: . . . There are two related works made of Cor-ten, >>

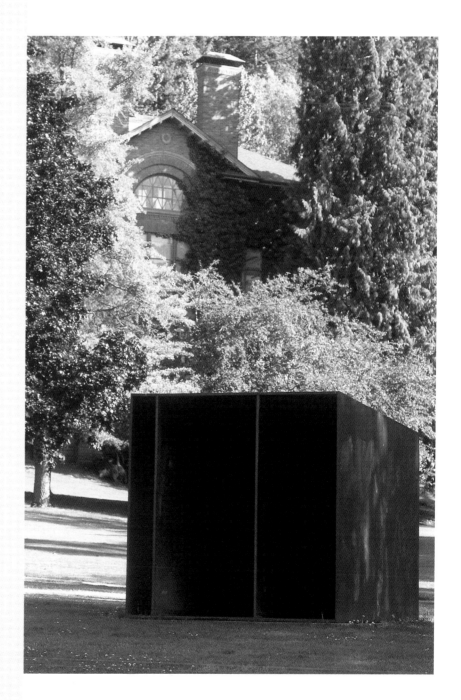

>> constructed in '82, one at Western Washington University in Bellingham and one at the *Gemeentemuseum* in The Hague. And, there are the fifteen works in concrete at the Chinati Foundation in Texas. These are on level land, but specifically, so as to avoid one protruding knoll and to end before another, extending one kilometer, aligned north to south. . . .

Freestanding works, single or several, on level land are not a problem to place. The land is always beneficial as space and if not remade by man has no meaning. Placing freestanding works in cities is a problem. The old parts of cities either assume that there will be a statue in the square or that there will never be one. The new parts usually assume that there is no such thing as art, and, unlike original *piazzi* in Italy in which a statue in the center would be an intrusion, the new public spaces, like the Holy Roman Empire, are neither public nor space. There is no definition of the space; the surrounding buildings are an unconsidered jumble; the bleak and vacant areas are full of odds and ends. These areas are social and political public spaces only in the least sense of ignorance as meaning. The *piazzi* were highly social and political and still are: I can tell still that they were much more so than the schematically defined, generalized, somewhat arbitrary spaces of the eighteenth century. De Tocqueville wrote that you can tell the nature of a government by taxation. You can also tell by its public spaces.

Placing work, then, in public is difficult. There is no context, either for the space of the work or of real meaning. If art is finally thought of, the delay, like a course in art history, seems to make it impossible to get to the present and so something like a statue or a monument is suggested. This is what is in front of skyscrapers everywhere. This is the possibility I rejected in '83 in Providence, proposing a structure or several that would be developed and integral. A middle-sized work is impossible. It becomes a statue or a monument, only in my case, lying down. A large single work has so much material and space that, uneasily, it defends itself. A large work with several parts is, simply, larger, and, importantly, much more horizontal, escaping the suggestion of the totem requested. The replica of *David*, incidentally, in the original position in front of the *Palazzo Vecchio* looks much better than the real *David* in the *Accademia:* the sculpture also has integrity. It also has a meaning not generally known: it was commissioned by the Florentine Republic as a warning to tyrants.

. . . Space is new in art and is still not a concern of more than a few artists. It is generally accepted that vertical, anthropomorphic, totemic sculpture is no longer possible, although I don't know that those who believe this know why, but a general interest in space has not replaced the interest in such solids. (There are other solids.) There is no vocabulary for a discussion of space in art. There was a traditional vocabulary about space in architecture, about proportion, volume, and sequence, East and West, but it was discredited in the seventies by the architects who are not architects and so could not judge. They appropriated the appearance without knowing the substance. For both art and architecture, the vocabulary of the space of the past should be reconsidered and in relation, but newly, which is not impossible, a vocabulary should be built. There has been more discussion of color than space, at least since Goethe and Chêvreul, and recently by Albers and Itten, but there is much more to say about color. There is much more to say about art. Color is still new in art. It hardly occurs as a reality in architecture. . . . <<

(Excerpts from "21 February 93," *Donald Judd–Large Scale Works* (New York: Pace Gallery, 1993).
© 1993 Donald Judd Foundation/Licensed by VAGA New York, NY, courtesy The Pace Gallery of New York, Inc.

and nature. But of equal importance to his text in this catalogue, Judd chose a photograph specifying the temporal dimension of his *Untitled* work, which supported the idea of the nondistinction between the perception of art and architecture. His view through the contained space captured both the traditional architecture of Old Main and a passing student.[16]

ROBERT MAKI

By framing the student in his photograph, Judd had exceeded the role of mere architect and encouraged a role for the viewer. Robert Maki, a graduate of Western (1962), took up this perceptual theme in his own sculpture, but has pushed the "envelope" in his quest to understand how we see. Earlier as a Western student of industrial design, engineering, and drafting, Maki brought to his art a concentrated focus on geometry's elements of line and plane.[17] Similar to Caro's *India*, Maki's *Curve/Diagonal* (1976–79) was purchased during a gallery exhibition, so that the work had to undergo his critical study of the difficult transition from studio or gallery to public place. Along with defused memories, the integration of landscape with dominant buildings came into play in Maki's decision to site *Curve/Diagonal* along High Street. Now the new dorms of Mathes and Nash next to the student commons faced both the Greek revival Edens Hall and Paul Thiry's early modern, stacked concrete apartments in Higginson Hall on the other side of the street.

From 1968 to 1969, during a NEA fellowship, Maki had made studies through both drawings and geometric cut-outs in order to visualize the numerous ways an object can be seen. While he could skillfully draft triangles with wavy or rounded diagonals in varying views with different ground lines and elevations, he took his triangular cut-outs, joined by a fold, outside to stand upright in the natural sunlight. Here, light was the actual agent for drawing out or reversing the stability of their shapes. In these earlier studies, Maki made a proposal for his alma mater in which one triangular cut-out would be set on a hill, perhaps Sehome Hill or the west face of the ledge on which the University sits. The work

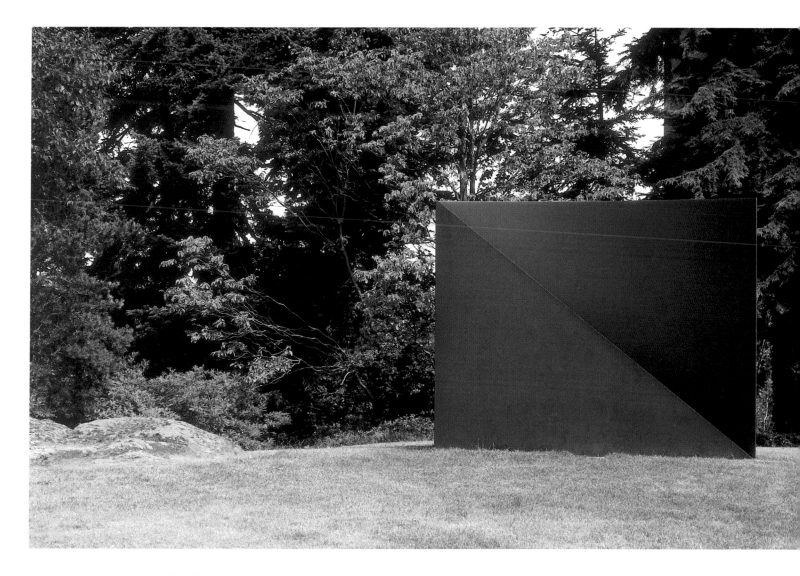

would be situated so that the hill and changing light would seem to leach into the shape, perhaps even evaporating some of its hard edges. One drawing in particular accented details of just one plane of this cut-out with rounded diagonals; one rounded edge emerged from the ground line as if a rock or mountain.[18]

Twelve years later when Maki had the opportunity to site a work at Western, he no doubt remembered his earlier drawings. However, not only had the campus changed with new buildings and more artworks since he was a student, but also he came with a more complicated, fabricated work. On the west side of campus, two new dormitories (Mathes and Nash Halls) had been built on the outer edge or ledge of campus. While some in the community might have criticized their looming presence on the Garden Street Hill, others marveled at their curving façades reminiscent of the Finnish architect Alvar Aalto.[19] Coincidentally, the younger Finnish-American artist finally chose to site his work adjacent to Mathes Hall across from Edens Hall where he

Robert Maki
(BORN 1938)

Curve/Diagonal, **1976–79**

Painted ½" plate Cor-ten steel, 8' h. × 10' 6" l. × 17" w.
Gift of the Virginia Wright Fund, 1980.
© Robert Maki

ROBERT MAKI *artist statement*

Curve/Diagonal on the WWU campus was selected by Virginia and Bagley Wright out of my 1979 Richard Hines Gallery exhibition. After looking at pieces in that exhibition, they decided to purchase this piece and later gifted it to the University. It was constructed in 1979, but it actually comes from models and studies in a series done between 1974 and 1976. It was one of four pieces executed for the Richard Hines Gallery exhibition. They were all fabricated from Cor-ten steel, although the piece at Western has since been painted gray.

The piece appeared completely different in the exhibition space. Even though the gallery was quite large, the piece felt much larger in that space but, of course, seemed to diminish in size once it was put on the campus site. For this reason it was rather difficult to site the piece on campus. We looked at various sites and made a full-scale model out of wood and visqueen allowing us to move it easily in the siting process. This is how we decided on the present site. It is sited specifically for the flow of traffic past it and in relationship to the giant boulder that sits under the ground and peaks through slightly. It is oriented so that the sunlight hits it and restructures the piece visually. Just beyond the sculpture site is a slot between two buildings, and as you move along the sidewalk, the piece, visually, fits perfectly into that space. From another approach the backdrop is the bay, but this view is now somewhat blocked by overgrown vegetation. All of these elements influence the scale of the piece.

The boulder extends and reinforces the piece. It is a powerful shallow basalt outcropping that barely shows above ground. When I site a piece, I consider everything in the environment. The sculpture alters the site, and the site alters the sculpture. I have always thought my sculpture a fragment completed by the site. If not site-generated, they are positioned or placed to activate the site geometry and reference their surroundings, extending to engage the viewer visually and physically. The giant basalt slabs of the Columbia River Gorge are etched in my thinking. I like the connection.

As I mentioned earlier, I really consider sunlight and shadow as elements that restructure the piece and fuel the visual ambiguity of the work. Many of the pieces I have done that precede this one were flat, and the concern was to create an illusion of a dimension beyond what was really there. Here, there is a real curve that tends to flatten out and change as you move around the piece, so I am not interested in a single gestalt but in a composite or a cinematic kind of perception on the viewer's part of the piece that becomes an accumulation of information and continual discovery that will go on and on and build over a period of time. As one passes this piece over a period of hours, days, or even throughout the school year, it will visually change very dramatically. Light, shadow, and weather conditions are a part of the piece. I like the piece painted light gray with a small amount of red added because

the surface becomes very sensitive to picking up the color from its surroundings—reflecting the green grass, trees, sky, and building.

I think the issues really were formulated by the environmental concepts and the structural theory solidified in my linear wood constructions of 1966, which were environmental pieces that dealt with articulating the viewer's space and acting as an extension of both the space and the viewer's body. At the time, the work was basically linear and appeared to grow from a geometric form or was isolated within the geometric volume of the room and later changed to more specific planar objects. But, they were objects where there was an attempt to control the viewer's movement and perception to experience the symbiotics of viewer, object, light, and space, and there was the specific intent that the object not displace space. By 1968 I had flattened those pieces out, and they became wall images where the sculptural experience was reduced to 180 degrees, a bisected sculptural space. In this way, a single image of the sculpture could be viewed from a multitude of angles and it would follow you like a hologram as you moved across the room.

I later proposed these same flat panels in the landscape. As a matter of fact, in 1969 I drafted a proposal to the NEA to fund a project on the WWU campus that would have been a hillside of metal plates where the subtle, undulating curve of the landscape is played against the curve of the sculpture in an illusionistic fashion. What I liked was that the plates could be put in the ground without having to worry about welding or mechanical joining. In the NEA proposal, I had hoped to develop a hillside piece, possibly, at the foot of Sehome Hill and probably south of where the Fine Arts building is, but as you are aware, many buildings have been added to the campus that have changed it dramatically. I would have been happy with any hillside site because I was very excited about this concept due to the time frame and the relationship to the wall pieces. Working with the wall pieces and setting them on the floor in my studio made me very aware of the potential and gave me a solution to move back out into three-dimensional forms after flattening these pieces.

In 1971 I was awarded a major commission for the Seattle-Tacoma Airport and my first opportunity to develop a permanent larger-scale piece that you could walk through. Prior to that I had done several large-scale mock-ups for exhibition purposes. They were done with two-by-four plywood construction that could be assembled on site. They were all quite large but selected for specific sites at that time. The airport piece was a site-generated concept that led to projects and lectures around the country.

At the same time, I got into the curved steel plates. Interestingly enough, the curve was developed by taking a flat plate and pushing a curved plate into it, forcing it to match the curve, and, once that resulted, it developed into a series of curved pieces. Some are still >>

>> in model form, and some were actually executed. The pieces for my 1979 Richard Hines Gallery exhibition effected the transition to the curve. There was funding from a project I had just completed and some private money, so I was able to speculate and build four big pieces pretty much the scale of commission projects, so it was a very risky situation. It was very nice to have the Wrights purchase one of those pieces during the exhibition and later have it sited at Western.

Drawing has always been an important element of my work, and I consider it to be connected to photography. A lot of what I have learned about—what I wanted out of my sculpture—came from the mid-sixties photographing early pieces and realizing that I was taking these from specific angles and wanting a certain thing out of the image. My drawings do the same sort of thing. They limit the image to a specific angle to show, many times, the nature of its versatility or its ambiguity; this builds information so that the viewer can further understand the sculpture. For a long time people talked about my work as though the drawings developed into sculptural forms, but really it is the other way around. I use drawings to understand and identify aspects of the sculpture. I want people to consider and also to expose and to objectify connections to other works or themes.

I have been involved in both responding to public input and/or the development of your own work, as in the Westlake Park in Seattle. But, generally, the information from my work comes from a strong background in geometry and site context, and I am aware of how much, for instance, the Washington State landscape has influenced my work. I am interested in bringing a lot of information to a viewer, and I like the idea of the viewer discovering this information over a period of time, so my approach is probably extremely optimistic and requires a certain amount of participation on the part of the viewer to extend himself or herself.

Because of the all-encompassing structural theory that is the foundation of my work, my environmental and experiential concerns, specific site and contextual information only strengthens my public sculpture projects. The way I have explored and developed concepts hasn't changed but the nature of the ingredients do, and that's the reason my work is continually expanding. This becomes clear when you see a portfolio of my work.

I don't separate public and private work. I follow through with ideas from the studio and take those to a site and then work from a specific site's information. The big frustration is the reality of what you hope to accomplish with the unpublished concepts you have developed that are critical to your aesthetic and the number of opportunities to implement them. <<

(Interview, July 15, 1991; revisions, July 15, 2000)

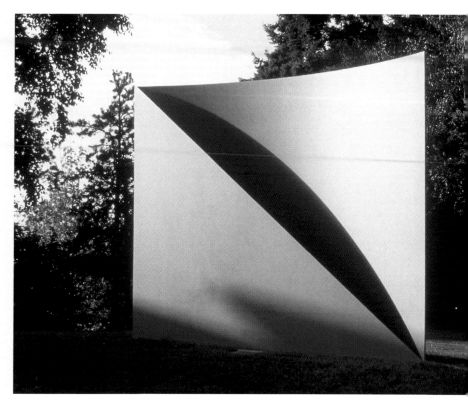

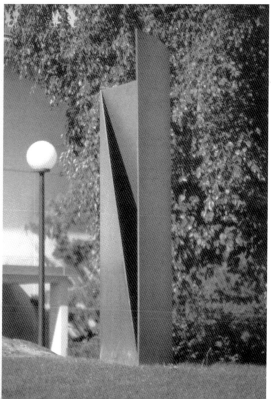

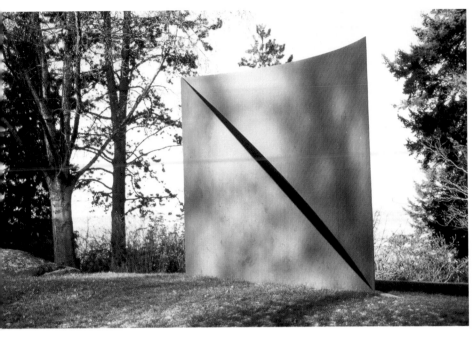

had been as a student. As a student on the porch of Edens Hall, he could see beyond the hill on which the University rested, but the forested Sehome Hill to his back gave protection. In the distance was the bay; in the rear was the felt but unseen presence of Mt. Baker. However, in the defining moment of these memories he allowed two details to emerge. First, he placed his own clear structure made out of an industrial material beside a rock, the tip of a larger geological formation that runs under the ground and erupts with an irregular line at the point of his sculpture. Secondly, he turned the outer curved back of his sculpture so it would echo the larger curving façade of Mathes Hall. Attached to the sculpture's curved back are two triangular flaps that fold across its interior. While the overall shape does not disappear into the landscape or hill, varying light conditions at different times of the day and seasons either flatten or open up this hidden structure, an envelope-like shape. As opposed to the function of the dormitory, Maki's construction only contains perceptual issues. And unlike the expansive dormitory, Maki's sculpture has a different sheltering capacity.

RICHARD SERRA

Maki would agree with Richard Serra's statement that "drawing can be an activity that filters reality into another form that allows one to rethink one's experiences."[20] In taking a drawing from a two-dimensional to a three-dimensional space, Maki tends to continue to emphasize the eye while Serra has also built into his response a gravitational theme. Using the same geometric shapes as Judd and Maki, Serra had led the way in pointing out that these forms' meanings had nothing to do with an ideal philosophy. In taking on the cube, he slanted its walls so that any sense of ideal conditions turned to a world of contingency. After all, *Wright's Triangle* (1979–80) is a free-standing prop piece.

When Serra first proposed *Wright's Triangle* the idea of the work was based on the confluence of college pedestrian traffic at the base of Red Square. After University engineers deemed that the floodplain ground was too unstable for such a heavy work, Serra moved his concept south to the crest of the hill beyond the square. At the base of Red Square the sculpture would have been in a more urban space. The horizontality of the sculpture would have contrasted with the taller buildings, but the sculpture's angles and wedged openings would have thrust the dense traffic flow into its interior. At the crest of the hill, Serra's sculpture was clearly at the edge of a more natural environment of open grassy mounds and tree-lined paths. Here, pedestrians also converge from two southern paths (at times parallel or diagonal to each other) to head

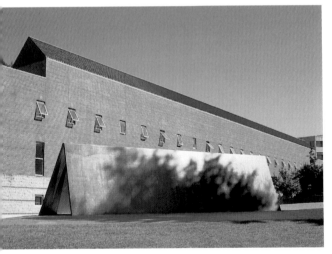

Richard Serra
(BORN 1939)

Wright's Triangle, 1979–80

Cor-ten steel; approx. 9' h. × 42'9" w.
Western Washington University Art Allowance from Arntzen Hall and Environmental Studies Center, the National Endowment for the Arts, and the Virginia Wright Fund.
© Richard Serra

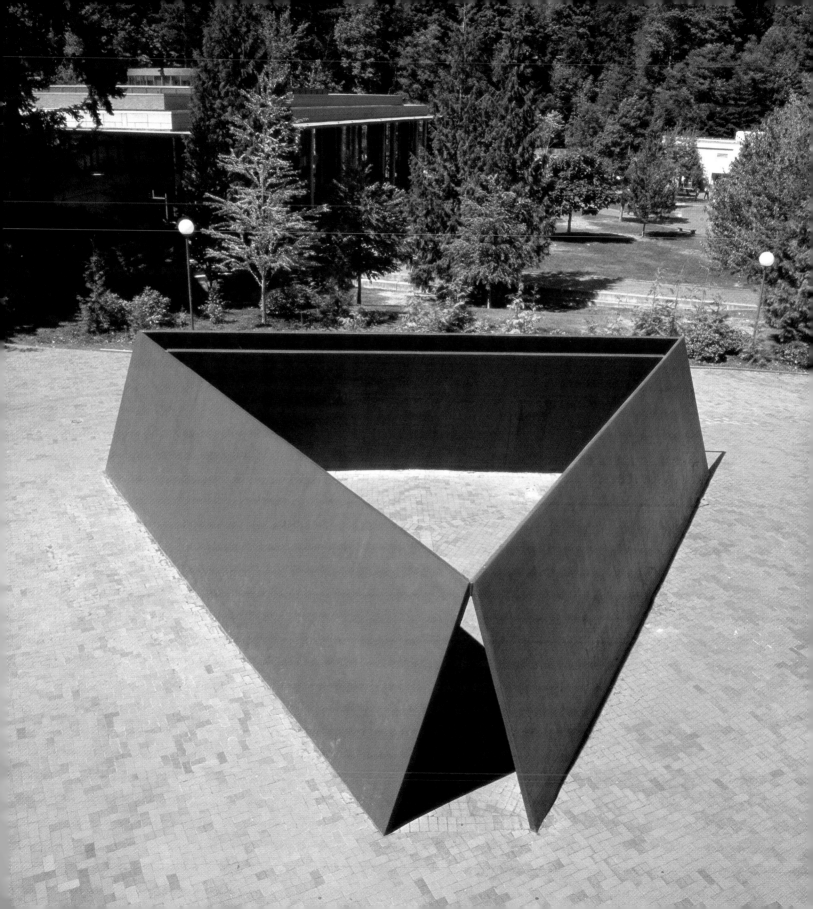

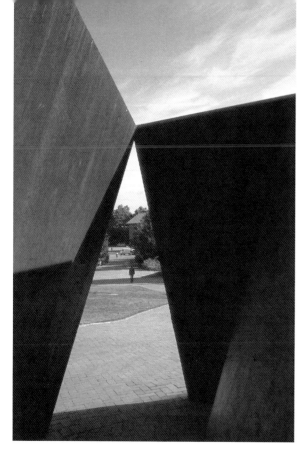

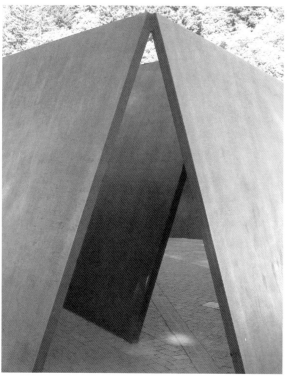

downhill toward Red Square. While the path alignment has remained relatively constant, newer buildings (Ross Engineering Technology and Chemistry building) have pressed their own strong shapes onto the site. The walkways have increased in scale to become more like a plaza.[21]

The fact that the surrounding elements of the site have changed since the eighties does not take away from Serra's long-held view of the importance of a site. Comparing how a ball bounces on a street versus in the landscape, Serra feels that urban spaces are really interior spaces turned inside-out. In contrast to the vertical and horizontal lines of buildings themselves in gridded space, the horizontal line in a landscape constantly shifts, and spatial coordinates are less obvious. He has been averse to the pragmatic concerns of architects whose primary vision is to match program with budget and who might select sculpture according to its ability to be in harmonious relationship and/or decorative balance with the building. If he has been most vocal against the architectural profession, one might wonder why his sculpture appears to take on the scale and some of the structures of architecture. From below or as one starts up the hill toward his sculpture at Western, there is no doubt that it looks like a great wall.[22]

But *Wright's Triangle* has never been a monumental object or a building. The work probably has the explicitness of a map that has been opened up; it is an active site. At Western, Serra did not want to correct nature with his geometry, but he used the contrasting shapes to make the landscape even more vivid, more irregular, more natural. He pulled the campus paths and those who walk them inside his sculpture to create a new internal structure and to give the viewer direction when he exits via the shifting landscape. Against the tendency of an architect to emphasize the façade as the single and only view—for example, the glass image of the Chemistry building—Serra created a free-standing prop piece so that the sculpture's balance is only understood by the viewer's constant circulation in and around it. Through this experience the viewer realizes that Serra has created a personal exchange at the site. In fact, the sculpture is a real site.[23]

At this site, Serra redirects our attention to real world conditions. He makes gravity visible not through neutralization as in the physics of stationary walls in a building but rather through kinetic energy as in the physics of a steel ball's movement down a slope. The weight in his material is correlated with the intensity of the event, the time it takes for the viewer to feel his own precarious balance, his own potential to rise and fall.[24] Serra is also aware of how weight has been transferred to our consciousness both from his art and from industry. He extends sculpture's process from artistic hand with tool to industrial technology. He refers both to the weight in Olmec Heads, Incan or Mycenaean architecture as well as to that in the work of engineers and riggers. Besides using an industrial material, Serra depends on the industrial laborer to help him make his work. By working in a public site and by using the standard means of production, he shifts emphasis from the persona of the artist to the work itself. Since the popular conception of art is that it is done with highly specialized, even fetishistic,

materials only encountered in a private space on one's free time, Serra revises this so-called uselessness and remoteness of art. He concentrates on the work process itself, which deals with using time and energy efficiently but in the end he makes an abstract product.[25] This product is a sculptural reading of this specific site that is not just a place where campus paths come together. It is also a sculptural place where a student finds parallels between his physical and intellectual weight; a place where he can find some type of balance in real world situations; and can perceive a unique relationship between work and leisure.

RICHARD SERRA artist statement

My recollection is that the sculpture at Western Washington University took several years to plan and that I made various trips to the campus. The site selection itself took two or three years. *Wright's Triangle* was originally placed at the south entranceway to Red Square. The openings of the sculpture were aligned with the three main accesses onto the plaza. The sculpture was to function as a hub to enter into the square. What happened was that after the piece was installed in Red Square, it was discovered that the ground was unstable due to underground erosion and that the piece would have to be moved. I knew the campus well and when the knoll above Red Square was suggested as a site for relocation I agreed since I thought that the piece could function there.

When *Wright's Triangle* was first installed, people were somewhat startled and there was some resistance to the piece. For a period of time the sculpture was covered with graffiti. It was probably more confrontational at Red Square than where it is now. The relocation was accomplished with forethought and consideration; lighting and landscaping were done with great care. This may contribute to the fact that the sculpture has been graffiti free and treated with greater respect, although that seems to change decade by decade.

Wright's Triangle is the first sculpture with an internal division. Subsequently I built a piece in Paris at La Défense called *Slat* which is a 40-foot-high tower that from the outside appears to be a monolith but has an internal division inside. You walk into it and pass from a triangular section into an open parallelogram. It is a direct outgrowth of *Wright's Triangle.*

The presence of sculpture is different from that of architecture or other kinds of form building. It can point your awareness and orientation to spaces and places in a way that architecture cannot. My sculpture is basically about walking into, seeing through, and walking around a structure that reveals itself as it reveals the decisions that underlie its construction. In *Wright's Triangle,* the interior division creates a passage with parallel inclined walls; an opening at either end of the passage allows you to enter into a large open triangular space. There is a certain ambiguity between the experience of the exterior and interior of this particular piece. Walking around the exterior of the sculpture does not inform you about the different spaces that are contained inside and vice versa.

Notwithstanding the fact that sculpture is generically different in presence and function from architecture, I could relate this particular sculpture to Pre-Columbian architecture—to an architecture that is based on more primary building units of great density and mass and very simple erection methods. Machu Picchu immediately comes to mind. The building mode of lean and balance is probably closer to a Pre-Columbian mode of building than to the strict vertical/horizontal post and lintel system that to me typifies Western architecture.

Theoretically, you could prop the elements of *Wright's Triangle* and the structure would be freestanding. However, small tack welds are necessary if you erect this structure in a public site. You are required to satisfy engineering and safety codes as they apply to public building.

Virginia Wright was the person who brought me to Western Washington and invited me to build a sculpture on campus. Virginia has been the prime mover in bringing significant sculpture to Western Washington University, and she was particularly generous in helping to fund my work. So I titled my sculpture *Wright's Triangle* as a memento to her. <<

(Interview, summer 1991; revisions, April 12, 2002)

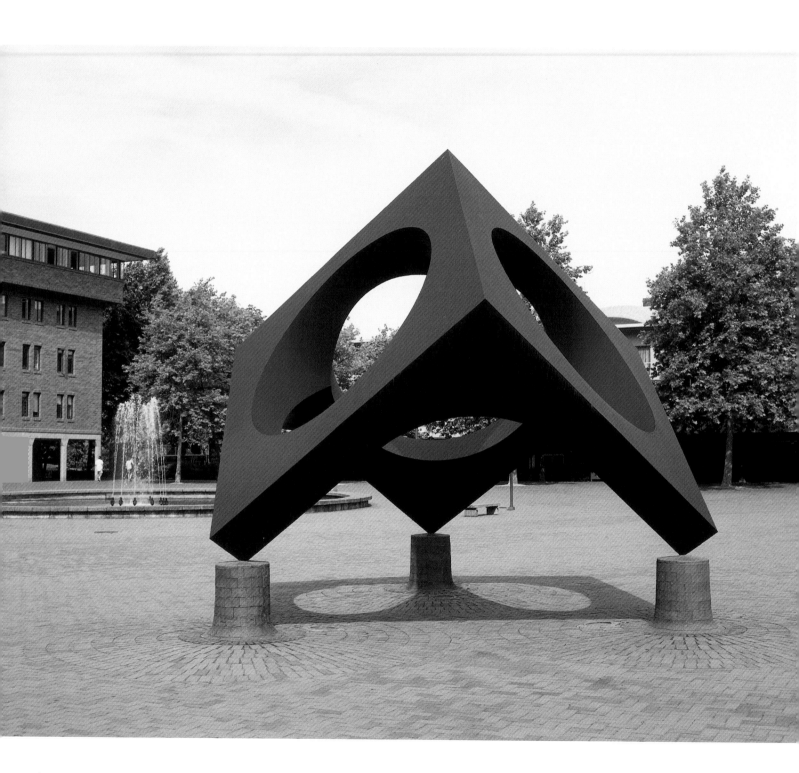

ISAMU NOGUCHI

With poise and grace, *Skyviewing Sculpture* (1969) balances its cubic shape on three points above the pavement of Red Square. Isamu Noguchi, the creator of this sculpture that seems at times to float over the square, and Ibsen Nelsen, the architect who commissioned the work for this University space, had in common their admiration for an older model, the Piazza di San Marco in Venice. After a visit to Italy in 1949, Noguchi actually described this older Italian square as a "gigantic drawing room where the outside permeates the inside."[26] At Western, Red Square has long been the center for students who enter and exit the buildings on the perimeter: going to childhood to adult education classes in Miller Hall; entering the Humanities building; back and forth to Bond Hall for math; checking experiments in sciences at Haggard Hall, only recently remodeled as part of the library complex. Since there are no natural plantings in this area, there is a strong play between brick pavement and open sky. Noguchi's first understanding was that the architect wanted something to clarify this open space so he proposed a fountain; then, he followed through with the existing sculpture. Both proposals indicate that Noguchi did not see the new square as a sculpture court but rather as a unique and central garden.

At the time of his commission Noguchi was traveling back and forth between his studios in New York and Japan, but he already was a seasoned world traveler. His two concepts for Red Square stem from his appreciation of both the ancient architecture and landscapes of the East and West. Among his inspirations were the pyramids of Egypt and the pyramids and cones of sand in Zen gardens; Greco-Roman architecture and an 18th-century Indian garden with astronomical instruments; the formal paving patterns of Italian piazzas, the interlocking square and circles of the Chinese Altar of Heaven, and the plowed fields of the great Midwest. Noguchi also had a strong desire to create playgrounds for children so he looked at abstract shapes from these ancient cultures and nature. He saw these areas as places for leisure as well as for daily recreational and experimental education. But Noguchi's spatial concepts were not just

Isamu Noguchi
(1904–1988)

Skyviewing Sculpture, 1969

Painted iron plate; approx. 14' h. × 17' w.
Western Washington University Art Allowance
from Miller Hall Addition construction funds.
© Isamu Noguchi and the Isamu Noguchi Foundation, Inc.

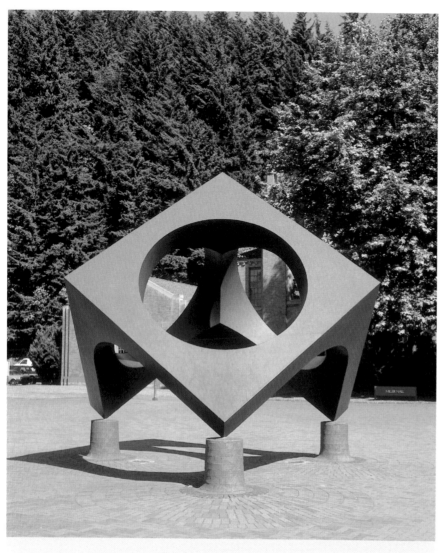

ISAMU NOGUCHI artist statement

"... The central campus at Bellingham, for instance, all of red brick, which has won great praise, is an ideal place for study.

Ibsen gave me the opportunity of doing a large sculpture for that campus. What was wanted was something that would clarify the open space while at the same time drawing the eyes of the passing students up toward the heavens. My first proposal was a fountain resembling a field blanketed with daisies in profuse bloom. But we didn't use this idea, as Ibsen thought it too expensive..." <<

(Excerpt from Isamu Noguchi, "Recent Works for Ibsen Nelsen & Associates of Seattle: Ibsen Nelsen as a Friend," *SD Magazine* [*Space Design*] [Tokyo] [December 1976])

tied to examples of architecture and landscape. In traditional Japanese poetry and painting, there was a celebration of seasons: moon viewing, snow viewing, blossom viewing. His interest in time extended from traditional Noh theater with its poetic dislocations of events to Buckminster Fuller's futuristic technology. The meanings of altered spaces could come from bending down to enter the curved doorway of a rectangular Japanese teahouse as well as bending down to lift a dancer into the air.

Initially, Noguchi proposed for Red Square "a fountain resembling a field blanketed with daisies in profuse bloom."[27] Whether daisies or lotus petals, Noguchi's nozzles would extend out into the circular pool to create a pattern of radiant energy. This water pattern would draw the eyes of the students up toward the heavens but the design became too expensive to pursue. Earlier in his career, Noguchi had made the statement that "seeing stars from the bottom of a well can also be a sculpture,"[28] so in this case, he changed his proposal to a cube with open spaces through which one could see the sky. Yet in both singular designs, Noguchi intended his work to integrate the plaza into a single sculptural space similar to a playground, or even a world stage.

Skyviewing Sculpture pulls together many of the elements seen in some of Noguchi's earlier works. First, some of his early proposals (*Play Mountain* and *Monument to the Plow,* both 1933) incorporated a three- or four-sided pyramid, a key shape relating to the ancient earth. Western's sculpture is a "cubic pyramid." Secondly, by creating set designs for the Martha Graham Dance Company, he began to understand how to interweave the abstract void of the stage to his forms and the performers. A description of the design he executed for Graham's *Frontier* (1935) is strikingly similar to *Skyviewing Sculpture;* both imply a penetration of space. "A rope, running from the two top corners of the proscenium to the floor [of the] rear center of the stage, bisected the three-dimensional void of stage space. This seemed to throw the entire volume of air straight over the heads of the audience." The dancer would start from and return to the section of a log fence at the rear

of the stage. In Red Square, the "frontier" begins at the spectator's feet where the cylindrical bases send forth radiating lines on the brick pavement as well as lifting the viewer and the sculpture into the sky. Thirdly, Noguchi had created a sunken garden (Beinecke Library, Yale University, 1960–64) where all three shapes in the one *Skyviewing Sculpture*—pyramid, circle, and cube—are found on a marble pavement with radiating lines. At Yale, Noguchi worked out a total concept using long-held symbols: (a) the square, an earthly place of humans; (b) the pyramid, the ancient geometry of the earth; (c) the circle, the ring of energy as well as the zero of nothingness; in Japan, the sun and its attribute, the mirror; (d) the cube balanced on its point as *chance,* the man-made imitation of nature.[29]

Skyviewing Sculpture is part of a tipped cube series that began with the solid stone in the Beinecke Library's sunken garden. Four years later, for a corporation in New York City, Noguchi made *Red Cube* of steel plates with a hole in the center. While the solid cube in Yale's sunken garden represented nature and past human history, the metal cube in New York brought man's technology to the foreground. While the hole could have negative connotations of "an abyss," Noguchi used the positive nature of the void—the opposing energy or duality implied in the human condition in relation to both nature and technology. Most importantly, as a tipped cube, Western's sculpture rests on three points, suggesting the University's square as a monumental base for man's aspirations, including technology.

While some roll their eyes when students describe the sculpture like the helmeted face of Darth Vader, Noguchi went on to create a hydrodynamic, pyramidal fountain in Palm Beach (1974) with clearer suggestions of a science-fiction spacecraft; earlier this shape was also one used for a design for a playground. But also in Yale's sunken garden was the white circle or sun, from which he developed *Black Sun* (1969) for the Seattle Art Museum in Volunteer Park; *Black Sun* was made at the same time as *Skyviewing Sculpture*. If as Noguchi stated, "The white sun belongs to the East where the sun rises, the black sun in the West where the sun sets," one wonders

if Western's sculpture—a cubic pyramid with circles—does not belong to this East-West group. In fact, this cubic pyramid with circles onto the sky is one of his most total cosmic concepts.[30]

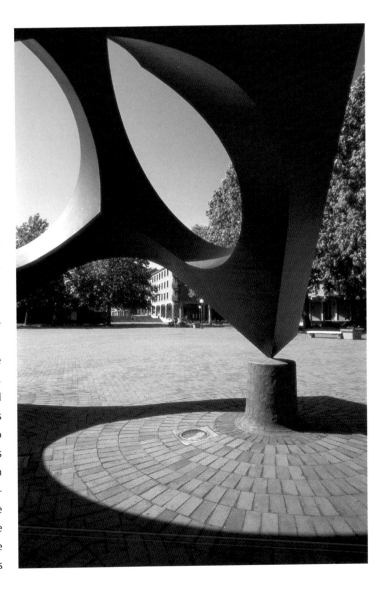

NANCY HOLT

Noguchi said "he wanted to tie sculpture to the awareness of outer space as an extension of its significance, much as one finds in early observatories."[31] Interestingly, Nancy Holt interprets this desire—wanting to bring the sky down to the earth—in different sculptural terms that tie together cyclical patterns of earth, man, and sky. Whereas Noguchi's sculpture is thrust into the air, Holt's *Stone Enclosure: Rock Rings* (1977–78) is solidly on the earth and made of rock from our geological past. Holt found the Brown Mountain Stone, the 230-million-year-old schist rocks, near Harrison Hot Springs, B.C. The multi-hued rocks were quarried from the side of Red Mountain (Lillooet Mountain Range) where they lie in small outcroppings or loose on the ground. At Western, Holt

worked with Al Poynter, a stonemason from Ferndale who restrained himself from applying mortar as he normally would, which would have filled the crevices of the rock's natural, irregular surfaces. In the majority of her works Holt also works with astronomers who can help her with the movements of the stars and revolutions of the earth, sun, and moon; for example, the extreme solstice position of the sun, constancy of the moon, and constitution of true north. At Western, Williard Brown helped her find the North Star Polaris with which to align the arches within the heavy walls of *Rock Rings*. However, Holt knew that just as Stonehenge does not work accurately anymore, she cannot be strictly dependent on Polaris being the North Star. Therefore, she is not interested in the literal readings of astronomy but rather its metaphoric nature and what it can imply for her structure.

The shape of the circle is present not only in Stonehenge, but also in the past amphitheatres of the Roman Empire, the ring forts of early Christian Ireland, and the medicine wheels of the Plains Indians. After Holt built *Rock Rings*, she was not surprised to find that centuries ago the Native Americans of Chaco Canyon (New Mexico) had repeatedly aligned some of their domestic buildings with the North Star. The circles in Holt's own work appear early as "locators." These were actual tubes that extended a person's eyes; light in the pipes reflected as if a mirror and also brought back physical images. In *Rock Rings* this zone of vision has been enlarged to become an architectural type of space. The functional windows pointing northeast, southwest, east, west, southeast and northwest allow the viewer to be a part of the landscape. The openings make the spectator aware of the real time in his circling paces. Both circumambulation inside the two rings and alternating sights outside place the spectator into a cycle of time larger than himself.[32]

Just as the mason Al Poynter stated that he could return someday and say he was ". . . inside those walls, somewhere," Holt started only with her own interior reality and built a quiet chamber in the south fields away

Nancy Holt
(BORN 1938)

Stone Enclosure: Rock Rings, 1977–78

Brown Mountain Stone, 10' h. with outer ring 40' d. and inner ring 20' d.
Funding from the Virginia Wright Fund, the National Endowment for the Arts, Washington State Arts Commission, Western Washington University Art Fund and the artist's contributions.

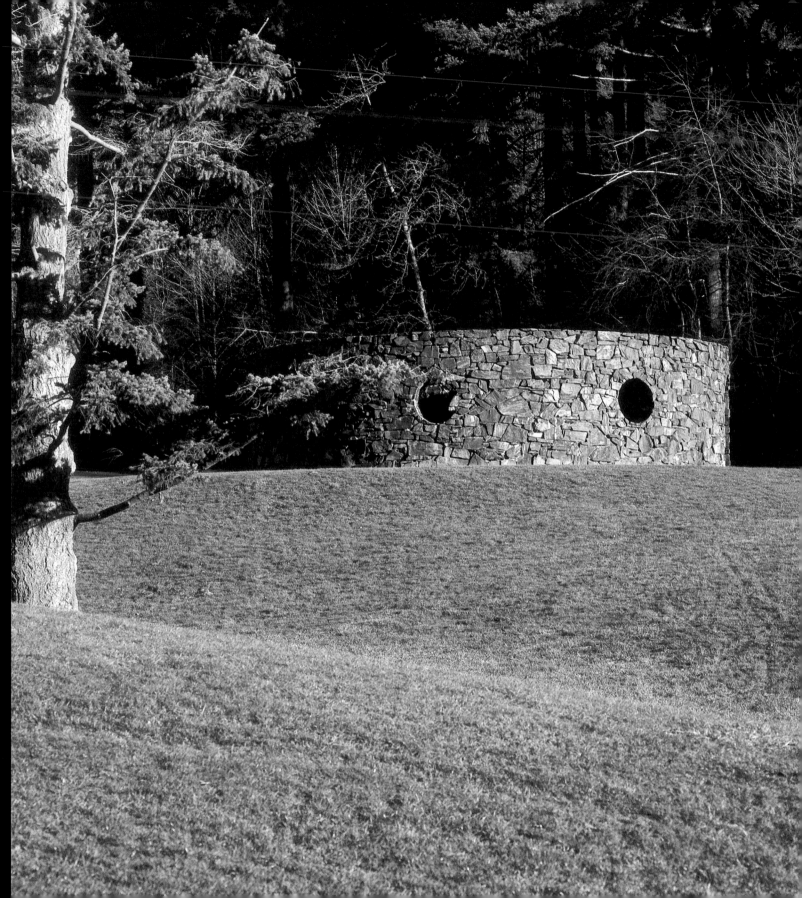

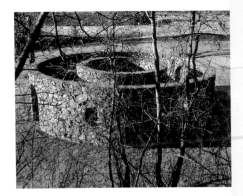

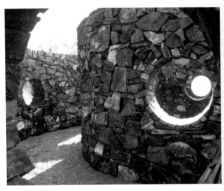

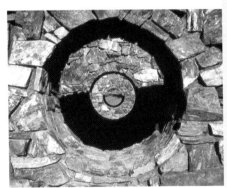

NANCY HOLT artist statement

In August 1977 Larry Hanson showed me around the Western Washington University campus so that I could select a site for my sculpture from several possible areas on the university grounds. I was immediately attracted to the *Rock Rings* site—a removed, meditative space away from the university buildings, open on three sides, and bordered in one direction with tall pines.

When I returned to Bellingham in December 1977, I searched for rocks in local quarries and looked at the different kinds of stonemasonry in the area. Al Poynter's rugged style of stonework stood out strongly—it was just what I needed—for *Rock Rings*. In April 1978 when I was again in Bellingham, I got in touch with the mason. He showed me Brown Mountain stone (schist) which I immediately knew I wanted for the sculpture, and he gave me an estimate for the work. After several months of fund-raising for the project, I contracted with Al Poynter to do the masonry in *Rock Rings* from July to October 1978. I remained close to the site overseeing the project during its preparation, construction, and final landscaping from June 15 to October 15.

Rock Rings came into my mind when I first saw the site—it seemed to be a natural outgrowth of the Northwestern terrain with its colorful mountain rocks and misty green hills. In my studio in New York I made models with possible dimensions and configurations. I used the final model as a guideline for *Rock Rings,* but as I was building the work the materials themselves began to suggest other directions, and I made a few changes in my initial conception.

As the mason worked, *Rock Rings* grew stone by stone out of its site, and massively assumed its position in the landscape. The stonework is bold, uneven, heavy looking—the stone walls are actually in relief with crevices, ledges, and crags. The mineral composition of the rock causes hues of orange, yellow, purple, brown, gray, and blue. In the rain the iron oxide bleeds quickly into the dark gray mortar joints, making the mortar the same color as the stone.

Three months of labor is caught within the walls of *Rock Rings.* This "stilled activity" becomes part of the art. Energy surrounds the viewer, seeming to concentrate around the holes and arches and to disperse within the expanses of the walls.

The four arches of *Rock Rings* run North and South—directions calculated from the North Star, Polaris, in a way similar to that used by Northwest Coast navigators in plotting the courses of their ships. The holes in the sculpture are aligned NE E SE NW W SW.

Through the holes and arches various aspects of the landscape come into focus—a tree trunk, a road, a walkway, woods, a hill. The center of the work was adjusted until the views in each direction were worked out within the parameters of the given site and the position of the North-South axis.

Rock Rings is meant to be seen from many points of view, from both the inside and the outside. The work changes perceptually as the viewer changes position, sometimes causing the viewer to question his/her orientation in space. The holes and arches line up four deep when seen from the outside looking in, resulting in a layered, tunneling effect. At a certain distance away the four arches or holes appear to become the same size, and the work seems to flatten, to become perceptually two-dimensional. Closer in, the work opens up and deepens in space until it finally engulfs and surrounds.

Though the work can encompass the viewer, *Rock Rings* is an "open enclosure." The way in immediately indicates the way out—it is in no way a labyrinth. The massiveness of the walls is punctuated by the airiness of the holes and arches, in other words, the heaviness of earth is intermeshed with the lightness of air.

The work is built to human proportion—the scale is neither megalithic nor constricting. The ten-foot-high, two-foot-thick stone walls of the sculpture are solidly built. *Rock Rings* should remain for a long time, weathering and changing color slowly through the years. <<

(A version of "Notes on *Rock Rings*" first published in *Arts Magazine,* June 1979; reprinted with permission of the artist, 2001.)

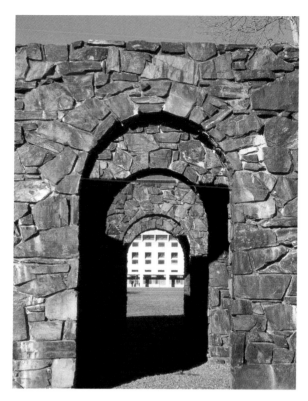

from the bustling squares. From a distance, *Stone Enclosure: Rock Rings* has often looked like an old stone outcropping or ruin facing the dark grove of trees against which it is nestled. In the past when the south campus was simply playing fields, one had the feeling that he/she was taking a long walk or pilgrimage toward this mysterious stone enclosure. In a statement after completing the work Holt quoted the *Tao Te Ching:* "We pierce doors and windows to make a house; And it is on these spaces where there is nothing that the usefulness of the house depends." To her, the solidity and architectural form of the deep circle (walls two feet deep) or tunnel has symbolic connotations of the cycles of life—birth, ceremonial rituals, transitions, and death. When the new Communications building is erected within the next two years, the content of Holt's stonewalls will starkly contrast with that of the adjacent building with a curriculum of high technology. Her choice of ancient rock, simple technology of masonry, and enclosed space will reinforce even more the individual spectator's perceptions and consciousness

about the order of the universe. As she has stated, "even when we think in celestial terms, there is still indefiniteness."[33]

LLOYD HAMROL

Similar to Holt, Lloyd Hamrol in his tipi-like structure called *Log Ramps* (1974), stresses the interiors of sculpture by using architectural components. Rather than the domeless enclosure of an observatory, Hamrol provides walls and a roof suggesting shelter. When he stated that *Log Ramps* is ". . . like some place on the frontier . . . ,"[34] his concept was not of the cosmos as was Noguchi's design for Graham's *Frontier*. Instead of an imagined adventure in outer space, Hamrol wanted to create a contained space with sociological function. His use of elemental materials and structures relates to human beings in ordinary life situations.

Typical of most artists in the early to mid-sixties, Hamrol created dominating works isolated in a room where, for example, a colorful triangle spread its edges out to the surfaces of the walls and floor. He soon realized that he could transform this visual form of covering a corner to include psychological references. Hamrol was also interested in using materials that combined a sense of immediacy with function. Gradually he worked from interior "situational" environments of balloons, water, and dry ice to cone-shaped structures of adobe,

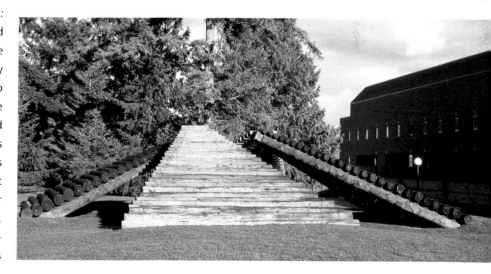

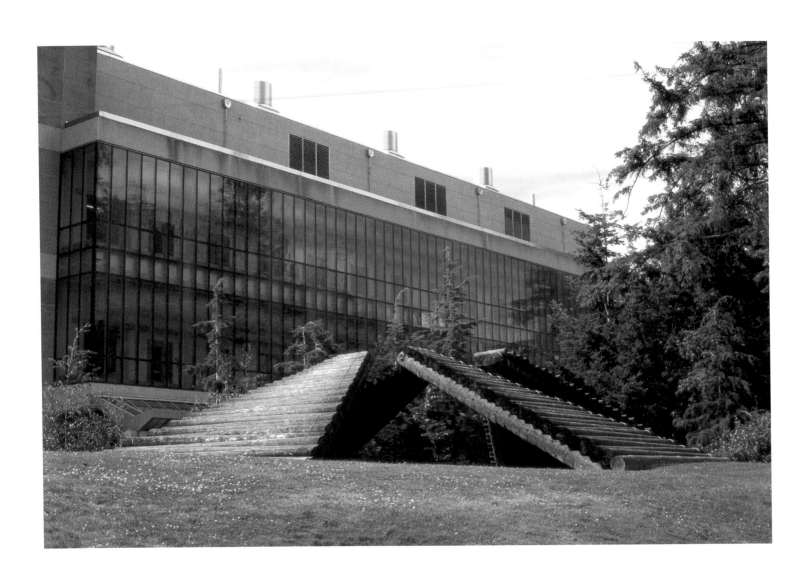

rope, and sandbags. *Log Ramps* clearly brought to the foreground these concerns as well as a new emphasis on audience participation.

Hamrol, working with his student workshop, first decided that his proposed structure should go in the south fields, but they changed to a more penetrable ground surface near the Environmental Studies building.[35] Soon, local Douglas Fir logs, cantilevered deep in the ground, supported four triangular ramps positioned so that their tops became the tangents to a gap, an empty circular space between them. Hamrol's initial concept was to have the logs covered with sod so that the whole structure appeared to erupt from the earth. While his use of sod would have referenced a natural, cataclysmic event as well as an archetypal shelter such as a cave or sod hut, his change to bare logs allowed for a wider range of references to functional structures such as tipi and log house, fortress, and exterior seating arrangement. Just as nature restores itself, *Log Ramps* has undergone both re-siting and replacement of its

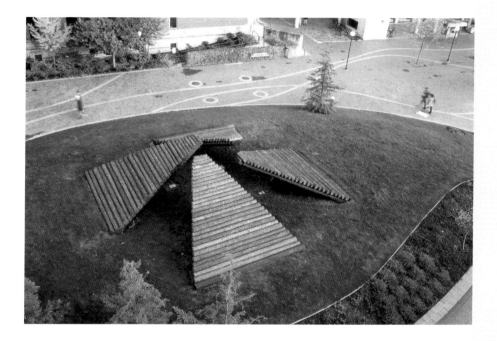

Lloyd Hamrol
(BORN 1937)

Log Ramps, 1974

Reconstructed 1983 and 1995
Douglas Fir and Western Red Cedar, approx. 8' 7½" h. × 40' w.
Combined funds from the National Endowment for the Arts,
Bureau for Faculty Research, Department of Art, and Art Allowance from Environmental Studies Center construction funds.
Funding for 1983 reconstruction: Parks Hall construction funds,
gifts from Georgia-Pacific Corporation and Builders Concrete.
Funding for 1995 reconstruction from WWU Physical Plant.
© Lloyd Hamrol

LLOYD HAMROL artist statement

The project originated when I was invited to the campus as an artist in residence for the spring quarter of 1974. At that time, Larry Hanson was a faculty/artist involved in overseeing the outdoor sculpture collection—maintaining it, and also seeing that it continued to grow. He suggested that we offer a workshop for credit that would produce a permanent piece for the collection. He cobbled together a budget from several campus sources and a NEA project grant, which became the funds for the materials. I began developing the concept through drawings and models in my studio before I came to Western. Those early concepts were important because I knew that we would need the entire quarter just to construct the work. I wanted to have a concept fairly well in mind and worth presenting to the class of fifteen students. I introduced the concept as a site-specific sculpture that took as its general reference the idea of primitive Northwest shelter. In my studio, I had envisioned the four ramps covered with sod and continuous with the surrounding grass to suggest that the structure was an eruption of the earth's surface or a pealing back of the earth. But, that idea really proved impractical as I began to explore it, since it was unlikely that the sod was going to stay on those ramps. Eventually the whole thing was going to rot and fall back to the earth. I didn't like that idea at all because I was looking for something more permanent than that. So, the notion of shelter and gathering place became the compelling concept.

During construction and subsequently, I began to see that I really was interested more in a gathering place and in an interactive, site-specific work than anything else. So, this project was seminal in the conceptual development of other pieces. It is like making art itself—nothing really develops in a clear linear fashion. I had been involved in participatory works of a temporary nature for some years before the Western project. I had already planted my feet and feelings very squarely in an area that involved a participating audience. But, I hadn't really brought that value into a site-specific situation or a permanent work. So in that respect, *Log Ramps* became a point, an intersection in the development of my ideas. Formally speaking, it descended directly from some smaller conical pieces that I had done a few years earlier, but they were ones with interior spaces that were difficult, if not impossible, to penetrate. So, *Log Ramps* was a breakthrough piece. I mean literally breaking through the walls and opening the interior to the outside. Nice way to think about it.

Originally the work was not built where you see it today. From 1974 to 1981, it was located where Parks Hall now stands. When I arrived on campus for this project, the Facilities Planning Office took charge of the logistics of the project and offered me the Parks Hall site with the understanding that >>

>> the vacant site fell within the future building master plan. Apparently, there was an increase in state funding that allowed the plan to be accelerated, so *Log Ramps* was demolished. Every bit of it had to be rebuilt on the present site. I originally was offered some other options, but I chose that first site because of its proximity to a major campus path and because it was across the path and adjacent to the Environmental Sciences building. I liked the work speaking to the natural environment and being an architectural antithesis to the new Environmental Sciences building, which was a very state-of-the-art building at the time. Since *Log Ramps* was close to the campus path it was easy for students to see it, leave the path, and climb up the work. Also appropriate, the work is an *ad hoc* classroom in relation to the Environmental Sciences building. I saw it frequently used in that manner and everybody seemed to enjoy the experience. So when we moved the piece, I wanted to keep it in the same general area and really the only place left was the present site. Any further north, we would have run into Richard Serra's *Wright's Triangle*. I like where it is sited now, still in relation to the campus walkway, classrooms, and general architecture. In fact, I think it is more comfortably sited now than it was originally because it seemed, back in 1974, to be under-scaled for the size of those broad fields. Even though we suffered an embarrassing catastrophe, we claimed victory in the end by having a better built piece in a better site.

I am very interested and concerned with reaching a large audience. The last fifteen to twenty years have been very instructive to me in that respect because I have had to learn how to do something that, then, was against the grain of traditional teaching of the artist's role in society. I inherited a bohemian notion about an artist's alienation. I think the point is to understand that if you are going to work in the public domain, you have to take into account a lot of public needs and limitations. One important issue in the past few years has to do with the public's response to what we call confrontational art. It has been my concern over the years not to produce that kind of work but rather to make an appropriate gesture for a public space. I have not had to bend my will because I think the kind of work I am making is reflective of my own personal relationship to the world. I am not a confrontational person, and I boil it down to simple psychology. On that level we make autobiographical statements whether we want to or not. I am particularly interested that my work has multiple levels of approach for the audience, meaning that the work can be engaged aesthetically in an unconscious, functional way. You don't really have to be looking at it to feel your way toward it and sit down on some part of it, thereby making minimal contact, which may allow you to make further contact on another level.

I am also very interested in associations or references that have to do with shelter and primitive architecture. I would like people to make a connection with the work at the level of cultural memory. Most public spaces, at least in the urban-suburban world, are in a new context. The art projects are in situations where a municipality has money to spend because they are making improvements; the percent-for-art program is kicked into motion by virtue of some other capital expense. That means that a new park, plaza, library, or a new public space is going to be built that will be from a new zero on the timeline of our experience and memory. What I think about in those situations is to set an anchor down in that new space that calls up something from time past. It doesn't have to be literal or actual but rather an evocation of some mythical or fictional history. That can happen through the generation of an image based upon architecture of some sort. The most primitive kind of form through which we associate our origins in the world—in seeking primitive shelter—has all of the implications of protection, safety, security, social gathering, community, and identity. So those are the kinds of issues that are really the deeper ones in my work if someone wants to look beyond the most immediate physical and sensory experiences of the work. <<

(Interview, June 6, 1991; revisions, December 21, 2001)

rotting logs. Its strength comes from its evocation of the Northwest landscape and from its ceremonial form and function. The wedges provide a path upward toward a seat—a base for socializing; under these triangular seats or sections there is a space for private meditation.

GEORGE TRAKAS

Both Hamrol and George Trakas enjoy the dedicated time, concentration, and physical labor involved in the building of their structures. Trakas actually wanted to be an architect but soon realized he could translate this craft into a sculptural experience. He could infuse sculpture with the architect's research into materials, site, and function. Similar to Serra, Trakas goes where he can build work. Influenced by Serra's precedent of generating sculpture from a particular setting and directing the viewer's physical awareness of self and site, Trakas took his response one step further to include in his work the themes of a site. When he was asked to participate in the University's site-specific symposium in the late eighties, Trakas no doubt saw in the old lumber mill town of Bellingham on the bay something that reminded him of his various backgrounds. He had grown up along the St. Lawrence River in a rural area of Canada with economic foundations in manufacturing. Later he was attracted to New York, a city transformed by industry and built at the merging of river and ocean traffic.

Some of the titles of Trakas' works—*Locomotive and Shack* (1971), *Union Station* (1975), *Union Pass* (1977), and *Transit Junction* (1976) suggest movement from one

George Trakas
(BORN 1944)

Bay View Station, **1987**

4 sections of wood and steel on a site of 45' × 144'
Temporary installation in 1987 Site-Specific Sculpture
Symposium funded by the National Endowment for
the Arts and private donations.
Permanent installation, gift of David and Kay Syre
Family, 1995.
© George Trakas

location to another. Others as *Crotch Dock* (1970) or *Berth Haven* (1983) and *Pacific Union* (1986) imply a nurturing place at the edge of the water. Trakas' title for Western's work—*Bay View Station* (1987)—indicates a standing place from which to view a landscape. But rather than positioning someone in front of something like a stilled or timeless view of a place, Trakas only takes certain clues from traditional landscape painters. He uses their vocabulary of paths, waterways, bridges, and other landscape features to help measure movement and punctuate intimate spaces and grand vistas. Rather than planning a formal garden with openings and closings to orchestrate the vistas, Trakas utilizes the existing landscape at the site. Most importantly, the patterns of his structures are linked to the themes of the site.[36]

At Western Trakas chose a site that could only be called a weedy hill on one side of the Performing Arts Center. On this hillside there already was a cow path begun by students as a shortcut from Garden Street, which winds up the long hill to the University. As artists before him, Trakas knew that the University's niche is located on one of many steps down from Mt. Baker, close-by Sehome Hill, and Garden Street Hill, before reaching Bellingham Bay. Another one of the measurements of that distance from mountain to sea is the Nooksack River which flows into the bay northwest of the University. At the edge of Bellingham's waterfront are other types of posts and arteries: park trails, streets, railroad tracks, train and bus station, ship dock, log mass and paper mill effluent, and wakes of ferry traffic to Alaska. As an intervening material between earth's and industry's processes, Trakas decided to use cobblestones from the Nooksack River to emphasize the natural path and to form a foundation for his welded steel catwalk. At the top of the path he created a series of segmented decks constructed of fir planks on wood and steel posts. In responding to the immediate details of the concrete modern pillars of the Performing Arts Center and the existing rectangular benches on a small concrete plaza, Trakas chose to weave his path and shaped decks irregularly across the hill.

The viewer traversing Trakas' structures comes to understand the site's physical conditions and to perceive the larger narrative of what is beyond. Since he was involved in dance in the late sixties and early seventies, Trakas, like Noguchi before him, knows how to transfer a sense of balance and movement to the viewer: for example, a constant change of differing heights and widths in rock steps; spaces between decks; shifting segments of decks; slow and fast slopes or paths; and the spring and sound of metal catwalk. But dance also has metaphoric meaning. Just as one viewer interacts with another while sitting on the decks or passes another on the catwalk, he also can reflect on his future participation or passage from University community to city, industrial waterfront, and ever expanding horizon of the water.

GEORGE TRAKAS artist statement

The work was composed and built with the elements, instruments, and physics of music in mind. The steel walkway, from the breakthrough at the lower landing on the stairs from the street to the limit between the pinnacle rock and the fire exit stairs from the concert hall, signifies and feels in its navigation on foot both as the vertical range and domain of the site from the upper treble pitch to the lower depths in the bass clef and as the connection between the secular and the sacred, the city and industry with the university sanctuary.

The four decks are also layered and composed as major and minor movements, from high to low, from steel pipe by spruce tree to the cedar post by the rock and birches. The vertical steel and timber elements, rooted in the ground with concrete, structurally support the work and play with those under the concert hall as stabilizers and marking posts in our movement through the work and take on the characteristics of organ pipes where the planks of the decks may become foot peddles [sic] to some and hand keys to another, though the rhythm of the verticals and horizontals is abstract and more musically harmonic than literal as I am writing about it here. The experience in the field with the seasonal and diurnal variations is infinitely richer and more diverse than could be written about.

The work is an open window with an omniscient view of the world where the materials of the work come from. On the decks one can see the Georgia Pacific log pond, the Mount Baker Plywood peeler log pile, the Oeser Cedar Pole Mill, the Morse Steel factory, and, in the distance, the evergreen forests and mountain peaks. Though probably not realized by the viewer, these connections are intuitively felt in the experience of looking out from the work over Bellingham. The composition and concept of the work attempts to encourage, reinforce, and transport the student viewer through the transition from the ideal to the real, from the sacred to the secular, and back again as a harmonic oscillation; a daily riff; a *pas de deux* with the self and collectively with others in the big dance. <<

(Statement, April 8, 2002)

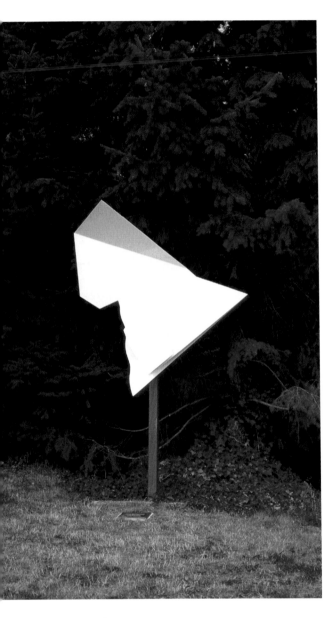

John Keppelman
(BORN 1940)

Garapata, **1978**

Painted aluminum plate, 10' h. × 7' w.
Gift of Annie Dillard and Gary Clevidence, 1985.
© John Keppelman

JOHN KEPPELMAN

Underlying Trakas' carefully paced movement is a sense of adventure between landings. In John Keppelman's *Garapata* (1978) there is a sense of soaring above the ordinary. The work comes from a series where Keppelman was using an automatic method of cutting and folding paper to arrive at shapes for sculpture. In Keppelman's sculpture certain traditions mingle with flights of fancy. The art of folding paper to form a natural shape is a part of Japanese customs, the subconscious game of the surrealists, and the entertainment of schoolboys. Since Keppelman knew the writer Annie Dillard, it is useful to compare her writing with Keppelman's search. In "Seeing," a chapter from her book *Pilgrim at Tinker Creek,* she is interested in the difference between the "naturally obvious" and an artificial construction. Thus, she could write: "The secret of seeing is to sail on solar wind. Hone and spread your spirit till you yourself are a sail, whetted, translucent, broadside to the nearest puff." Working in his automatic mode, Keppelman felt that his paper shapes suggested a sense of flight. After he changed his paper study into a white aluminum work, he named the sculpture after a dramatic California setting, a river and a canyon intersecting with the Pacific Ocean.

While his concentration on strictly formal shapes—plane against plane—brings to the foreground his memory of a particular place, Keppelman's choices for sites also parallel Dillard's writing about "seeing." As she states: "I used to be able to see flying insects in the air. I'd look ahead and see, not the row of hemlocks across the road, but the air in front of it. My eyes would focus along that column of air, picking out flying insects."[37] Originally sited against an embankment of trees, *Garapata* was moved due to construction of the new Chemistry building. Both the original site of the "ridge" and its present location at the edge of a row of trees adjacent to the south campus road allow a frontal view; thus, nature provides a wall to accent the simple shapes of flight.

JOHN KEPPELMAN artist statement

Garapata was done in 1978 and purchased by Annie Dillard and Gary Clevidence who gave it to the University when they left Bellingham. It was one of a series of pieces where I was working with folded paper. My method was to cut and fold paper in a very automatic way to avoid any specific ideas about the intent of the work and where it was going, and to get in touch with my unconscious self and maybe find some forms that were surprising and interesting. I would fold and cut until I found a shape that pleased me and then stop to figure out if it could be executed in another form. Most of those pieces were intended originally to be wall works. Very few actually ended up being pieces that would stand on posts because the shape had to have certain characteristics to work in that manner. But the quality of the shape, the way it functions in terms of two dimensions versus three dimensions, is the same on a post as it would be in a wall piece. If you look at *Garapata,* it postures a wall, an imaginary wall or flat plane which is behind the piece or which is the basis for the back plane of that piece.

My titles often have to do with experiences I have had as a child in certain places or experiences in nature as an adult while traveling. *Garapata* is a place—it is a canyon and a small river which runs out of the Big Sur area in California, which was a playground for me as a kid. I think there is a connection in my mind between the way in which that sculptural shape seems to soar and the sort of mythic beauty that particular area of California has.

These pieces work like signs and they work best along the edges of public spaces. They relate to wall pieces in the sense that they directly orient you as a viewer. They are viewable from positions on either side, but basically they tell you to get right in front of them; they aren't intended to be seen from behind. So, when I sited that piece in its present location, I was looking for a spot where viewers passing along the pathway or road would be able to see the piece and not get behind it. It is an unusual siting for sculpture because normally, of course, sculpture is seen completely in the round. In the case of my work, that is not true.

I do find these pieces work best against a natural background. I have had that piece in a couple of different sitings; one was an open field where it seemed to be like a galleon sailing across the grasses of the field. The piece isn't site-specific in that it has anything to do with the geometry of that particular area where it is sited now. But it does belong on the edge of a public space and it seems to gather some energy from the tension between the abstraction of the shape and the surrounding nature. I think it is a very successful piece. I like its clarity and its simplicity. I like exploring the expressive qualities of shallow space by shaping and folding a single plane into inside and outside, compression and expansion, so that it is readable just by the modulation of light on the surfaces.

I think it is very hard to identify "the public" and I am often surprised by the people who like my work. Sometimes they are sophisticated people and sometimes they are not. What I do is determined really by what interests me in terms of problems and solutions. Wallace Stevens said that there was an ideal reader and, of course, he was talking about poetry. There is also an ideal viewer and often that is the person in me that steps back, strokes his chin, looks at it and says, "well, yes" or "no." In that sense, the public is somebody who is with me all the time.

Since I made *Garapata* I have experimented with a lot of colors. I tend to go back and forth between using color, or in this case, avoiding color, because the simplicity of that piece allows the whole shape to work. One of the disadvantages of using a variety of colors is that the shape tends to break up into those little episodes on the surface. The advantage of working with a single color, like white in *Garapata,* is that the shape holds its own. Another advantage with white is that it reflects the color of the light around it, which is very dramatic and beautiful here. <<

(Interviews, July 15 and December 18, 1991; revisions, December 16, 2001)

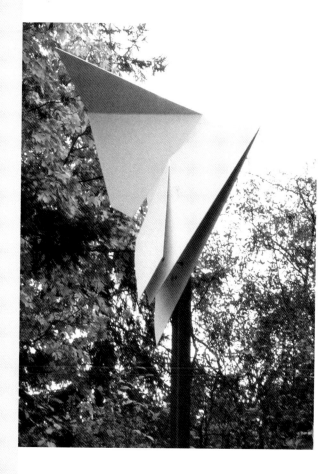

James FitzGerald
(1910–1973)

Rain Forest, 1959

Bronze fountain, 14' h. × 12' w. × 24' l.
Western Washington University Art Allowance
from Haggard Hall construction funds.
© James FitzGerald and FitzGerald Estate

JAMES FITZGERALD

James FitzGerald's sculptural fountain symbolizes the great rain forest of the Olympic Peninsula. The commissioning architect Paul Thiry sited the fountain between the Romanesque Wilson Library and his international-style pavilion of Haggard Hall, which originally housed the general sciences program. Interpreting the process of nature at work, FitzGerald created a tall, vertical element weathered by wind and rain. Observant of geographical location, he also placed in the pool a horizontal element incorporating shapes reminiscent of Asian calligraphy and architectural details. As other artists had done, FitzGerald responded to the special nature and varied elements of forests and water in the Northwest. Characteristically, he singled out a tree dripping with water, one of the Pacific Northwest's most beautiful and defining sights.

Yet, underlying FitzGerald's observations and intuitive feeling for nature were the prevalent philosophical and intellectual concepts of the position of man and nature in the post–World War II era. In the late thirties, FitzGerald had studied philosophy at Yale where he no doubt had come across the writings of German philosopher Friedrich Nietzsche (d. 1900). Popular among American artists and writers in the thirties, Nietzsche conceived a new type of being who, through study of his ancestors and nature's powers, could undermine the strict dependence on science of modern civilization. Artists studied both Native American and Asian cultures to see how earlier civilizations had related to their dramatic natural surroundings; how early man

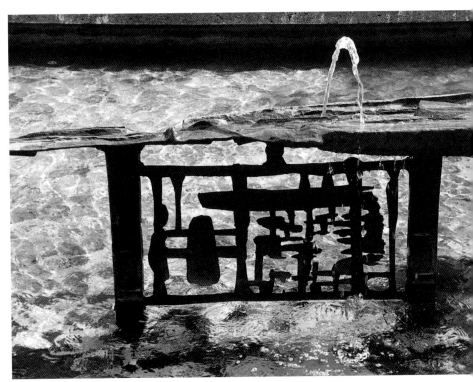

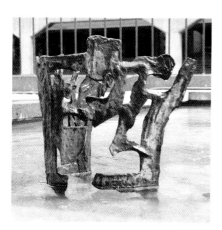

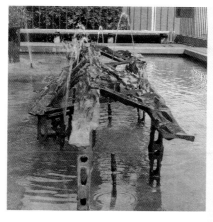

communicated with and appeased natural spirits; and how he fit in with all living things.

For example, early in his designs for the Mercer Island Bridge Tunnel (1938–40), he had referred to Seattle's role as a link between the United States and Asia by carving in relief a whale flanked by a Northwest Indian motif with an eagle and an Oriental motif with a dragon. His paintings from the mid-forties to the early sixties with such titles as *Resurgent Sea* (1945, Collection Seattle Art Museum) and *Witness Tree* (1962) evoke turbulence and a search for levels of human consciousness.[38] In his sculptures, as *Rain Forest* (1959), these metaphors are captured through the ragged crusted surfaces. During the early nineties *Rain Forest* was taken down due to the remodeling of Haggard Hall as a wing of the library. When the sculptural fountain is reinstalled at the new Student Recreation Center (see below), it will be a quieter metaphor of replenishment.

JAMES FITZGERALD artist statement

[KING-FM Radio Interviewer] *Elise Kelleher:* And I wonder about sculptors—where can sculptors show their things?

FitzGerald: Well, this is a kind of a strange community, I think, for sculpture, because first of all it's kind of a gray atmosphere, in that there's not too much sunlight to bring out sculpture, so I believe, that it's a community where you would make kewpie dolls for atop the piano, or something—little tiny things but strong statements in sculpture—so far haven't been made. I believe it's just part of it that the whole place isn't aware of the possib[ilities] of sculpture. In this town, it's only commissioned sculpture that you see, really, I believe, produced. There's a few things that are smaller things from the studios . . . well, I don't know.

Kelleher: Well, you only see sculpture once in a while at the Henry Gallery or at the Seattle Art Museum.

Margaret Tomkins: Well, that's typical—it doesn't have anything to do with sculpture—that's just the pattern—it's a one-night show twice a year—and that's enough for an artist. He only makes about twenty-five paintings a year, and if he can show two small ones out of twenty-five, I suppose he thinks he's a lucky guy.

FitzGerald: It would be so easy to do that I can see it myself: Like if you had like a "sculpture northwest" or something, if you had a vacant lot with an old crummy building, you fenced it in, why, and sculptors brought their things in to it you could see that many sculptors start making larger things and setting them up out there one after the other, and the first thing you know, the scale would be . . . there would be sculpture, you know. And it wouldn't be these little, dinky things, but the artists keep working in their studios because it's the only place they can show them, and the chance they can sell them—but if you could just get an area where you can show them, I'm sure that you'd find a whole renaissance of sculpture going on. <<

(Excerpt from an interview with James FitzGerald and Margaret Tomkins by Elise Kelleher, KING-FM Radio, 1962. James FitzGerald Papers. Courtesy of Manuscripts, Special Collections, and University Archives, University of Washington Libraries, Seattle.)

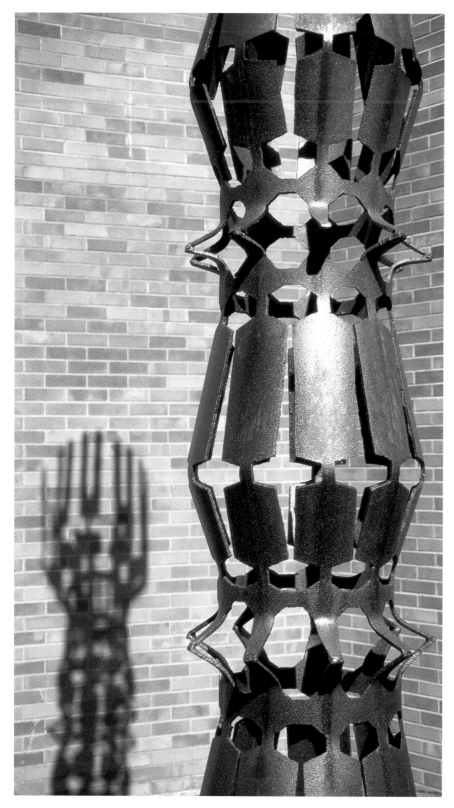

NORMAN WARSINSKE

Only after World War II did most sculptors become free of being statue-makers. Where they had created public monuments before, they now turned to fountains, park and garden sculpture, and functional screens. They also began to create their personal art on a similar scale. Younger than FitzGerald, Norman Warsinske belongs to a generation of artists who came to maturity during the Cold War. Capturing a transcendent spirit in their art, these artists expressed their feelings about the world predominately in an abstract mode. Warsinske's art stems from this connection with sculptors of the fifties who translated these emotions through attention to scale and surface and from his own background in jewelry making, sculpture, and interior design.

Norman Warsinske's bronze reliefs grow on the Humanities building's walls as if they were vines. His tower-like sculpture nearby is constructed with a faceted surface topped by vertical tendrils, stems, or

Norman Warsinske
(BORN 1929)

Totem, **1962** [LEFT]
Steel filigree, approx. 12' h.

Hex Sign, Wall Relief, **1962** [ABOVE]
Bronze, 3' 6" h. × 4' 6" w.

Western Washington University Art Allowance from Humanities Building construction funds.
© Norman Warsinske

posts. Warsinske had a desire to project his universal connection with nature in a way that would demonstrate that his inner feeling was just as tangible as a piece of furniture, a screen, a lantern, or a torch. Commissioned by the architect Fred Bassetti, he placed his *Hex Signs* and *Totem* to identify the corners and main entrances of the Humanities building and its lecture hall. Warsinske inherited the attraction FitzGerald's generation had for the Native American and African cultures and the concept of the "totem." This custom decreed that certain presences needed to be secured or set apart from daily life. Using the idea of "totem" or fetish, American artists of the forties and early fifties had made stacked or totem-like structures to portray their own personal desires, beliefs, and emotional feelings. In some cases, artists created cage-like structures as metaphors to describe the outer bulk of a figure and its wrought interior. In other cases, artists used the metaphor of the totem to contrast it with modern technological advances. By the time Warsinske created his *Totem* (1962) and *Hex Signs* (1962), the format had lost most of its original freshness. While commonplace objects, his works reflect nature's decorative powers and myriad patterns of growth.

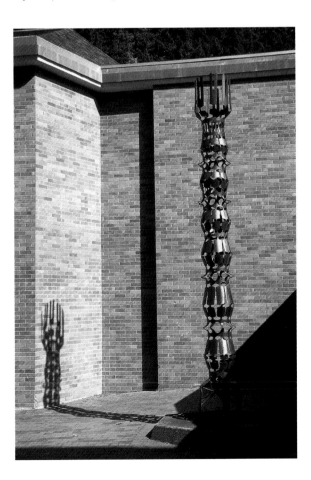

NORMAN WARSINSKE artist statement

I was commissioned by the architect Fred Bassetti. We had been talking about some sculptural things, and he came over to my studio and looked around. He picked out the character of things that he liked. He mentioned the price, and what he said was that "I don't want it all in one place or don't spend all of the money in one lump." So that was the concept of having several pieces on the Humanities building. It was a great commission.

The commission was given before the building was built. So I was working directly with the plans of the building and the site location was my choice. I presented my ideas to him and he accepted in all cases where the pieces were to go. In some of the cases, it was merely the situation of having the student identify a corner of the building. By walking past the piece of sculpture it would do something to make the building more personal to a student. The other interest that I had was in the growth form.

I don't know that *Totem* had as much to do with Native American tradition as it had with just a strong ethnic feeling that I enjoy. I wasn't thinking of Northwest totems when I did the tower, but more of a torch or a tall form like a tower, but not necessarily a Northwest totem. At that time, I had just begun my bronze casting. The bronze casting lasted into the next ten years. I have not been casting bronze since then. The cut steel was where I started in sculpture—a construction of cutting things rather than sculpting chip by chip. So the steel piece, the tower, comes from something that I did for years. The cast bronze pieces use lost Styrofoam casting. *Totem*, or the tower, is like architectural jewelry as far as I am concerned. It is just getting away from the T-square and putting a finer scale of design next to the solid forms of the architecture. I think the scale of the piece in its proximity to the architecture and the sun, where the shadows fall, is important.

Hex Sign, the spiral form, is not continuous other than as a growth form. It has nodes that connect the form. I guess it is just a very simple human design that the Africans would have painted on a wall or that anyone would do—just a simple, sculptural form combined with the richness of the bronze rather than a flat, painted hex.

After that time, I went on and did some mountains in bronze that used the same process. It involves simple systems that are available here in the Northwest and a boat foundry process. Thematically, I can think of a couple of other pieces of that character that came out of that work. Currently, I am doing some pieces in cut steel and doing a lot of paintings in acrylic and gold leaf. >>

>> The African house painting theme that was part of that concept is very strongly repeated now. I don't think of *Totem* relating to Africa as much as the cast bronze pieces or painting the walls. Their Benin bronzes are very fine things. I think of *Hex Sign* more like bones and that kind of a thing in an arrangement.

Eighty percent of my work—the large commissions—has been with architects, and I very definitely have been involved in the site selection. I think that the artist, if it is going to be very successful public art, has to consider the public. You have to consider someone. Maybe it's only the curator of a museum of modern art that you are interested in reaching, but if you don't want to reach anyone but yourself, then it is just therapy for the artist. I think that there should be a strong consideration of the public but not beating people over the head with the art. The public is paying for it. Educating them is one thing, but you can only make people jump so high at a given time.

I don't find a great deal of difference in my work between studio projects and public art. One is an extension of the other. A large commission, in order to be successfully completed, involves a design that is accepted by someone and then the execution of that design. The only problem that I find many times with public art and a large commission is that you get a lot of ideas after acceptance of the model, and you really can't do them. The big problem with sculpture, or with any kind of design as a building, is that there are seventeen good ideas that all get put into the same one and they are not necessarily very successful. So I find that there are experiments in my studio, but, in general, there isn't any great difference in my studio and public art.

I think in looking at anything that I have done, I find avenues I wish I had taken further. Once things are done, they just disappear, and the photographs rarely help. So once they are gone, they aren't something that you can contemplate. And I'm always amazed, did I really do that? As time goes on, you take on commissions that are large before you know you can't do them. The older you get, the more you think I don't know if I can really do that because you know the problems that are involved, whereas when you were younger, you didn't know you couldn't do them. But they got done. I find them to be very strong and enjoy seeing them.

The only thing that I would say of my work is that I hope that it is not so mysterious that people can't conceive of how it was done, if they are interested in art. <<

(Interview, June 25, 1991)

MICHAEL MCCAFFERTY

In the largest of Warsinske's *Hex Signs,* the tendrils swirl outward to a fingered nodule in the same motion as if a person rotated his hand to pronounce that he was "putting a hex on you." Michael McCafferty can relate both to this empowered hand movement as well as to the repetitive circling patterns of the tendrils. During the late seventies he used his body alone to make sculpture. In some cases he would draw with the entire length of his body in the earth or sand as if performing a lifeline connecting man and earth. From the late sixties through the mid-seventies, interdisciplinary modes, like the performances or body work of Yvonne Rainer and Robert Morris during a 1971 symposium at Western, showed younger sculptors the way toward real-time and real-space events. While he was not involved in dance as was Morris or Trakas, McCafferty came to the same 1987 Site-Specific Symposium as Trakas to share an engagement with space that had moved from a discrete object on the wall or pedestal, to architectural structures, and to the creation of a new setting or place.

Also, since the late sixties and early seventies, artists as Morris, Robert Smithson, and Nancy Holt, had called attention to process by working with nonprecious

Michael McCafferty
(BORN 1947)

Whirl, Wind, Wood, 1987

Temporary work, 1987–2001
5 mounds of earth covering a site of 95' × 149'
1987 Site-Specific Sculpture Symposium funded by
the National Endowment for the Arts and private
donations.
© Michael McCafferty

materials as dirt, rocks, and steam. They were interested in the concept of moving out of the studio or gallery into real-time systems where the time of artistic making joined with the time of nature. Particularly in the case of Smithson, the spiral became a visual metaphor for an entropic condition. Richard Serra helped Smithson and Holt stake out *Spiral Jetty* in the Great Salt Lake of Utah in 1970. He went on to generate sculpture from clues provided by a setting. From this type of environmental sculpture Serra enhanced the viewers' awareness of themselves and the site. For McCafferty the writings of Smithson and Morris were also important in regard to sculpture as site.

To stake out a potential work, McCafferty's process was to take repetitive walks to find a suitable location on campus. He began to notice the convergence of pedestrian traffic and strong wind patterns at the southern edge or main entrance to campus. Nestling in at a cul-de-sac near the Visitor's Information Center, his work would reflect this pedestrian traffic and wind pattern by creating a segmented spiral of earthen mounds among the existing trees. Contrary to Hamrol's original intent to have sod-covered logs erupting from the earth, McCafferty allowed his mounds to rise as if swelling only from the proliferation of candytuft flowers, yellow Vancouver Gold annual blooming Broom, and flowering cherry trees. Amongst the rush of wind and passage of seasons, foot patterns press forward stamping or performing their own rituals in *Whirl, Wind, Wood* (1987). Although initiated as a temporary work, McCafferty's special place lasted for fourteen years. Man's hand (the University master plan), not nature's cycle, has blown it away.

MICHAEL MCCAFFERTY artist statement

In the fall of 1987 art professor Larry Hanson asked me if I would come up from Seattle to participate in a site-specific conference. He was inviting three artists to spend about ten days on campus to give a talk and to work with students while building their projects. I accepted that invitation and visited the campus several times before really committing myself to exactly what I wanted to do. Larry and I walked all around the campus, and he offered me the choice of about three sites: the site George Trakas eventually took at the other end of the campus, a very steep ledge dropping down to a street; a hillside along the campus boulevard heading toward the Information Center; and the little clearing closer to the Information Center. Privately, I would return to the campus and go to those three sites and walk around and around, get on terraces above the sites, look at them from the road, and try to get the lay of the land.

I ended up choosing the site at the end of the long boulevard as you enter the campus just to the left of the Information Center, the area behind the tennis courts. It was a very attractive, small site, but it had a lot of intrinsic energy to it. The site had a growth of trees and at the end of that boulevard the trees seemed to be twisted because of the wind that just storms up that boulevard and blasts onto the campus. I wanted to take advantage of that destination point and energy that seemed to be spinning around inside that small clearing. I decided to build some mounds out of earth and to make more or less a pinwheel out of the whole clearing. The mounds are 4–5 feet in height and 50–75 feet in length. There are several mounds that are broken so that the students or any visitor to the campus can enter into the clearing itself. I was trying to suggest that they would be spun around the central hub of the piece and would be lifted up as they exit through some of the openings in the mounds to look at the various views of the campus. There are wonderful fir trees, poplars, a giant spruce, and vegetation on the mounds that provide these openings and vistas as well as give the piece an area for private reflection. It would be a good area in which a student could take a break or study or find privacy for a couple. It is a very well trafficked corner of the campus, and yet, it is a very private, little nook.

For years I have been very intrigued with the archeological sites in the British Isles. I have visited the British Isles numerous times to look at the stony sculptural remains of places like New Grange or Stonehenge or even the more modest stone dolmans in Ireland. I look at those sites as places where very public performances took place centuries ago. They are very mysterious locations, but they were places where cultures gathered, held feasts, even marriage ceremonies, and buried their dead. When a person walks into my piece, I am interested in how they reflect on the site itself as being a social gathering spot.

I am interested in the physical feeling and the psychological feeling that's elicited by the piece. I wanted to go way back to when our civilization first began to collect and make major statements on the landscape. The piece is constructed of earth with groundcovers planted on it. The earth eventually will erode in our Northwest rains. The vegetation, the original, surrounding trees, and my addition of ornamental cherry trees will eventually die. There will be some slight remains left many years from now, and I think other visitors will wonder what went on here, the same way I wonder what occurred when I visit those sites in Ireland, Scotland, and England.

Whirl, Wind, Wood is part of a series of pieces I have done on the landscape. It is one of my very favorite ones because I had a great deal of freedom. I wasn't collaborating with a landscape architect or a group of designers. But I did have the wonderful assistance of the grounds crew of the Physical Plant, especially the knowledge of Joe Mackie. He gave me the names of nurseries and tree farms in the area, and that type of collaboration was wonderful where Joe gave me his knowledge so I could select the proper plant material. The grounds crew was so great, and they gave me such confidence that we tackled the project in a matter of ten days. They provided all the sources for the materials, wrangled the dirt from a nearby road project, and found the topsoil from the bottom of a pond. What I really learned through this project was that I am not interested in collaboration with landscape architects, architects, or really other artists. I think my sculpture is the best, the least diluted, when I do it myself and when I have the wonderful assistance of people who know more than I do about the building of the mounds, the planting of the vegetation, the temperature zones of the plant material itself, and do the continual maintenance.

Most of my projects have been very transitory. I have worked with Rich Haig, a landscape architect, on Ruby Chow Park for viewing aircraft taking off and landing at the King County Airport at Boeing Field. That is a very public area, but, in contrast, this corner of the campus is well trafficked where I created a very quiet piece in that very busy area. I think normally I work in swamps, woods, or beaches that are very remote. So the public/private nature of Western's project was very intriguing, including observations of people and the exposure of the work itself in process. A lot of my colleagues are studio artists, but my studio really is outdoors. I have a studio where I do drawings, make models, even work with lath, but that is not where my heart is. The answer to my work is always in the site. It is always revealed by the site itself, and if my work is successful, it brings out the form of the site—the forms that are already there before I arrive. <<

(Interview, July 17, 1991; revisions, November 27, 2001)

MIA WESTERLUND ROOSEN

Mia Westerlund Roosen created *Flank II* (1978) at the Vancouver Art Gallery where she was preparing for a show. Although earlier in the seventies she soaked coarse fabric with polyester resin to place over irregular armatures, she now was pouring concrete into pre-formed trays. To the poured wedges of concrete she often added a steel plate with its natural markings and her burned line. As in the case of *Flank II,* she faced the concrete wedge with two sheets of copper so that the textured line of the pigmented concrete separated the copper sheets colored by natural oxidation. Similar to other artists such as Judd and Morris, she used simple forms reminiscent of architectural structures, but there always was something more improvisational in her method and more organic in her shapes. Rectangles were skewed into wedges; surfaces were pitted with color; concrete slabs often looked as if they were about to crumble back into a heap of materials or sluff off onto the earth.

Rather than working with machined metals and surfaces, Westerlund Roosen chose other dominant materials of the urban environment: concrete and asphalt. While others looked at blocks of buildings, she looked at the façades of old buildings and the surfaces of sidewalks and roads. Appropriately in her title *Flank,* she referred to both fortified walls and to a section of flesh between the last rib and the hip. Just as concrete is the

MIA WESTERLUND ROOSEN artist statement

Flank II was an extension of the Slab and Muro series done in the mid-seventies combining concrete with steel and asphalt. My intent was to use concrete as an immediate and mundane material to make a reductive but imperfect geometric piece that would exude energy from its core and a monochromatic painterliness from its surface. In *Flank II* the copper is part of the form into which the concrete is poured. Unlike a very precise forming method, the varied imperfections of the shape activate the surface and accentuate the density and weightiness of the material. The wedge shape is an echo of the Muro series, but being low and horizontal, the copper surface is facing upward toward the viewer.

Although they can be very beautiful and pure, I was never interested in making a truly minimalist object. I wanted to subvert this ideal with discrete expressiveness, drawn line, sensuous surface, inherent color, and wonky geometry. Then I hoped the pieces would not only be present but alive. <<

(Interview, summer 1991; revisions, March 12, 2002)

Mia Westerlund Roosen
(BORN 1942)

Flank II, 1978

Concrete, steel, copper, 1'6" h. × 12'2" l.
Gift of the Artist, 1999.
© Mia Westerlund Roosen

"flesh and bones"[39] of modern cities, the skin protects the body's structure as well as reveals its condition and past history.

At first glance, *Flank II* is often described by the uninitiated as a traffic bump or a heave in the sidewalk. But the sculpture does not rise up on pavement but rather lies horizontally on the grass under a grove of trees adjacent to a major path leading into Haskell Plaza. At present, beyond this area bulldozers and shovels methodically rupture and shift the earth's skin to improve the University's aging infrastructure and to realign its passageways. Over time, the concrete structure of *Flank II* also has begun to separate and crack; its copper skin has loss its sheen with its natural oxidation and at the edges it crinkles with age. While absolutely abstract, Westerlund Roosen's sculpture evokes connections with urban ground-scapes. When the work was brought to Western after its museum exhibition in Vancouver, it also began to make connections with general slopes of the earth and with the prone body and layers of earth. Westerlund Roosen's siting connects the natural processes of earth and body while her process and materials suggest the changing of structures from fortifications to modern buildings.

MARK DI SUVERO

Mark di Suvero works with both the I-beams of modern buildings and the discarded materials of modern life. When he came to campus di Suvero found that a work he had been carrying around in his mind would fit the space of the newly reconstructed Music building and plaza. He has often stated that his sculptural ideas evolve in "dreamtime . . . pure music of the mind."[40] He likes music, whether classical or jazz, because it is an example of disciplined emotion. He also can relate to the rigorous labor and challenges involved in the construction trade and engineering. Di Suvero's *For Handel* (1975) originally combined a hanging wooden platform or swinging bed with the steel girders of modern technology. The fact that the bed was removed soon after the sculpture was erected does not diminish the sculpture's impact or meaning.

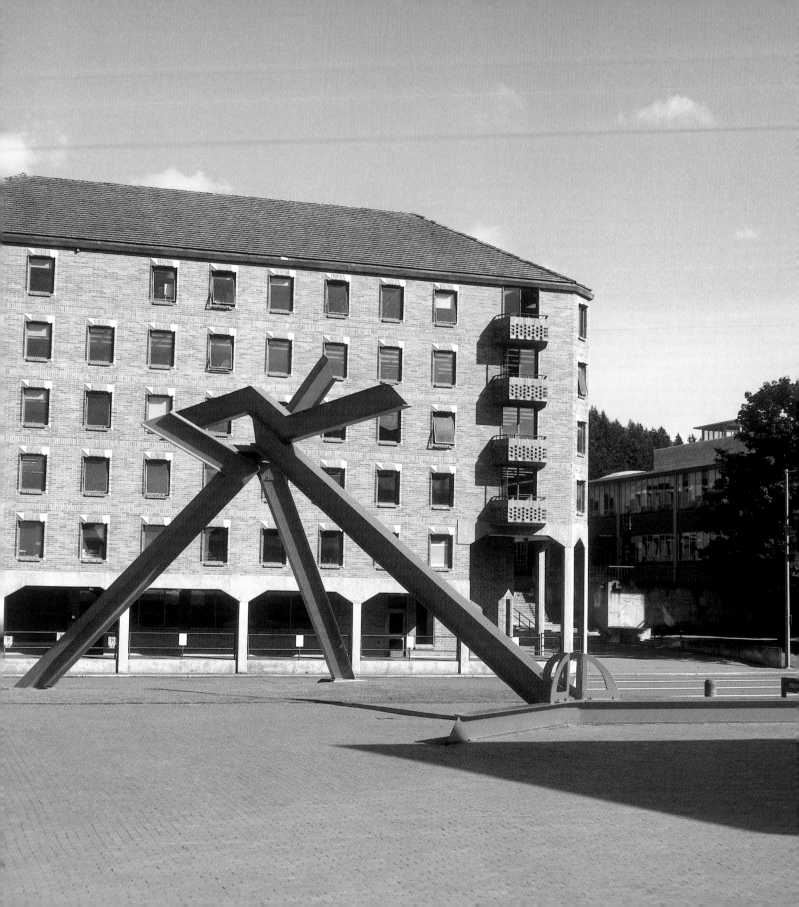

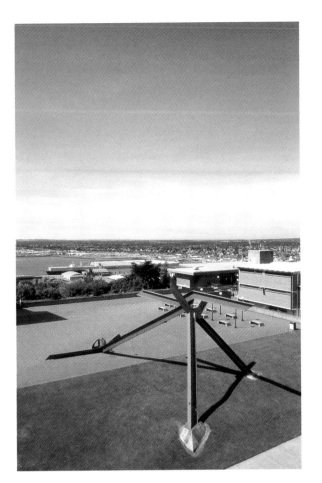

As di Suvero said to students at the time, "most people come to college to expand their horizons, not to see and do the usual things." While he himself was in college, he majored in philosophy and appreciated Bertrand Russell's idea of the logical construct: to Russell, unity was an assemblage of various empirical observations. Di Suvero was also interested in Einstein, whose theories made him think about the relationship of space and time. His desire to break down the barrier between his art and the viewer parallels a political mood during this era of more expansive participation.[41] *For Handel* has the scale of Henry Klein's architecture of the College of Fine and Performing Arts, but one of the ways that di Suvero allows the spectator to feel his own size is to actually provide horizontal girders on the ground. Two beams expand outward and contain at their juncture an inclined beam that invites the spectator to make his first move to step upward. One detail that some older observers like to point out is that they see a "peace sign" cut into the steel plate, half circles framing the inclined beam, which together make an entrance. But they are the ones who miss the point for their peace symbol of the U.S.–Vietnam conflict is no longer a cut-out. It now joins other sculptural parts to become a functional gateway that redirects the thrust of the heavy I-beams toward the sky.

The fingers that make this type of sign are only one part of the body's language. From the late fifties through the early sixties, di Suvero made a series of small sculptures involving the hand that was a way of objectifying expressive gesture. Di Suvero was interested in getting beyond potentially false interior

Mark di Suvero
(BORN 1933)

For Handel, 1975

Painted steel, approx. 27' h.
Gift of the Virginia Wright Fund, 1974
Installation cost from Performing Arts Center
construction funds.
© Mark di Suvero

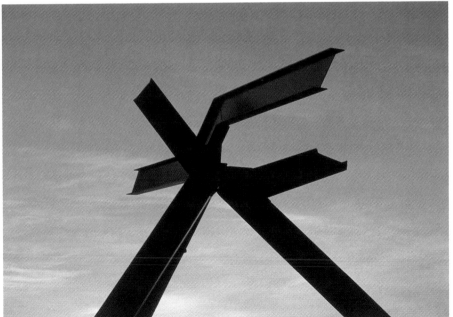

MARK DI SUVERO artist statement

For Handel has to do with a relationship with architecture and the function of that architecture. The architecture is the music building, and they asked me to put a piece there. It was donated by Virginia Wright, and she most graciously was able to accept the idea of a different piece arriving than the one she originally chose, because there was a dealer that beat me out of the original piece and being paid for it. That happened while I was away in Europe in a self-imposed political exile because I couldn't stand what the United States was doing in Vietnam. When I came back they asked me to come up and build the piece during the school year; then, when I arrived they told me I was too close to the library to be actually working there, so I had to build it near the Physical Plant. It took me a couple of months during the rainy season, and when it came down to the moment of meeting with the students, it turned out that there was only one student who asked me a question that did not seem important at all about the art. That is how the piece ended up getting there.

The title is the relationship that deals with the music and that is the function of the architecture. Also, I had discovered that Beethoven in the last two weeks of his life read Handel. I listened to Handel, and I think that he is a magnificent conductor. I tried to give something to that space, which is not just a plaza but also a roof for the rehearsal hall downstairs, and it has a magnificent view. I tried to give the sculpture a little bit of that inspirational moment/movement that Handel's music has—the sensation of rapture, a spatial concept that gives a sense of being able to make it blaze. I was trying to do something that was similar under pretty difficult circumstances. As you know, the right time to work up there is the summer, which is what I wanted to do, but they wanted me to meet with students and so it ended up in the fall when you get a lot of rain.

I think the swinging element is part of the sculpture's history just like I had to first build it and then move it a few hundred yards, which is not very easy to do onto a roof. I saw about nine students standing on it vertically and swinging sideways on [the platform]. They were very enthusiastic about it, but I preferred in the end to leave it off.

I think one of the things that is remarkable about Western's collection is that you have a lot of people on the cutting edge of the world of sculpture in America, which has been so exciting in the last thirty years. I really think it is because of Virginia Wright who was able to see that this idea was not just a whim but it had a capacity to turn into something even better than an open-air museum. It is truly a sculptural experience without having to go through the claustrophobic feeling a museum can give you. I think that she should be praised for this leadership that she took up there, and I think the students in Bellingham really across the years have slowly come to appreciate it. There was an awful lot of controversy against my piece when it first went up.

To get so many out-of-town visitors—that is not at all normal at a state college. State colleges do not get that kind of international attention or even national attention. <<

(Interview, November 19, 1991; revisions, April 25, 2002)

emotions and in engaging directly with others. The fact that all of his hand sculptures on pedestals either point, hold, or extend to something else (for example, *Hand and Foot*) shows that he was adding to the sense of touch an image of juncture. The hand joins the individual and the world. Under the brick plaza where the sculpture *For Handel* stands, music students work in their practice rooms using the strength of their arms and the finesse of their fingers.

Di Suvero extends out to the world through his method of assemblage of old I-beams and wooden parts. Even in his large-scale sculpture, he leaves a sense of his hand or his immediate touch in the rough welds. But his primary mode of contact with the world is his construction of movement through space. Along with the cutting torch and welding tools, di Suvero uses a crane. Perhaps, without its swinging element, Western's sculpture might seem static. But the artist knows that those constant DNA forms that fix our framework or determine our being "can electrify our lives." Aware of great changes in technology and economics and their mutual effects on society, the artist reaffirms his belief in the power of creative energy. Like Serra, di Suvero did not want to arrange predetermined structures or to erase references to production and labor as the minimalist Judd. Yet, whereas Serra's sculpture reflects the state of technological culture as a place of deliberate construction, intentional use, and depersonalized work and play, di Suvero's art includes a more personalized and hopeful control over technology.[42] While there is a general grounding to his sculpture, there is also a great striding forth. In fact, the stance of di Suvero's sculpture, *For Handel,* along with its brilliant burst of orange against the blue sky and distant water, gives great rise to a feeling of elation.

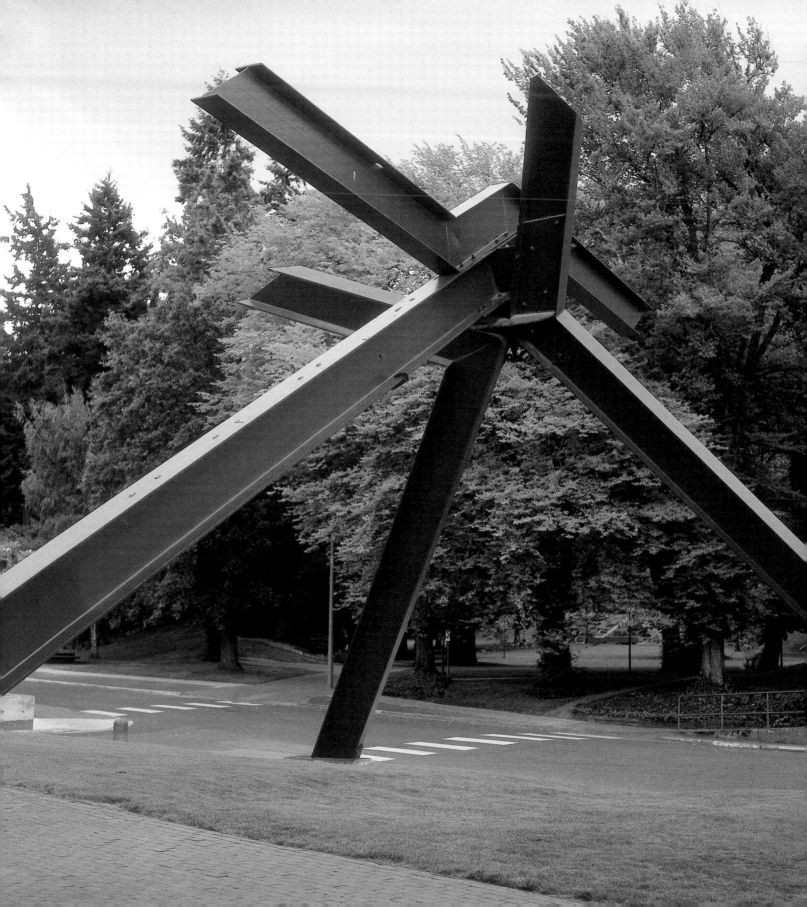

STEVE TIBBETTS

One way to join the world was to use its refuse. Both di Suvero and Steve Tibbetts, the senior winner of a student art competition at Western, saw the world in a constant state of demolition and rebuilding and decided to reuse its discarded parts in their sculptures. From recycled automobile parts, the younger Tibbetts created *Scepter* (1962), which is both a practical staff to hold by the hand and to lean on and also an ornamental icon of authority. Yet, Tibbetts did not allow the assembled car parts to retain their old identity. He held to the earlier generation's belief in totemic power by totally transforming the refuse into a rod with biological form.

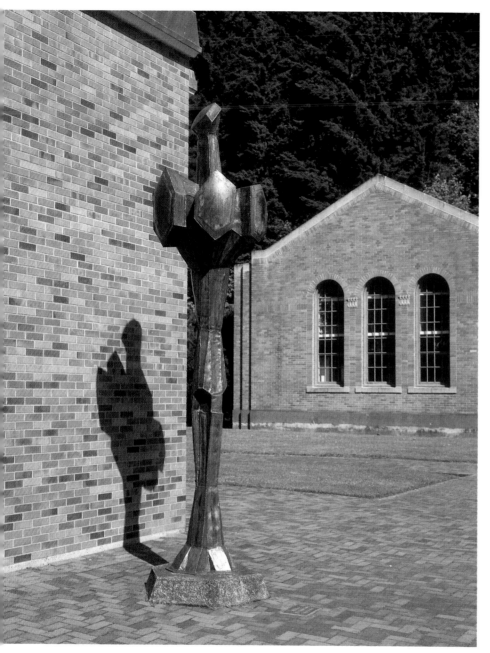

Steven W. Tibbetts
(1943–1983)

Scepter, 1966

Steel, approx. 12' h.
Gift of the Associated Students of Western Washington University.
© Steve Tibbetts

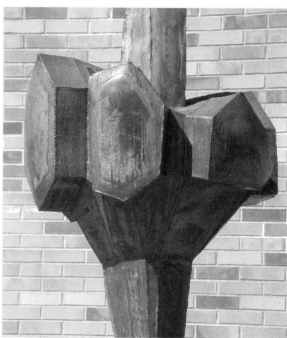

STEVE TIBBETTS **artist statement**
Waste not, want not . . . Something that's made out of something that is discarded has more value.

 Personal response to a piece is influenced by its surroundings and your frame of mind when you come to it. «

(Excerpts from an interview with Daydre Stearns-Phillips, September 1976)

Magdalena Abakanowicz
(BORN 1930)

Manus, Hand-like Trees Series, 1994

Bronze, 15' h.
Western Washington University in partnership with
one-half of one percent-for-art law, Art in Public Places
Program, Washington State Arts Commission; and with
the generosity of the artist.
© Magdalena Abakanowicz

MAGDALENA ABAKANOWICZ

Similar to di Suvero, Magdalena Abakanowicz has utilized both the image and the metaphor of the hand to respond to cultural conditions. In her work for Western, the separate elements of tree trunks, human bodies, bark, skin, heads, and fingers come together in *Manus* (1994). To understand the origin of this work, it is important to first look at an earlier fiber sculpture, *Hand* (1976). Here, with its thumb tucked into the palm and likewise with the remaining fingers curled inward, this

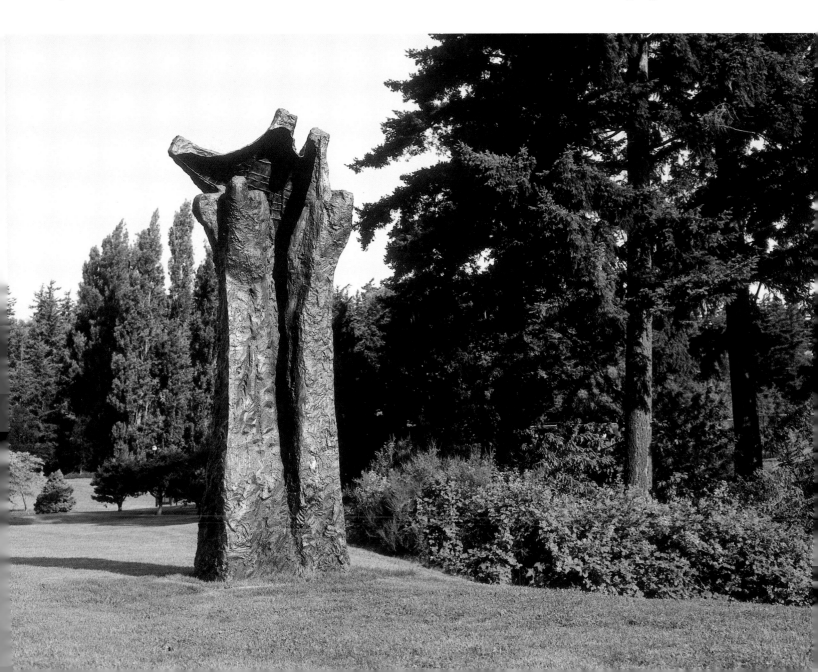

body part resembles the brain. While she can speak scientifically about the brain's divisions and its functions, she is more interested in connecting its structure to the art process. At times she acknowledges the conflict between these centers: physiological functions working with both instinctive and conscious behavior result in wisdom and madness, dream and reality. In other cases, she welcomes the intricacy of biological systems, including those of the body. Similar to a scientist, she involves herself in constant observation of natural phenomena. For example, having grown up in the dark forests of Poland, she was eager to see the tropical rain forests of Papua New Guinea. Research followed by experimentation leads her to different techniques, materials, and avenues.

In 1990, Abakanowicz proposed to the French government a new way to develop the landscape of the urban region La Défense. Based on her conception that the landscape was a body and that architecture was a living organism, she translated this area's traditional tree-lined gateway into twenty-five-story-tall "arboreals." These man-made, tree-like towers covered with real vegetation would provide healthy, energy-efficient, economically productive residential and commercial spaces. While her *Arboreal Architecture* proposal was accepted for study, Abakanowicz's real questions were: What solutions can the human brain invent? How will the human species grow? What new ways of synthetic thinking can an artist provide? Out of this project Abakanowicz began to develop her *Hand-like Tree* series in 1992.[43]

Interestingly, when Abakanowicz visited Western in 1993, she made two proposals. One dealt with the theme of biological growth and renewal metaphorically worked out by using sandstone boulders. While the architects were planning the Biology building and adjacent plaza, huge boulders were being piled high in the grassy area of the future Haskell Plaza. Attracted both by the source of the boulders dug from the devastated ridge and also by their shapes, she proposed a new cycle of her earlier ongoing work *Embryology* (1978). In stone rather than soft burlap, these sandstone rocks would be rescued boulders as well as elemental forms, oval shapes with varied connotations such as cocoons, nesting eggs, and brains. Her other proposal was a singular work from the *Hand-like Tree* series where a Styrofoam shape would be carved with a large kitchen knife, built up with plaster, and transformed into bronze at the Venturi Arte Foundry, Bologna. Although a very difficult decision, the committee finally accepted the latter proposal. While siting her sculpture alone near the trees of Sehome Arboretum and the tree-lined entrance of campus, Abakanowicz knew that her work was on the edge of further campus development southward. But unlike the "arboreal," *Manus* merges the image of a massive amputated tree trunk with a giant defiant hand.

MAGDALENA ABAKANOWICZ artist statement

Manus: The idea of *Hand-like Tree* sculpture explores the similarity between different creations of nature. I see muscles and veins in the body of a tree, a spine, sometimes only visible while looking into a disintegrating or perished trunk. Its bark-wrinkled skin—each square inch differs from the other—the mystery of the organic world on our planet.

Nature does not pretend to make art, we do. What is the meaning of man's sensitivity in comparison with nature's wisdom?

I once saw hands stretched vertically, voting, protesting, manifesting. They were similar to branches moved by the wind. I saw trees with branches stretched in a pompous movement—still and frozen, but dramatic like hands.

The idea to make *Manus* for Bellingham came immediately as the only solution for this spectacular space. The decision, however, was difficult. There was very little money to execute such important sculpture. I visited local foundries, then other foundries in the country. Much too high prices. Finally, I moved to Italy to an old friendly foundry. I worked there on the spot for about a month creating the sculpture in its natural size out of plaster and Styrofoam. We calculated the casting and the transport by boat over the Panama Canal. The available money seemed to cover all expenses, but nothing was finally left for the artist.

Manus is my never officially declared gift to the Western Washington University Outdoor Sculpture Collection.

I am glad to know that it performs there the role I expected for it. <<

(Statement, April 3, 2002)

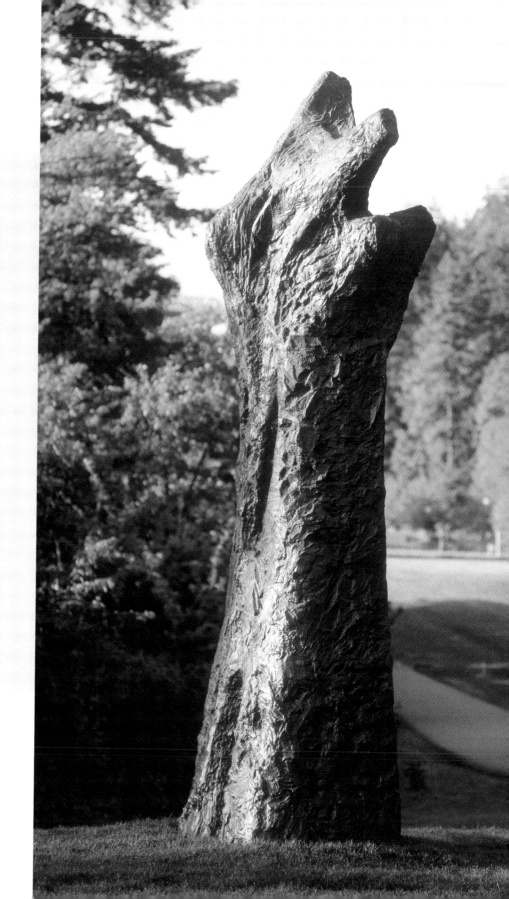

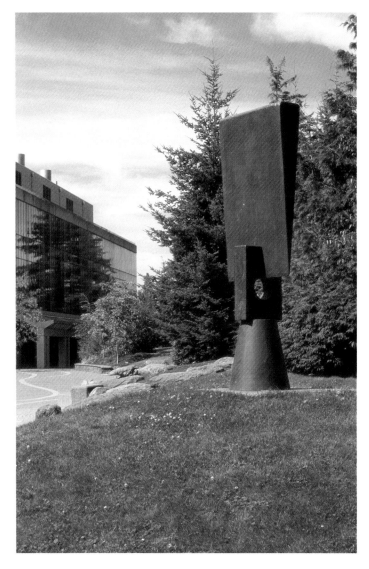

Beverly Pepper
(BORN 1924)

Normanno Wedge, **1980**

Cast iron; approx. 7' 3" h.
Western Washington University in partnership with
one-half of one percent-for-art law, Art in Public
Places Program, Washington State Arts Commission.
© Beverly Pepper

Abakanowicz is drawn to the image of the forest because it draws her back to her past. As a child in Poland she had played in the forest. Later in life, she would remember that the graves of World War II had replaced those green markers. But just as she does not give individual features or gender to her figures, she universalizes the condition of man at war and the devastation of the world's forests. Returning often to the forest as an artist, she noticed the spines of old tree trunks, the similarity between humans and trees with cut limbs, and young trees growing inside or on top of stumps. From one view, *Manus* is a tree with an open cavity as if blasted by nature and/or war. However sheltered deeper within this torn trunk are the veins of a leaf as well as those of an inner palm. From another view, *Manus* is planted firmly in the earth with its trunk rising to a clenched, knuckled hand. As if emerging from the mantle of the forest, the singular form evokes a human being dressed in a cloak waiting to help with the necessary reintegration of man and nature and man with man. Abakanowicz has the power to make an image that is situated in history as well as local in its evocation of the strength of nature in life and death.

BEVERLY PEPPER

Just as Abakanowicz sensed the enchanted quality of the cold forests of Poland or the primitive nature of the tropical rain forests of Papua New Guinea, Beverly Pepper was transfixed by the thick growth and gnarled trees interpenetrating the Buddhist carved reliefs that covered the temples at Angkor Wat in Cambodia. Caro, too, remembered similar encrusted temples in India. While both Abakanowicz and Pepper have created a sense of a total environment in a singular object and have made a large environment with one type of object, Pepper's recent interest has been the sense of transition one finds in any culture's tools. Her experimentation with materials, whether wood, earth, metals,

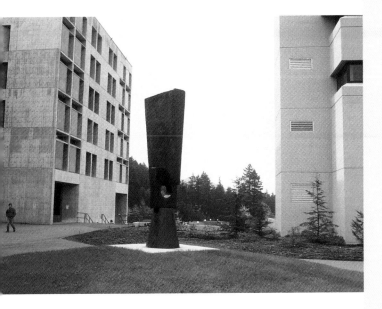

BEVERLY PEPPER artist statement

Normanno Wedge is part of a series of sculpture based on tools and allowing their meta-morphosis into something else. The embryonic state of the tool evolves into something beyond a tool. This began when I was working in foundries and factories and became involved with the beauty of the instruments I used. As a work in process, it is inevitably seductive. With each new mutation, you wonder if you're finished when you actually need to push on to a final form.

I used wedges in making some works to split the sculptures and create a space between —to keep them engaged in a dialogue. Then, the wedges themselves invaded my mind. This began with the first wedge I created—a very small, forged steel sculpture, made with a drop forge. It was initially difficult because I felt I needed to do the forging myself, though I was not physically capable of manipulating the forge and maneuvering huge weights of steel. At that point, I decided to shift to casting since it would free me to work directly in iron. The originals could be made out of more malleable material.

While working on a show for the André Emmerich Gallery in New York, I decided to see if the wedges would work on a large scale. This resulted in *Normanno Wedge*, the first in a rewarding series of concepts. They were cast in Terni, Italy, so I used related names to identify each work. During the Emmerich show, an architect asked me if *Normanno Wedge* would work at 17-feet high. I said yes, but with reservations. One can't just enlarge a work. Proportions change—each wedge has its own personality. I went from 12 feet to 17 feet, but only after encountering numerous problems. And I am still making variations and exer-cises, using *Normanno Wedge* as a point of departure. I consider it a major piece of work because it is the first one of that series, but it was a complete hands-on experience. There was much to learn, and it expanded my vocabulary. This included the original wood pat-terns. They had no cores, as did my later work. Later I worked in plaster.

Sometimes there are initial troubles when you work in factories. I was invited to work at the John Deere foundry in Moline, Illinois—one of the inventors of ductile iron, used mainly in casting industrial parts. Casting industrial equipment and casting sculpture have different requisites, and they had never adapted it to a monumental-scale sculpture. A 17-foot wedge is complicated to cast; particularly when it is to be cast hollow. At first, the work collapsed during the casting. Also, I explained we could not show seams or scars. At Deere, this meant that the vents required to allow air to escape had to be placed where they wouldn't be seen. It became a major undertaking to solve this and other technical problems. In the end, the solutions enabled me to use iron more freely on my own.

On occasion, in factories I have had to convince people that I know my craft. Sometimes when I take on something that is very difficult technically, they insist that it can't be done. But what they are really saying is, "We don't want to deal with you because it is just some woman's cockamamie idea."

I call WWU's sculpture "Normanno" because the man who owned its foundry in Terni was named Normanno. Still, it took a lot of persuasion to convince Signor Normanno Bernadini to cast that wedge. Eventually, we became great friends and did a lot of work together. Other foundries followed—my cast iron sculptures made in an industrial foundry, not an art foundry. Industrial casts are coarser and relate more to the concept of the tool.

Frequently, I allow my work to guide me. The columns were the natural outgrowth of using files, punches, and other tools. I was doubling them up, or elongating them, or otherwise changing them. Vertical sculpture or columnar sculpture has to do with stasis, as with a man standing. Each invites other pieces to stand next to it. They live very well >>

or their combination, might belie her real intent to bring the past into the present or to have "the past to participate in [the] presentness" of her sculpture. Although she began her career as a painter, Pepper's experience at Angkor Wat turned her to sculpture. Yet, when she changed from two to three dimensions, Pepper worked from a tradition of sculpture as did di Suvero, rather than reacting against the illusionism of painting in a literalist manner as did the minimalist Judd. Both she and di Suvero wanted to be directly involved in their art processes rather than using fabrica-tion or mechanically reproductive means to enlarge sculpture from maquettes as had Noguchi. She was one of the first to use Cor-ten as she liked its intrinsic color, a rusted patina from the exposure to the sun. But it was the (earthen) iron's endurance through time and its sense of prehistory that gave her the greatest inspira-tion. First discovered through meteorites, the Sumerians had described it as "celestial metal" and the Hittites knew it as "the black iron of the sky"; then, found in the veins of the earth, smelted iron was worshipped as a gift from the deep earth god of fire.[44]

Pepper acknowledges the immediacy of a tool as an extension of herself, just as the crane is for di Suvero.

>> alone of course, but they assume another dimension when grouped together.

What engaged me in *Normanno Wedge* was its surprising unpredictability. In fact, *Normanno Wedge* is a column, or an exclamation point, from one view. From another, however, it presents a flat broad expanse. Actually, this was the prelude to my "altars." In this sense, it is a seminal piece—for it brought me to the series of *Urban Altars* that followed *Normanno*. They allude to the inevitable relationship of people, yet also their inability to stop and privately reflect, particularly in the urban area.

With public sculpture, the site is a defining factor. At the same time, however, a work must have a life of its own. It should not compete with the site—nor the site compete with the work.

I eventually get another dimension in my work that was not in the original concept. When I look at the finished sculpture, I should feel that other dimension. How can I explain it? I try to avoid descriptions that sound mystical—but here there follows a pervading sense of quiet. When a work like *Normanno Wedge* is sited away from my frame, my boundaries, I want it to be able to exist with a separateness, as well as being capable of blending in. I believe this sculpture works very well at Western Washington University because it is integrated into the landscape, as well as the frame of the buildings. At the same time, it has separateness, which is what I am very keen on obtaining in most of my work.

I do a lot of site-specific, public participation art. I worked six years on a 35,000-square-meter urban park in Barcelona (*Sol i Ombra Park*, 1985–91). This site-work has vertical and horizontal elements as well as the earth going through the sculpture. The vertical elements are cast-iron sculptures that have splits, which allow it to function as a radiating light. It relates very much to my public sculpture in Buffalo, New York: *Vertical Presence–Grass Dunes.* I also made a sculpture/theater, *Teatro Celle,* 1988–91. There are cast-iron columns, textured walls, and shaped grass for a public theater. Once again, from certain aspects, what looks like the "exclamation point" of *Normanno Wedge* is seen in the void between the columns.

I work in many mediums—stone, bronze, aluminum—but I always return to cast iron. As the workers told me in Piombino in 1962, "When you work with iron, lady . . . it gets in your blood." Well, I think it got in my blood. I also believe artists are always autobiographical in signature works that constantly return, and mine is to iron. To begin with, I always want to make the best piece I can—for the public or the private collector. In effect, one should try to give the public a museum experience outdoors. One should not have two standards: public art and private gallery/museum art. It should be exactly the same aesthetic. My audience may be people who may know nothing about art, or know everything about art. Either way, they should be touched, involved with the work somewhere along the line. I think it is a major mistake to seek a public level—or "talk down to the public." Hopefully we can give them a new experience, rather than confirm their old ones. <<

(Interview, July 31, 1991; revisions, March 4, 2002)

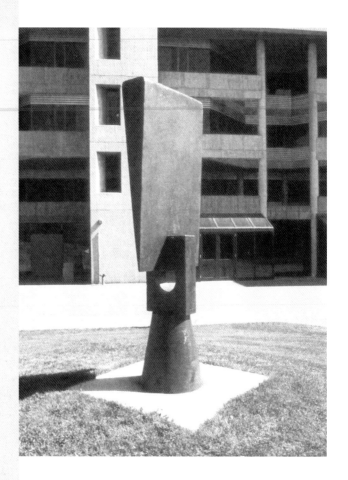

Then, she takes the tools of technology as a point of departure, either reinventing shapes or repressing the original use of the found object. For example, when she was in Iowa at Herbert Hoover's birthplace, she was impressed by an axe in an old barn. Later, two axes emerged in a vertical sculpture as part of her *Urban Altars* series. *Normanno Wedge* (1980) at Western is one from this series.[45]

Sensing early industry's tools, such as axes, chisels, drills, and files, are already parallel with those of the Iron Age of the Hittites, Pepper gave vertical form and the look of ancient, sacred iron to her new markers. As in *Normanno Wedge,* the uneven quality of the iron, the worn edges (wood cast in iron), and the darkening patina suggest that time marches on.

Similar to Westerlund Roosen, Pepper used the irregular form of the wedge, not the rigid rectangles, perfect circles, or sharp diagonals of the minimalists. Pepper's choice also makes one believe that the shape has been dug from ruins rather than fabricated in modern factories. In siting *Normanno Wedge* at Western, she was concerned that the work did not relate perpendicularly to the buildings or any major pedestrian path. At the time, the future Haskell Plaza was only a grassy area, so that a clear sense of procession occurred from the steps between Environmental Sciences and the new Parks Hall (College of Business) to the major path in front of and along the façades of Environmental Studies and Arntzen Hall. In turning the thin edge of the wedge on a southwest/northeast axis she negated this sense of the processional, but she still retained the sense of columns and obelisks as guides through a city just as skyscrapers today are visual markers. Therefore, when the viewer comes up the steps from the south, *Normanno Wedge* marks the place (at first a grassy area, now an institutional plaza); on a mound, it thrusts itself against the sky. Just as an axe can signify violence, a wedge or plow implies the intertwining cycles of man and nature. But in *Normanno Wedge,* civilization's tool slides or slices into a circle, an abstract symbol of the void or sky. However, when viewed from the front door of Parks Hall, the wedge shape is only a raised flat plane. Using the format of the free-standing altarpieces of medieval cities, Pepper created an abstract frame, picture plane, or altarpiece for an urban or modern space.[46] Just as the four years of a student's life is short yet filled with personal history and new revelations, Pepper's new monument is not limited to any specific event. By creating a plane on which to rest one's eyes and a mark against the sky, she points to the idea of memory itself and how it shapes the future. Totally abstract, the sculpture alludes to the sense of transition in all of society's tools—from iron wedge to computer—and to the power of memory to effect and color change.

ALICE AYCOCK

Both Pepper and Alice Aycock are interested in archaeology where nature and architecture mingle. Both make reference to Etruscan tombs. Pepper concentrates on the tomb's contents: how the slag of that culture's remnants can become a new material for tools. Decades later, she makes a vertical sculpture. Aycock notices how the Etruscans carved tombs, a type of architecture, out of the earth. She creates a work close to the ground, such as *Islands of the Rose Apple Tree Surrounded by the Oceans of the World, For You, Oh My Darling* (1987).

An avid reader of literature, history, and architectural books, Aycock finds that architectural language more than often speaks only of function. But she feels it can exemplify more soaring emotions and ambitions, as did the great monuments of the past and present civilizations: Mycenaen beehive tombs, pyramids, medieval churches, Renaissance temples, even today's roller coasters. In creating her own structures she wants to investigate these spiritual origins in order to capture her memories and fantasies. One of her methods is to use architectural structure as if it were script. In the late eighties she became intrigued with primary methods of forming letters or figures: Egyptian hieroglyphics, the Rosetta stone, which combined Greek inscriptions and

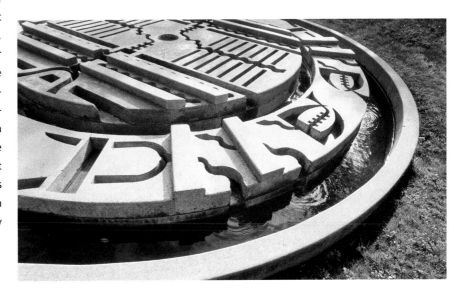

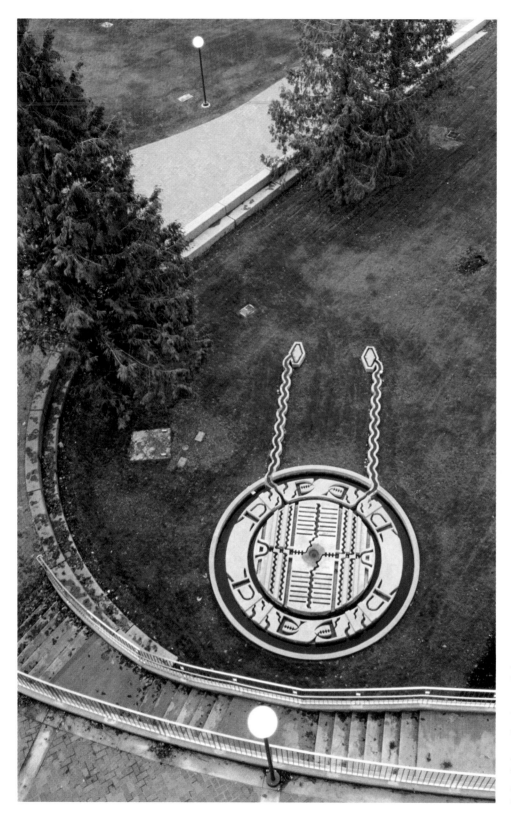

Alice Aycock
(BORN 1946)

The Islands of the Rose Apple Tree Surrounded by the Oceans of the World for You, Oh My Darling, **1987**

Water-filled cast concrete, 21' d.
1987 Site-Specific Sculpture Symposium funded by the National Endowment for the Arts, Washington State Arts Commission, and private donors.
© Alice Aycock

Egyptian picture-writing, and Tantric diagrams. For example, she gave herself the problem of drawing the two-dimensional symbols on the Rosetta stone as if they were not cut in relief but actually in three dimensions. She went further by transforming these symbols into imagined rooms or buildings as if she had drawn an isometric view of a modern city. She was interested in archaeology's "memory palaces" or how ancient civilizations had built a warren of rooms where each held a certain key figure or idea. In another drawing she explored how the *Indian World View* (1985) could be a mental construction or map of the entire world.[47]

In Aycock's sculpture for Western she has cast her script in concrete; the low edifice is a fountain with a narrative about a place, a world, and a person. Whereas FitzGerald's fountain symbolizes the sounds and vertical cycles of Washington's forests, Aycock's fountain gives life to the surface and just under the earth. She was stimulated by Tantric drawings that place the symbolical Mount Meru at the cardinal center. The mountain is also an outward representation of the center of the inner body; within the center is a spinal tube called the *merudana*. From the center, plateaus and regions radiate out from continents to constellations. Beyond the farthest visible circle lies the sphere of the invisible. Aycock's Mt. Meru is a circular depression reaching into the concrete or earth and a mountain or body that rises when filled with

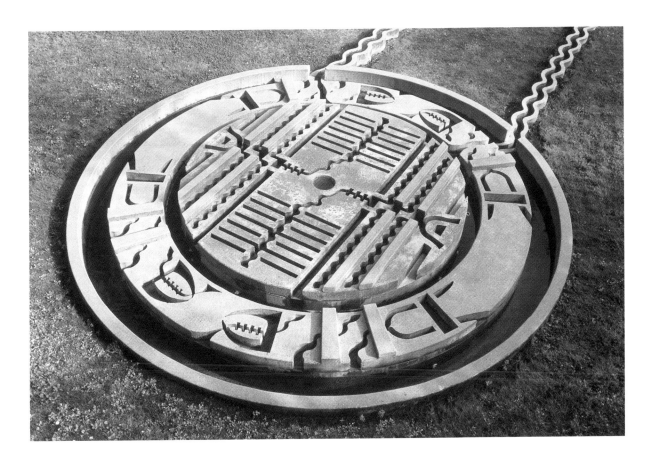

ALICE AYCOCK artist statement

I made fantasy drawings several years prior to the Bellingham sculpture, in which I incorporated diagrams and drawings from Tantric Indian art. I took the architecture of actual theaters, especially the interior of these theaters, and began to fantasize these diagrams in a three-dimensional way and overlay them inside the theater. I assumed that there would be water; that you would walk inside and instead of having seats you would have this very strange environment in which water would move. Perhaps water with all different colors. These were images that I had looked at for maybe ten or fifteen years, trying to figure out how to crack them. In other words, how to utilize them in a three-dimensional way and in a transformational way. And that's often the case that something will, for reasons I don't understand, attract me, and I will go back to an image over and over, and buy more books and sit with them sometimes for long periods of time and then suddenly it's like cracking a code. I will find a way to utilize it. At the time of the Western Washington project I knew what materials I wanted to use. I knew I wanted to use some of these two-dimensional diagrams in a three-dimensional way, but I wasn't sure why. In other words I didn't quite have a strong theoretical reason. It was more of an emotional and instinctual need to do it. Afterward I began to understand how it relates to my ideas. But at that point I had the methodology. I was going to make the sculpture in concrete and water and set it into the environment. I wanted some sort of interplay between these very stylized negative forms in the sculpture that imply water and the real water that flows in these spaces. It wouldn't be a traditional fountain that sprayed water but a dialogue between artifice and nature. In the actual diagram that I was using there were metaphors for the Tantric Indian religious concept of the origin of the world and also concepts about heaven and hell. Just like in Western art there are illustrations of what hell and heaven look like. For some time I have been attracted to various cultures' conceptions of these places, primarily because they are things that don't exist in the world and that people have to imagine. I am very interested in the architecture and geography of the imagination as opposed to the architecture of the utilitarian. In other words, one might have to construct a house or a building a certain way because it has to conform to gravity. But when people begin to imagine states of being that don't exist in the world, I find it very curious. It doesn't matter what the culture, I am constantly looking at what the architecture of these places is like. It's really about finding different ways of constructing things that are unlike what I just see around me. Most of these things are two-dimensional, often diagrammatic. They don't have to conform to the physics of the world.

In Tantric art there is a sacred mountain, Mt. Meru, from which everything originates. All the rivers of the world flow from this mountain and there are many levels that conform to states of being, not unlike Dante's Paradise and Inferno. I looked at many versions of this particular Tantric diagram, which is incredibly complex. For years I tried to figure out whether there was any way of using it since it came from something that was so foreign to our culture. At any rate, at a certain point in time I realized that I could use concrete and use water and that I could set this into the landscape and create this dialogue that I have been talking about between the artificial and the natural. This was really my first attempt to use concrete in this way; that is, to make it conform to very elaborate designs and to cast it in place on the site and to get these kinds of designs in the negative (where water would flow). In that sense, it was somewhat of an experiment since I had never used the technique of cast-in-place like this before. I imagined early on that I could actually put fish in the water and that I could have pure water and so-called dirty water—"poison"—water in a very elaborate sort of design. As I got into it and dealt with the reality of the situation, this idea fell away. I would say that the cast-in-place method proved to be, with some experimentation, rather exciting for me in terms of the fact that I could really get this plastic, curvilinear quality from the concrete. Hopefully the concrete will merge into the surrounding earth and gradually things will grow. As the concrete ages, it will settle into the land and relate to it in a more organic fashion.

A lot of the work I had been doing was out of metal and motorized and very "techie," but at the time of Bellingham I was interested in going back to the landscape and not necessarily in the way that I had been working in the early seventies. I was familiar with the University from photographs of other sculptures there, particularly Nancy Holt's and Bob Morris' works. I had some sense of the landscape before I went on a visit and some sense of what direction I was going in. I think it's not just the specific site, but the overall environment, that is, the mountains and the ocean and the general sense of the place that I responded to. We walked around the campus for a couple of days looking at places that would be suitable for a work. I knew that this would be a piece with strong presence from above. So when I found the site I knew that you could look down and see it and then walk down to it >>

>> and encounter it in a more direct way in the land. I haven't visited in several years, but I know the piece is now enclosed in a building complex.

Another thing that I looked at was Islamic water gardens, which are very sculptural. I was also intrigued by the idea of a very busy street—dusty and chaotic and then you go into a compound and behind is a garden that is completely separate from the world. You are in another place. Just as the French gardens were topiaries sculpted with vegetation in complex designs, Islamic water gardens are incredible designs in stone with water moving through it. So that was another influence.

I think that each piece, whether it's indoors or outdoors, has to take into consideration certain practicalities and there are a variety of things that come into play. One is where my interests are at the moment. Because I have not come up with a sort of style that is always consistent, it changes according to how I change and what I want to pursue. So that's the first thing; and I think that the second thing is that there are obviously some materials that one can use indoors that cannot be used outdoors and vice versa. Indoors one cannot dig down—you can't really pull up a floor and establish all kinds of different levels that are integrated into a building. You can do a big installation, but it usually is impermanent. Outdoors you can change elevations. I look at a site, and there are definite pieces that I would not do on that site. It's not only what the surroundings look like but also what they represent philosophically and psychologically. The one thing I would say is that I try very hard not to let a kind of attitude creep in like "what will please the audience." Or what will they accept in terms of tailor-making a piece to be pleasing to the public at large or whatever. That's not to say that I don't take into consideration the context in which I'm working. I am very wary of the public art mandate that says there's a public taste out there and we, as artists, must cater to it. We are the servants of the public and we must strum that string inside the public in certain ways so that we won't offend them and they will like it. I am very wary of that and consequently I would say that I don't err on the side of playing it safe. If the project is lost on that basis then it's too bad. I have to feel really committed to a project in order to see it through. I think an artist should awaken the curiosity of the public and get them to find out about things they don't know and to wonder about things they don't understand. An artist's job is not to simply appease the public taste—we have plenty of people in America who can do that.

Finally, there is the obvious reference to a memorial or burial in the sculpture. No one is actually buried there but the image of a tomb surrounded by water, as well as the title, speaks for itself. <<

(Interview, June 18, 1991; revisions, February 27, 2002)

water. She selected just two of the regions that circle Mt. Meru. This island with apple trees surrounded by the oceans is not unlike the Atlantic and Pacific Coasts of the United States or even regions of Washington State. Beyond the persistent memories of births and deaths in her own family, this fluid or water slowly circles and pushes against the outer concrete wall to send ripples into an unknown life or place. Here, the natural colors of rain and mildew sink into the concrete.

Aycock's work is mesmerizing in the sense that she places the viewer between two worlds. When she created the fountain during the summer symposium of 1987, she sited it adjacent to Carver Gym and a parking lot in a low-lying area. As the viewer emerged from the

tree-lined parking lot he could veer from the main sidewalk into a glade containing her water-filled, cast concrete structure. In this low ground literally below the high grade of the major north-south campus walk, her circular form with extended arms beckoned the viewer into its center. Walking between the extended concrete arms with water channels, the viewer comes to gaze into the circles imprinted with a maze of shapes. The natural element of water fills or completes the artistic water imagery: passages, channels, moats; abstract wavy lines and boat cut-outs; the linear structure of docks or moorage. At that time, the more prominent view of Aycock's work could be seen from the walkway between Noguchi's observatory to the north and Holt's observatory to the south. As the viewer traversed this higher path, he could sidestep into a resting or viewing station that

looked down onto her work. From this bird's-eye view, Aycock's fountain has more cosmic allusions to the orb of the earth, oceanic worlds, and gardens of paradise.

Rather than a simple bird, some of Aycock's favorite images of flight imply a more elaborate narrative: images of angels in Italian paintings; a photograph of a man leaping from one rock to the next; a woman on a horse jumping from a scaffold; the Wright brothers in a glider. In her original creation and siting she wanted a bird's-eye view because she equated flight with a state of desire. When the Chemistry building and its accompanying science, math, and technology lecture hall were constructed in the mid- and late nineties, Aycock's fountain was threatened. But the architects' solutions were to curve the encroaching end wall of the Chemistry building and later, to add to a walkway between the two buildings a series of steps that cascade down to her work. She was pleased because another of her favorite cultural images is a stairwell by Sangallo in Orvieto where "steps wind down deep into the earth; two sets of staircases wrap around each other, one descending, one ascending, and ledges where you stop; you feel as if you are suspended in air."[48]

ROBERT MORRIS

Robert Morris' work, *Untitled (Steam Work for Bellingham)* (1971) is a special type of fountain that gurgles underground and swells to an amorphous column; then the misty cloud dissipates. Its point of origin was a U-shaped pipe above ground where steam escaped in one area from the University's heating system of underground pipes. In 1971, after participating in a symposium, Morris was commissioned to create his steam piece that was finally built in 1974.[49] Morris replanned this source of regulated but fluctuating power; he determined the amount of steam to be released, reconfigured its visual appearance, and re-sited the new work in the rolling landscape of south campus. When the fountain is turned off, only rocks fill his container, a plain square outlined by wood beams set in the ground. Natural environmental factors such as sun, wind, and condensation in the air affect the rate of evaporation and the shapes the steam will form. Economic factors such as energy conservation often erase the boundaries between those who love it and those who oppose it.

Since excess steam is also vented at the steam plant, the question might arise as to the significance of Morris' work. One answer lies in the convoluted statement made by Morris to a student reporter soon after the work was completed: "It is work done, like all work, in the world—and partly because its audience has become much less end-directed, seeing life in terms of people and action and responding to life in a way formerly reserved for art." Translated in another way, Morris sees art as the result of work equivalent to the product of the laborer. He also feels that both artists and laborers share the same devaluation in the decline of industrial society.[50] Therefore, his solution is to join his art product and their life's product in the same space or at a particular site so that the viewer feels a sense of uncertainty and resistance when the product's worth is questioned or when it evaporates. The second way to understand is to call attention to several of his other works, perhaps less abstract, which also embody this

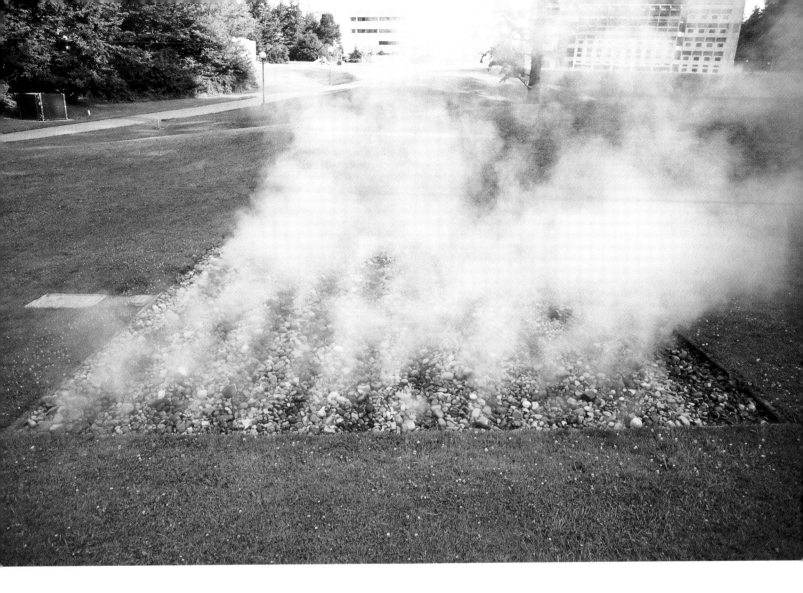

Robert Morris
(BORN 1931)

Untitled (Steam Work for Bellingham), **1971**

Installed 1974. Rock 20' × 20' with variable height
of steam
Western Washington University Art Allowance from
Steam Plant construction funds.
© Robert Morris

ROBERT MORRIS *artist statement*

Letter August 10, 1971:

. . . Since I've been back I have been considering the Bellingham project. The lack of much of a budget and the lushness of that terrain have both presented problems to me. But I've come up with something I like and think right for the site. I would like to have a continuous sound or vibration of the ground occurring in that area we looked at just off the footpath—that sort of miniature ravine . . . I came to the conclusion . . . partly because of the peculiar, half-cultivated sort of order campuses have and I wasn't interested in either competing with it or subverting it . . .

Letter November 10, 1971:

I'm sending a drawing of the *Steam Piece* under separate cover. The more I think about it, the more I think this will be a fine work for that site . . .

Letter December 13, 1971:

In all my days of working with factories, getting working drawings and sketches made up by fabricators, etc., I've never encountered a drawing that looked more like it really meant business than G. Sullivan's. He must be a genius plumber . . . In fact, maybe he's just a genius . . .

Letter May 9, 1973:

Does it ever get steamy in Bellingham? Does one ever see a low cloud on the horizon, or even tucked away in a dale, or a cleft, or a corner? Does a vaporous mass ever hover over a small section of the earth causing passers by to point dumbfounded, giving the elbow to their companions, "was'at?" Has steam ever arisen, unnatural-like, there in Bellingham, asserting its dampness, its artifice, its sinister ground hugging stealth.

If ever steam rises there in Bellingham let me know.

Letter July 19, 1991:

ORIGIN. The exact origin of the work has vanished from memory. At some point, long ago, Larry Hanson and I discussed it. Then after years of delays it got made. "Concept." To make a work that had no stable form but was part of the earth. "Issues." There were a lot of plumbing issues. Fortunately we found a genius plumber.

RELATIONSHIP TO. As a seminal work this was a kind of a nocturnal emission. I dreamed about the work years before it was made and have ever since dreamed of making others.

SITE. Larry and I walked around and found a spot. I consider all art site-specific.

PUBLIC ART. Primary consideration: do something they can't sue you for. Studio art, as opposed to Public art, is usually done indoors.

Letter June 7, 1999:

I found your fax upon my return from Europe today. I definitely want to fix the *Steam Sculpture*. I am studying the four options you sent . . .

Letter February 24, 2002:

Thanks for the long fax bringing me up to date. It is distressing to know that STEAM has been non-functional for so long. It is one of my favorite works. But maybe some day . . .

[As to the student reporter's questions]: (a) The installation of STEAM at Western. When I was asked to propose a work for the campus I came out to visit the site. I saw along a roadway near the possible sites an inverted "U" of piping emerging from the ground. Periodically steam came out of this plumbing. I was told that this was excess steam from the heating system being vented. Because I had had for some time the idea of making a permanent STEAM sculpture, and the source seemed available at Western, I made the proposal.

(b) "What would you like to happen to the sculpture?": FIX THE GODDAMNED THING SO THAT ITS GLORY WILL ONCE AGAIN BE AVAILABLE TO THE PUBLIC!!!

(c) My "original vision" (what a phrase!). Chance, indeterminacy, constant change, responsiveness to the surrounding nature, something that was but not an object . . . STEAM is art that gives up the stasis and certainty of the artist's narcissistic shaping and allows the play of elusive, ever-changing natural forces to take over . . . all of these things must have been part of my "original vision." And "what does it mean to me today?" The same as before only more so . . . <<

(Excerpts from letters 1971–2002, printed with permission of the artist)

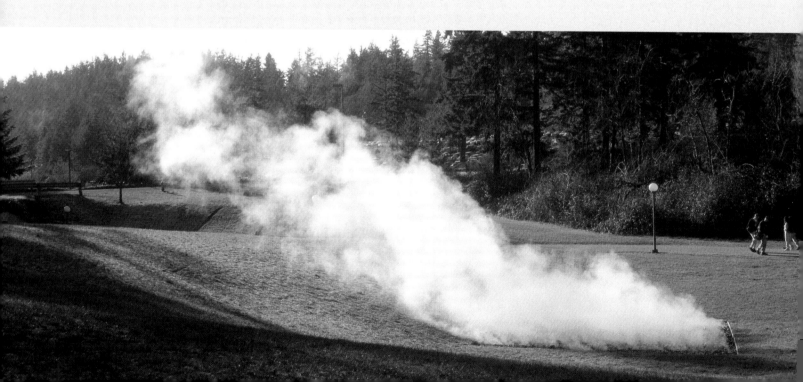

dualism of physical and mental time. For example, in *Box with Sound of Its Own Making* (1961, Collection Seattle Art Museum) and *Fountain* (1963), he combined both the aural and visual elements of work as he did in the steam piece's activity. In the former, he placed the recordings of the actual sounds of him sawing wood to make this studio piece inside a sealed wooden box; in the latter, he hid the noise of a pump circulating water inside a galvanized bucket and hung it high on the wall. In *Untitled (Steam Work for Bellingham)* the labor is underground in the industrial pipes, but the physical intensity of the work is felt through the hissing sound and the wet sensation as the viewer actually takes time to walk into the cloud.

Since he has a background in dance, Morris likes to overlap the labor of the performers with the labor of the visual artists. For example, in his task-oriented performance, *Site* (1964), he dressed as a worker with a mask. Behind the paper mask any expression was concealed as he, the visual/performing artist and laborer, went about his workman-like activity of uncrating a square box and rearranging its slabs or sides. At the end he repeated his steps to box up the original object—a nude woman who represents both another type of real worker—a prostitute—and other examples of reclining nudes in past art. In the steam piece, Morris allows the viewer to step into the site of the worker and wear the mask of the steam. The same viewer is also veiled by the cloud and becomes the object of interpretation to anyone outside the box.

Another example of Morris' works helps to explain this statement about art and life and, as in the previous cases, what is developed in one medium is elaborated further in another. While art lovers would enjoy the steam piece's ability to regulate itself depending on the amount of heat generated at the University at different times of the year, the administrators see the need for conservation of energy and limit the work through an on/off policy. Ironically, one of Morris' earlier works, *Untitled (Performer Switch)* (c. 1963), has an on/off mechanism. This oak file box with switch also has a velvet-lined lid with an inscribed mirror giving the instructions: "To Begin Turn On—Continue Doing What You are Doing—Or Don't—Do Something Else. Later Switch May be Turned Off—After A Second, Hour, Day, Year, Posthumously."

Just as Morris highlighted mundane tasks in his performances—carrying things such as slabs or boards (*Site*, 1964), and walking on tracks or pouring liquids onto the floor (*Waterman Switch,* 1965)[51]—he also began in 1967 to spread less than aesthetic materials such as thread waste, felt, and dirt on the art gallery's floor. At Western, Morris used steam and rocks but this time on the floor of the land. In his steam piece, as in the previous examples, he wanted to loosen up some old mechanisms of thinking, predetermined or static ideas about art fixed by institutions. He undermined the idea of a static object on a pedestal in a gallery. Like a bottle's contents dripping down a body onto a floor or the circling and evaporating steam, he wanted art to transgress certain spaces. Most importantly, he did not want to hold the spectator back but rather put the spectator in a direct situation, on the same ground, so that he would have the physical experience of encountering the art.

Untitled (Steam Work for Bellingham) is the epitome of Morris' constant anxious investigation of the relationship between body and mind, nature and culture. In its "on" position, the viewer experiences the duration of the piece and sensually feels his physical body in the

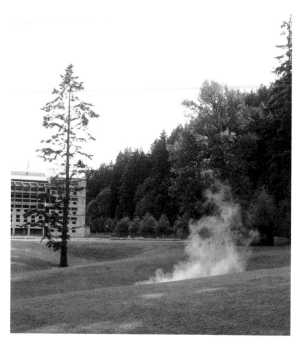

natural landscape of rock and steam often found elsewhere in the Northwest. Here, steam is like a trace or memory of the body in the world. In its "off" position, the viewer only has his memory of the work and how he experienced it. These subjective fragments form part of the history of the work or how others viewed it and interpreted it over time. Here, the rocks overlying the square also provide a concealed portal, whether gate or tombstone. Recently Morris stated, "History: *terra moto*. A shuddering of earth and memory."[52] As the steam piece oscillates, we feel that dread. We might see its labyrinthine substance as a strategy to make us think more deeply about how we act in private versus how we act in a public, cultural space. Or, we might view its cloud as the transitional space between life and death.

C. A. SCOTT

During the sixties, artists began more frequently to look at theories outside of art, such as scientific, psychological, and philosophical abstract ideas. Morris reconsidered Gestalt psychology and Chaos theory. Holt often used the advice of astronomers in orienting her works. Even the structuring principle of "the concept" became important. Rather than creating an object that would be separated from the world by its aesthetic value, they believed art could involve different types of memory and could become a way to exchange ideas with the viewer. For example: C. A. Scott's plaque is on the low wall dividing the College of Fine and Performing Arts Plaza, now the Virginia Wright Plaza, from the steep hill leading down and out to Bellingham Bay. The bronze plaque simply states: "Things are seldom what they seem." Having spent time as a technician for the Department of Art, the artist decided to leave Bellingham in 1976. Instead of writing a letter or giving one of his typical pedestal sculptures to the University, the artist offered a work that went beyond the common idea of what was considered art. To avoid the familiar emotional response to a gift, he both used the standard artist/donor bronze plaque and gave new meaning to art literally and figuratively as a point of view.

C. A. Scott
(BORN 1940)

Things Are Seldom What They Seem, 1976

Bronze plaque, 8" h. × 10" w.
Gift of the artist, 1976. Campus signs fund.
© Charles A. Scott

C. A. SCOTT artist statement

Things Are Seldom What They Seem, 1970–76. A personal statement and a public statement. The public deserves both.

During the first half of 1970 I was finishing graduate school in Santa Barbara, California, in the area of sculpture. I was concerned with what I would do after graduation. I preferred a teaching job. I was asked by a friend to visit Bellingham, after graduation, for a period of rest. As the job market for art teachers had fallen prior to my graduation, I decided to escape to the Northwest for a period of adjustment. Within two weeks from arriving in Bellingham, I was offered a job in the Art Department of Western as departmental technician. I took the job as a means to an end. *That* end never arrived. Another end did take its place.

The piece is about my time in Bellingham prior to, during, and ending from 1970 to 1976. As I see Bellingham for myself as a place to contemplate rather than to be able to work in the manner that I wished, I choose to leave, study, and work elsewhere. I will return to Bellingham when I again want to contemplate.

The plaque with its statement is the piece. The placement of the plaque is also part of the intent of the piece. The words I have carried with me; I can no longer remember the source. It is not intended as negative or positive, just a statement from myself, to those who choose to listen. My close friends and students from the art department, my close personal friends and a few of the faculty will know my intent in making this piece here and giving it to the campus. It gives me pleasure that the campus [administration] has agreed to accept it and place it where I wished. I will now take another deep breath and walk away from the time and place that kept me for the *past* six years. <<

(Statement, November 12, 1976)

BRUCE NAUMAN

Similar to Holt and Morris, Bruce Nauman has created work that dramatically breaks down the barrier that had kept the viewer on the outside of an object. Just as Morris did, he has given the spectator a new role as contributor of meaning. Rather than offering a plaque as Scott did, Nauman elaborates on the idea of spectacle. He creates sculptural situations for the onlooker so that spectatorship requires a deeper commitment. What we expect based on other experience can become unsettling.

In thinking about what he might propose for Western's campus, Nauman became intrigued with the area of campus south of the steps between Parks Hall (College of Business, housing business and speech pathology) and the Environmental Studies building. Perhaps, this major staircase triggered the notion that this was the public's "front door" to the University or that this standard, cultural idea of front stairs could be further examined in a more individual way. Earlier, at his own university, he had concentrated on math, physics, music, and philosophy. Later, when he began to make his own art, he found a type of inclusive methodology in this rigorous background and parallels among the disciplines. For example, in both math and physics there were examples where reason was contradictory or broken in a supposedly logical field. He liked the composer Arnold Schoenberg's use of variations in a structure as a means

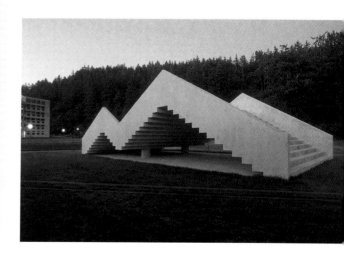

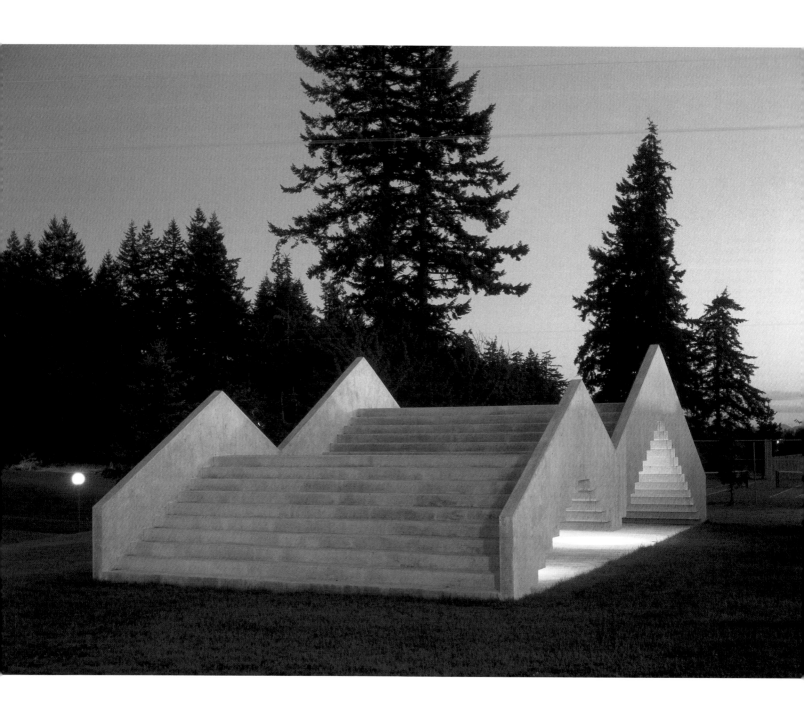

of timing. He appreciated the philosopher Ludwig Wittgenstein's ability to follow an idea to conclusion and his habit of including contradictory arguments in the finished thesis. He also admired his systematic process, which often included taking a step backward or also offering failed statements; and he liked his games, which allowed him to "find out what I was doing, how I was doing it." In Samuel Beckett's character Malloy he also found similar traits where the most ordinary, mundane human activities became important.[53]

Perhaps, the "front door" steps prompted him to remember earlier works or questions that could be freshly addressed in a university setting. For example, there is the story of the *Original Slant Step* (1965–66): When visiting a salvage shop, Nauman had noticed a strange wood and linoleum step that seemed to have the function of allowing shopkeepers to sit and/or to reach high places. When he closely examined it, he saw that it was actually functionless because of the degree of the slant of the step. He bargained for the slanted step because it exemplified the problems he was trying to solve in his studio. One was making art objects that appear to have a function, and another was to follow a philosophical principle that requires looking at things without preconceived notions. Nauman was interested in creating works that made the viewer think about what he knows and does not know, what he sees and does not see.[54] Most importantly, he wanted to invite the viewer to take a step or to become a performer.

At Western the "front door" steps are opposite the playing fields for students. Ironically, Western does not have an official stadium. While the University is strong in various competitive sports, students also enjoy the fields for exercises in theater, t'ai chi, Frisbee, and dog runs. When Nauman began to plan his work for Western, he knew the open fields would in the future become a new quadrangle including a Communications building, another academic building, and a multirecreational building joining the existing field track. So Nauman created *Stadium Piece* (1998–99), a structure appearing to be a series of steps but also having the qualities of a stadium or theater. The activity in a stadium or open theater takes place on the field; spectators on bleachers watch the activity below. Nauman liked the normal idea that students would use these steps as seats to watch the playgrounds or pedestrian and/or vehicular traffic. But he also knew that ordinary notions can be inverted. Therefore, he turned his stadium-like or theatrical structure upside-down and invited the stationary viewer to perform on and across a stepped structure that becomes a new type of playing field where everyone can participate. Playing on the variations of what is up or down, Nauman permits the spectators to face inward to each other or look at something—or nothing—on the way up or down and outward. While the steps can look ordinary, as something to bypass, the viewer himself has to make the decision whether to climb. The body remembers how to climb stairs but is suddenly forced to concentrate, and go more slowly as the normal ratio of risers to threads has been slightly changed.[55] Similar to the experience of facing a crowd or being alone, the climber discovers he is moving between private and public spaces. He pushes himself to the top where

Bruce Nauman
(BORN 1941)

Stadium Piece, 1998–99

Concrete, tinted white; approx. 12' h. × 25' w. × 50' l.
Gift of the Virginia Wright Fund.
© 2002, Bruce Nauman/Artists Rights Society (ARS), New York, New York

everyone can see him, then goes down, sinks quickly, almost out of sight to others, to his own private interior.

While on the exterior of the steps, our usual body movements can become slightly dislocated or accentuated. Raised on piers, the stepped structure also provides a lighted interior space that evokes the idea of spectacles on the one hand, or concealed movement on the other. It triggers our memories of all types of stadiums —the rules of the game—processional marches—or makes us think of underhanded and underground activities in cages. But where we are often in competition with each other, the light can shine. At night or twilight when the lights are on underneath the concrete structure, tinted white, the entire stepped shape echoes the snowcapped mountain ranges in the distance. Nauman's *Stadium Piece* embodies the student's learning to communicate individually or how to perform in a larger cultural memory or environment.[56]

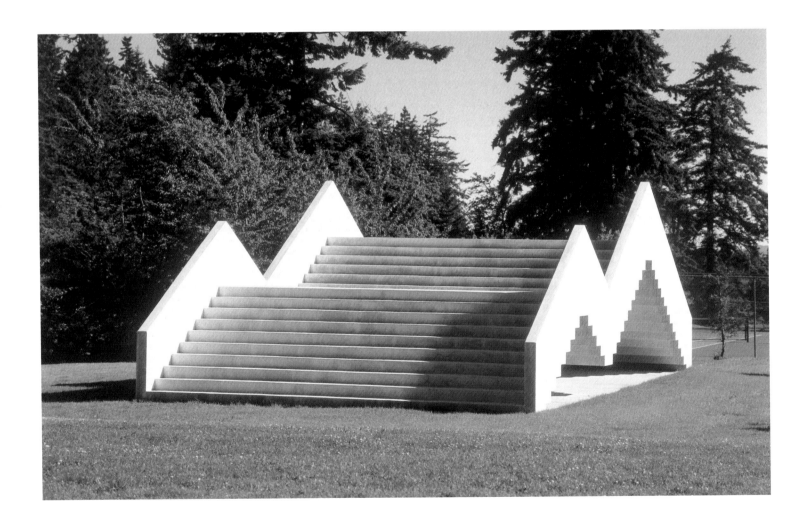

BRUCE NAUMAN artist statement

As to origins of *Stadium Piece*, I was asked to do a piece at the University of New Mexico at Albuquerque. The location that they had picked was in a plaza area that had a series of steps leading down into a big public area near the library and some other buildings. So, I thought about making a piece that would mirror the location. I made a more severe idea; it just went up and went down. You could climb on it and you could sit and face the library. It had quite a strong relationship to the existing stairway and you could walk under it. Anyway, they rejected the piece because it was a place where they played Frisbee and it was not useful for another structure. I ended up doing something else at the University of New Mexico. But I made a few plaster models of the idea for the piece. I also did some proposals for a version of the piece made out of standard rental bleacher equipment for a couple of locations in Germany for outdoor installations. Anyway, nothing was ever realized.

So, when the opportunity arose at Western, the concept for *Stadium Piece* really seemed to fit your situation. The general area had athletic fields with the track nearby; I also was trying to work with the idea of the future buildings proposed for the open area. So, I imagined that this could be a kind of stadium situation where there would be eventually a lot of traffic because of the new buildings, the existing track and practice area, and because one of the new buildings was supposed to be an athletic facility of some sort. I knew that there was going to be construction, so trying to imagine *Stadium Piece* in relationship to whatever configuration new buildings around it would eventually take . . . that was interesting to me. How it would change its function as the campus changed.

Some of the earliest drawings of *Stadium Piece* went to Germany. The earliest ones were much more severe. They were less user-friendly, let's put it that way. They were steeper and more stylized. When they were designing the new contemporary museum in Chicago, they sent me plans. Most of the entrances and the main entrance are at the corners of that building. I had an idea that the stairway could go up, go down and go up again to the "fake" main entrance. Anyway, I never proposed the piece as there wasn't enough room. But that was one of my thoughts . . . this up and down and then back up again. So, that movement worked into this situation in Washington.

A university is a little bit of a special situation because it is not like putting something in the middle of a downtown plaza or a shopping center where you really are dealing with an enormously diverse audience. I think that in a school you can do something that takes a little more effort. I think it can be more challenging in that situation.

When you do a large object in public, you have to take into account that it is going to get climbed, walked on, graffitied, and all kinds of activity so you allow the work to absorb that and still function. Those are things you take into account or learn to take into account. When you are in a gallery or a museum situation you don't have to allow for that.

The sense of fulfillment in making art is quite different from other activities. I have accepted few offers to make large outdoor sculpture, partly because the opportunities were not ideal for me and partly because of some really difficult experiences. In the seventies and later in the eighties, there were a number of drawings and pieces that were called models for large-scale structures that could have been built, but they were really excuses to make these large sculptures that were called models for larger underground pieces or constructions. It really didn't matter to me if they were ever built. And then later it became more important that it was possible to build them . . . that there might be some opportunity to actually do the structure. <<

(Interview and revisions, February 20, 2002)

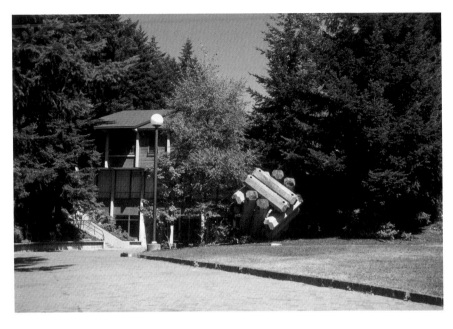

Fred Bassetti
(BORN 1917)

Alphabeta Cube, 1972

Wood and bronze, approx. 8' h.
Western Washington University Art Allowance
from Wilson Library, Phase II construction funds.
© Fred Bassetti

FRED BASSETTI

Although Nauman builds a structure on which students can watch performers or be watched themselves, he restricts total free play as an end in itself. Through precise measures he is able to control activity in order to ask questions about the nature of art, including the function of art. Fred Bassetti, like Noguchi, was interested in guiding the play activity of children. By 1960 Bassetti, in addition to having his own architectural firm, had started the Forde Corporation in Tacoma, which made "Flexagons," a cardboard toy. From the cardboard shapes with flanges, all kinds of objects could be made, such as rockets, stars, futuristic buildings, and geometric solids with numerous planar surfaces. Then, perhaps, there was no surprise when he built *Alphabeta Cube* in 1972 in front of Wilson Library. Echoing Noguchi's tipped cube series, including *Skyviewing Sculpture* (1969), Bassetti's sculpture is made of twelve octagonal redwood timbers enclosing a suspended bronze, 38-sided polyhedron. Placed between Wilson Library and Haggard Hall (the old science building), Bassetti decided to give his cube references to both buildings and to the idea of communication. He engraved the letters of the alphabet, numbers zero through nine, and mathematical symbols of pi and infinity on the bronze polyhedron. On the ends of the redwood beams he stamped contiguous letters in a cryptogram. When separated they spell out the alphabet and famous literary authors and characters from Moses to Jane Eyre, Ulysses to Huckleberry Finn. While he had seen a similar ad for National Library Week, he probably also knew about Noguchi's garden for the IBM Building in Armonk, New York. Here Noguchi had juxtaposed among other shapes, natural rocks with a black dome inscribed with mathematical formulas. Known for his designs of innovative playgrounds, Noguchi saw them as primers on shapes and simple functions such as uninhibited play. For example, Noguchi's *Play Mountain* (1933, unrealized) used the pyramidal shape as a way to

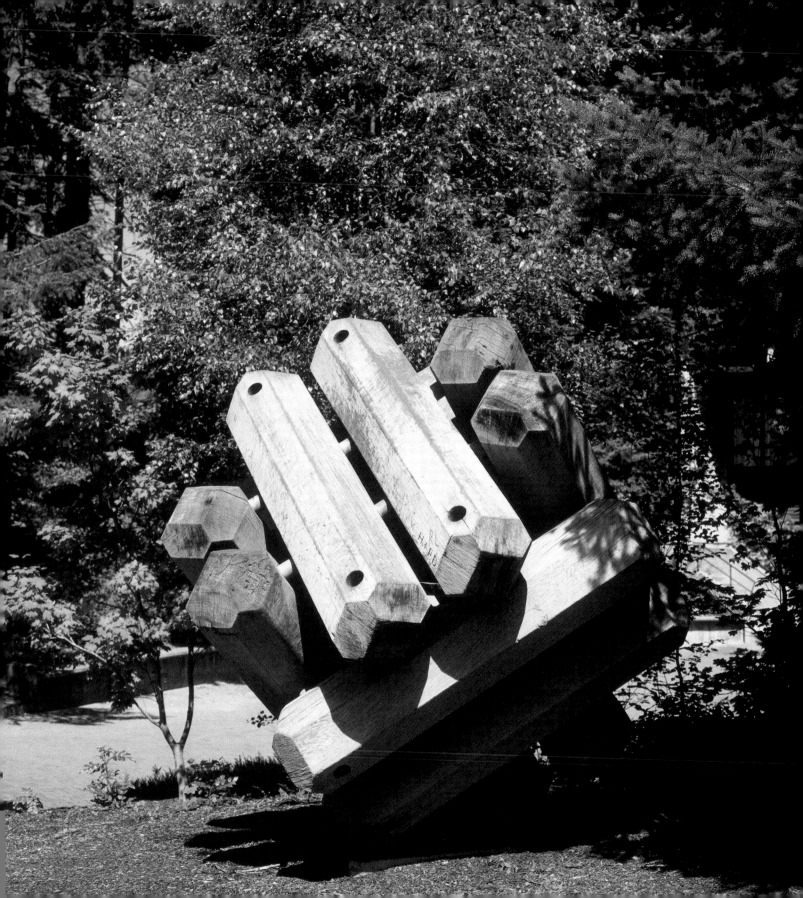

FRED BASSETTI artist statement

This work came into being when I was doing the design for the addition to Wilson Library. It seemed appropriate that something be said about language—about letters, words, and sentences. I happened to come upon the ad that the American Public Library Association wrote with the 26 letters of the alphabet. I was so taken with the idea of a library as a resource, as a tool for people trying to learn about the world, that I decided to use that ad in a modified form. I stamped with a little steel dye the association's statement on the end of one of the beams. Unfortunately it's gotten so weathered now that it can't be read. I felt strongly about the use of language and literacy and, therefore, wanted to pay homage to the alphabet and to the incredible usefulness that the alphabet gives us. I developed the general form of these twelve beams together in this rather unusual shape and called it the *Alphabeta Cube*. This shape was a means to put the bronze polyhedron—which has letters, numerical digits, and the symbols for pi and infinity—in the center. Then, placing the sculpture in front of the library seemed appropriate to me. It is not obvious that the letters are there, but if anybody goes and happens to look in, they will see them, and think of the significance of language.

Just as the cube that Noguchi cut and drilled, from which he made a "sky viewing sculpture," has a geometric interest, this one has it also. The shape is arbitrary, but it also has a natural quality. Each of the pieces of redwood is cut from an old growth timber, from the heartwood. I knew that kids would inscribe their initials. I hoped that it would take on the patina of time and mean something to the kids who have passed through there, looked at it, touched it, and even carved in it.

I did consider using bronze, but there was only $5,000 in the budget and I couldn't have done it with that. It would have cost $50,000 in bronze. I like the contrast between the weathered bronze inside and the weathered wood outside. I think it is appropriate in wood in that it is very heavy and very solid. If somebody tried to burn it down they couldn't do it. It would burn out and it would just get a surface crust that would be burnt ash. You could cut right into the middle of one of those timbers and it would be the same all the way through.

I have made several other designs and this is the only one that has been built full size. I did make other sculptures in that same form out of crystal and plastic—Plexiglas—which were given to Allied Arts for an auction quite a few years ago. But that was done on a smaller scale to hang inside a house and to refract the light as the sunlight comes through the window. I have since made others in glass that are purely refractive and other designs in bronze.

The site for *Alphabeta Cube* had to be around Wilson Library. Richard Beyer's *The Man Who Used to Hunt Cougars for Bounty* is on the side of the north entrance, so I chose the south entrance. The artwork and the site all tie together, and I would want it to relate to a building and its surroundings. You would consider what the piece is going to say, what interpretation you would like to place on it, what effect it would have on the students and faculty, or the public at large, that might go by there. I feel that the site is important, as in the Noguchi sculpture, and it should have a focus so that whatever energy the piece itself gives off, it is enhanced rather than diminished. In its new location away from the library much of the relevance is gone.

I don't believe in talking down to the public. The public is perfectly capable of responding to abstract work or work of almost any type, provided the work is done with sincerity, integrity, and skill. It seems to me that when the work is dashed off haphazardly to make money, which has happened, then, the public is often dissatisfied with it. I think that there is a lot of charlatanry in art, as in everything else. But the public has shown quite good sense. There is always some person who will object that the particular work has no meaning. You could go out and speak for motherhood and God, but there is always going to be somebody who is going to object, regardless of what you do.

As an architect, I have tried to do works with artists from the inception of a project. In practically every project where there was a prayer of getting some money for art, I have tried to convince the owner that he should put something in his budget for art. Ideally, you should work with the artist as early in the game as possible. However, long experience has taught that it is almost impossible to start out with an artist right at the beginning, because there are so many changes, so many variables that enter into the creative process of the building. The creation of the artwork has to come along later after the general parameters are laid down. It takes several years sometimes before the main outlines of a building are established. For example, half the time we don't know where the entrance is for quite a while. I have worked with Rich Beyer down in Seattle, with Noguchi at the Federal Building, and with others at Gateway Tower, a ten-year job.

As to other ideas I had for Western, there is a symbol for engineering. I still have a little model of it on my desk. Many years ago when I was in Bellingham, I ran down to the waterfront along the docks and saw a bunch of aluminum ingots of a rather unusual form. They were very heavy, very large in relation to the material, but marvelous objects of beauty. Then I made a little model in miniature scale for a work 15 feet high, either in aluminum, bronze, black basalt, or glass. But I thought that this design would be good to put outside an engineering building where kids studying engineering might see it and think in terms of the basic materials that they would use throughout their careers. I was thinking of a way of emphasizing the beauty of materials, which grew out of that chance observation of those aluminum ingots. <<

(Interview, June 25, 1991; revisions, December 13, 2001)

teach children about the ancient world, art, and architecture. Of interest is the fact that Noguchi's *Skyviewing Sculpture* is placed next to Miller Hall, the old campus school for children, and adjacent to its addition, now the College of Education.[57]

When Haggard Hall was remodeled as an addition to Wilson Library, the University consulted Bassetti who chose to move his sculpture in 1990 to Fairhaven College, known for its independent, interdisciplinary studies. In its original setting, Bassetti's cube made connections with Noguchi's interest in futuristic technology or contrasted with Tibbetts' totem to the recycled machine. With the original context of the library unavailable as a setting, the intent of Bassetti's sculpture becomes clearer as an educational toy. While his redwood sculpture is naturally congruent with the material of Fairhaven's buildings and wooded setting, its placement across from the college's childhood development center's playground seems more telling. This is where kids acquire their personalities; some later in life even stamp their personal signs on trees. Just as the letters of the alphabet are a writer's building material, the shapes and materials of Bassetti's sculpture are those simple building blocks for children, for future architects.[58]

RICHARD BEYER

Richard Beyer's earliest commissions stemmed from contacts with architects. At Western, Ibsen Nelsen used Beyer's services as a bricklayer and as an artist. Having created a small round fountain of carved brick for Seattle's Woodland Park Zoo (1968), Beyer was asked to make the bases for the Noguchi sculpture. In the late eighties he was commissioned by Mutual Materials (Bellevue, Washington) to do a work called *The History of Bricklaying.* At Western he also was given the opportunity to suggest a relationship with *Einstein among the Crows* (1970) on the porch of the addition to Miller Hall. Silk-screened on the tile pavers, the head of the scientist and several crows are placed on the porch floor, which leads from the building's interior courtyard out into Red Square. Beyer's subject suggesting the good and bad sides of creativity contrasts with Eric Nelsen's ceramic

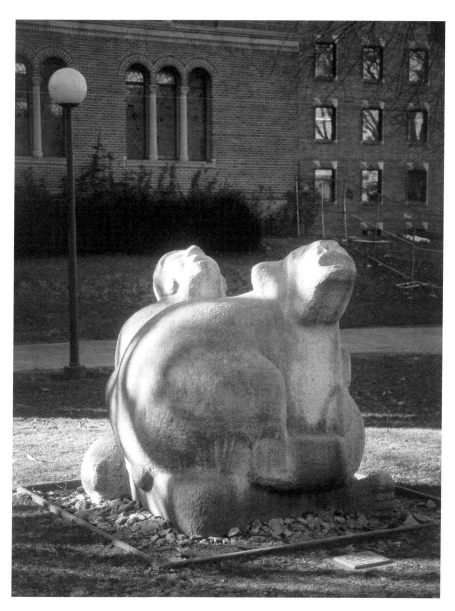

Richard Beyer
(BORN 1925)

The Man Who Used to Hunt Cougars for Bounty, **1972**

Granite, 5'6" h.
Western Washington University Art Allowance
from Wilson Library, Phase II construction funds.
© Richard Beyer

In the process of building the Western Washington University campus, there was a very innovative, intelligent fellow [Barney Goltz] who subsequently went to the legislature as a significant Democrat. For the most part, he instituted and encouraged collecting art, which was a pretty innovative program at that time. So he approved the architect for the addition to Wilson Library and the concept of using a percentage of money—and this was before it was legislated or at least before the arts commission got into the business of setting up a systematic way of selecting artists. The architect Fred Bassetti proposed two pieces of art—his on one side of the library and my idea on the other side. So I don't think anybody really knew what was going to happen when I had a big stone brought in from California and plunked it down. Then we moved up to Bellingham and went to work. My son, son-in-law, and a friend hammered and pounded the stone for about three months with jackhammers. It is beautiful up there in the fall when the trees turn yellow and when beautiful gray mists occur in the morning. The evenings are long, pleasant, and quiet. On the library piece we were running the compressor and hammering until eight or nine at night. After school started, there were complaints that we were disturbing the students.

People want to know how much it costs, how much it weighs, how long it took, and so on. All of these grand irrelevances help people get into what is trying to be said, but it is also used as a way of not saying things that are before them. My approach is to find the original concept —that is, old man hunted cougars—and to create an appropriate design for the Western Washington University campus. I fished through the library reference books for early Bellingham stories and found a story of this guy who hunted cougars. It was in a book called *Far Corner*. I believe it is available down at the historical museum and done by a local woman who went through the newspapers to tell the story of Sehome and Bellingham. One of my concerns is this: Is it worth being specific and dealing with the experiences of a locality—its architecture, forms, and feelings—rather than the work coming down as an international style from heaven for stupid humanity with another one of our shafts of genius? So, we dig around in the local stories or history to find a story that has some meaning. The form develops around the story. Once the form was made into a model and we had gotten the blessing from Bassetti, then, we just proceeded to order the stone from California, shipped it up and put it in place. We brought our compressor and went to work to try to pummel the design as best we could out of stone in terms of the model.

I will tell you my version of the story: There was this fellow who lived on the upper campus years before it was expanded and whose profession in Bellingham was to hunt cougar for bounty. He got $35 for a pair of ears, or something like that. So it was a good deal. I suppose he had dogs and was pretty professional. He worked for the state, so he was pretty well off. On long summer evenings, like that evening I was telling you about when we were working up there, with the golden trees, gray

luminescent fogs, and terrible quiet, you could hear him and his dogs way across the lake. Even back up in the woods the dogs barked and you, then, heard him shouting at them; and, finally, you heard the shot when they got the cougar out of the tree and they brought him back. The money had much more value than it has at present so that $35 would last a week for beans, canned milk, and whiskey. Well, that pretty vigorous life gave out. His lungs broke, he took to drinking more, and he sold his dogs. During the last days of his life, he would sit up on the porch of his cabin overlooking the lake and forest beyond where the cougars had been. The cougars are all gone now, they are all dead or away, and, finally, in his disillusion we have this ghostly re-meeting when a man and a cougar reconcile. He has the cougar on his lap, they both are drunk—there is a whiskey jug down in the corner of the statue— and they are singing "America." That is a true story!

The issue here is how the international style—a Brancusi or a Noguchi— comes off with these vapid, abstract formal symbols. I guess we have the basic problem of trying to choose between the universals and the particulars. I would elect local traditions; it is another way of dealing with wisdom. In the Bible you have Jesus telling stories, using words; then, we try to interpret it again and again as human relationships. The dictatorial or abstract or formal way has gotten us into a world of technological competency that makes us feel irrelevant and certainly helpless in the face of the terrible things that the state has done and congratulating itself for them. I can play that abstract game, but I really think it is a shuck. I understand the relevance of it in terms of our community, but as far as art is concerned it is still a shuck.

Some of today's art words seem so much a part of the whole bureaucratic consumption of art. Nobody was really concerned with fine ideas like site selection at that time. We were trying to put the thing where it would have some presence and challenge us to do the work. It is like an earth and a moon, with a Bassetti sculpture on the other side as the companion part of my work. In fact, Bassetti designed it and, then, asked me to make it for him, so we produced his sculpture. He had somebody else do the casting, but we did all of the lumber work. So the two sculptures are really binary planets. Bassetti wanted the front of the building, and the back of the building was fine as far as I was concerned. I like that green space where people can enjoy the grass, those pretty trees, and the shade on hot days. An interesting kind of thing, this feeling for the green grass in relation to the weight of the stone was just terribly important. If we had been working on that nasty concrete on the other side—the front—that would have been a different matter altogether. This kind of wonderful distance in talking about site selection doesn't tell a story.

Concerning the question about any development of a series of images, I see it really in terms of the brutal process of having to make these damn things and some money to rationalize doing it. Generally, the thing in art is not so much the art itself as it is the brutal business of making it. Some of us can get terribly clever in concept art where you don't have any kind of commitment, or other people can talk >>

>> enough money out of clients so that they don't have to do the work themselves. For example, Noguchi just made a little cardboard model and gave it to Ibsen Nelsen; they manufactured the thing in Everett, brought it up and put it there. I would like to set my piece off against Noguchi's piece of art as a couple of thrusts in the world in which we live. I can say awful things about the Noguchi sculpture that nobody would ever say. I would have to say that I more elegantly conceived my thing, and yet I would insist upon a certain genius or truthfulness that I think is probably lost in the Noguchi. As a matter of fact, I made the brick splint that his sculpture stands on too.

It was Ibsen Nelsen who put that sculpture up. He built a number of the other buildings, and, once again, this was at a time when the architect for the building and the grounds pulled it together to do something significant rather than make a collection. Public art is not to be collected. It is a matter of places and people and the artist giving some kind of life, meaning, depth, and interpretation of those places.

I don't know if there is a way to work out the complexity of the whole problem in this question of what is public art. Our art schools teach us a sort of superiority of the artist, and he takes a different role. An artist is put up on a plinth in a large measure and then honored. The state is now getting to meddle around in the art market and is pushing this kind of disease on the order of socialist art, as in Russia. The artist is co-opted to legitimize the state or authority. So, who is the public? The public is somebody that is used by this authority, manipulated and pushed around in this whole process. As artists, we are largely being sucked into all of this business by state money and the state's bureaucracy into being something other than we are. I guess you could say in a large measure that this is one of those fundamental paradoxes or problems in all of social life—either profit or priest. What do the priests do but take the profits or gifts and turn them into the business of organizing, and, then, you need another generation of profits. It seems to me that art is this gift at its best. But the authority would use it to justify itself, and I can't be a part of that in my works. So who is the public or to whom do we think we are talking? Anybody who will be responsible for themselves, be open to possibilities, and not fall into these scams. As artists, we try to talk about ourselves in both positions.

I call my work community art, and I think of it as a social service. There is a role or a necessity for art in a community and, then, given the demand of time on each one of us, it is a special division of labor. We could make out of art another ground for society rather than technology. We know that supply exceeds demand. We have our creativity and are frustrated by the demands of the economy. Honest young people get to play the game a little bit, but then they generally drop out. Who hangs on as a way to make public art a service, like medicine, banking, or the military or the religious service? Art falls out as a thing to be played with by people who have money and power, and we poor artists play the game with them in denying the social possibility of art. We need some vision of art as a way of peoples interrelating and expressing themselves rather than serving the status quo. The public is all of us, and our problems are all hung up together. Given a talent with form, including that in an architectural situation, then, I guess you can make public art and share the news.

About my tile work, *Einstein among the Crows* . . . essentially that is a matter of Einstein being one of the great, gifted, generous people, and I am thinking of using his gifts, his creativity, and so on to make bombs. That idea came from the 5-cent stamp. We also had a crow in a cage behind the house. I silk-screened a black chemical on a tile fired at Mutual Materials. The architects Bartholick, Bassetti, and Nelsen gave their hearts as they were making the campus as beautiful as it is, and it is just phony for the artists to try and set themselves out and away from the campus. The environment is what gives us a degree of presence. <<

(Interview, July 12, 1991)

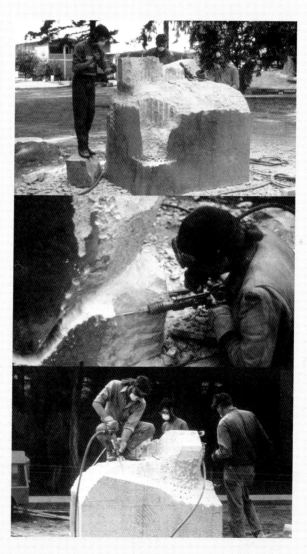

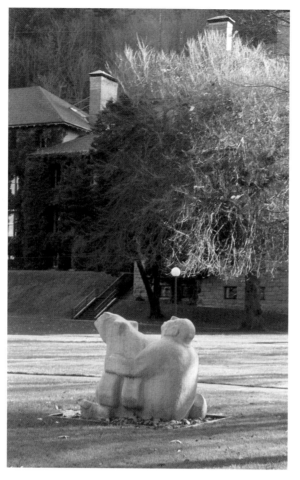

tiles depicting symbols of peace, longevity, and divine inspiration on the walls of the Environmental Studies building.

From Madison Park in Seattle to the Warm Springs Confederation Tribal Headquarters in Oregon to a sister city in Tashkent, Uzbekistan, Beyer is best known for his three-dimensional sculpture, which tells stories about communities of people and their daily lives in particular places. Just as he is interested in the full range of human behavior, he most often uses animal symbols or humans in relation to animals. For example, he has created works around the myths of ancient civilization's Romulus and Remus, the Northwest's Sasquatch, Native American dog-like Hywaco, and for Western Washington University, Sehome Hill's *The Man Who Used to Hunt Cougars for Bounty* (1972). When Bassetti remodeled Wilson Library, he commissioned Beyer to create a work across from the north entrance on the original side of Wilson Library facing Old Main lawn. From a large granite stone Beyer and his family crew carved a legend about an old man who hunted cougar in the forests of Sehome Hill, and their relationship as hunter and the hunted. Over the years interpretations have focused on the sympathetic relationships man develops in old age. Today, given the decline of the cougar in some areas, the reappearance of the animal in other places due to suburban sprawl, the controversy of hunting in general, and the transformation of the forests of Sehome Hill into an arboretum, Beyer's work is usually interpreted from an ecological viewpoint. In a recent statement even the artist himself has changed his emphasis.

TOM OTTERNESS

Tom Otterness and Beyer share common ground not only in their skills in engaging the public but also in their interest in types of narration. Since Otterness' *Feats of Strength* (1999) has come to the University, one cannot help but look again at or revise formerly held opinions about Beyer's troll-like "old man" and Osheroff's and Melim's Disney-like animals at the Ridgeway Complex. Otterness enlarges his character sketches beyond Beyer's native folklore to create a narrative cycle in Haskell

Eric Nelsen
(BORN 1954)

Ancient Life Symbols, **1975**

Raku-fired ceramics, 36 tiles,
each 12" × 12"
Funds from Washington State
Arts Commission
© Eric Nelsen

According to the artist, "The motifs interpreted in the tiles are referenced by the religious and cultural iconography of peoples of numerous distinct traditions." (Excerpt, January 2002)

Plaza where global references reverberate. While Otterness works in bronze on the same small scale as Osheroff's and Melim's ceramic figures—beaver, fawn, or owl—he goes beyond these artists/craftsmen to change the role of decorative scale. Rather than using the typical monumental scale of public art, he miniaturizes his figures, but he still gives them the same seriousness of most allegories found in large stone monuments in public squares. He embraces the fantasy scale of Disney and Looney Tune Cartoons, but places the viewer not in front of a distant cinema screen but rather seats them directly at tables or in table-scapes.

On campus, Otterness watched the constant pedestrian traffic as well as the leisure activities of Haskell Plaza while sitting at times on one of the sandstone rocks and at other times on the concrete ledge of the inner circle. At that eye level, he could see the plaza or landscape more like the surface of a table before him where, like a child, he could move his characters around. In his work for Western, *Feats of Strength,* Otterness placed one figure on the ledge where he himself had sat; the moon-eyed figure holds a rock as if it were a moneybag. In some cases the ledge acts as a frame or is contiguous with the grassy mounds where students sun themselves; here, Otterness placed one of his laid-back figures. At other places the sandstone boulders on the mounds reach over the concrete ledges; there, Otterness tucked some figures working under the rocks. Within arm's reach of the ledge where the viewer sits, he also placed a group of figures carrying one of the boulders out into the middle. Also separated from the other sandstone boulders, the landscape architects had placed a

granite rock at the request of the Geology Department. Finally, Otterness built a female Atlas-type holding a boulder on top of one of the largest rocks where students rest their backs while reading, thereby confronting the gender issues often implied in the work of Morris, Pepper, or Serra.

Since the eighties, Otterness has put his figures in complex scenarios of human behavior ranging from themes of birth and death, time, labor and money, class struggles, to engaging in battles of good and evil, including Utopian nature and postindustrial destruction. At Western Otterness found the landscaped plaza by Campbell & Campbell. They had excavated and utilized the sandstone boulders that had been submerged in the ridge that now holds the Chemistry and Biology buildings to create a plaza replicating on a miniature scale the San Juan Islands beyond the hillside University. Otterness' figures intervene to perform feats around these once submerged rocks on the plaza. When he was executing his "colossal two feet turned upside down as bench" for the Krannert Museum in 1994, Otterness had remarked that "the idea of a submerged monument is a metaphor for the mysterious or unknown part of society—maybe like a past society or a future society."[59] Using the Museum of Natural History in New York as his college, Otterness had become fascinated with archaeology and its buried monuments, fragments of memory.

Haskell Plaza is surrounded by the academic buildings dedicated to the sciences, technology, and business. On a whimsical level, Otterness' seven small-scale bronze figures lifting and pushing rocks and/or sitting and lying on a ledge seem to be the faculty and students simply working and relaxing in this University setting. But Otterness also found in the plaza two existing sculptures: Beverly Pepper's *Normanno Wedge,* a monument to tools, and Lloyd Hamrol's *Log Ramps,* a structure referring to natural resources and indigenous peoples. Therefore, on a more serious level his vignette reinforces the idea of natural and cultural forces at work in the region today. The small scale of his vignettes calls particular attention to the overwhelming forces of

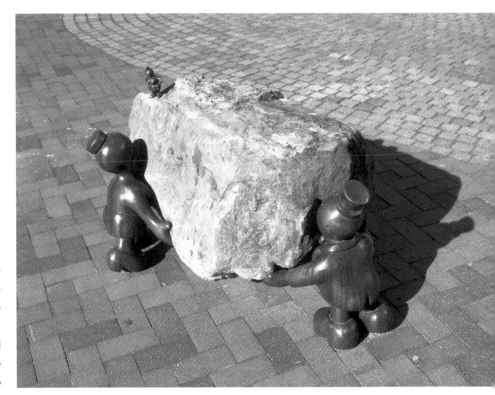

TOM OTTERNESS artist statement

When I was first invited to the campus, I had a blank slate as to what I would be doing. I walked through the whole campus area and came across the plaza where *Feats of Strength* was eventually placed. I found the plaza really engaging, both the design itself and the way the students were using it. My work was in response to what I saw there. I sat around for the afternoon and drew sketches. I watched how students sat on the stones and slept; how the light fell across the plaza and in what direction; what the main gathering points were; and where the traffic was heaviest and what this traffic flow was like. I built my drawings of both students and placement of figures and boulders in that one afternoon.

I initially liked the plaza's abstract representation of a landscape. I liked the idea of layering on top of the plaza a kind of a fiction of how it was made, a little architectural creation myth. These are the small bronze figures dragging the stones around and moving them into place. I think closer to the time when I made it I would have described it more literally. Now I see it as a three-layered abstraction where one layer is the architectural work that was there before I began. Another layer is the semi-reality of these bronze characters and an invented kind of making of that plaza that already existed. Then, the third layer would be the viewer walking around.

At the time I worked on *Feats of Strength,* I also was designing *Rock Man* in Minneapolis. One project would influence the other, back and forth. For the Minneapolis piece, I made both the figures and boulders out of bronze and animated the boulders. For Western's work, I advanced the idea in that I used the real rocks. At Western, there's a real conviction about their weight and their reality, that these little figures have really picked up a 2,500-pound rock. I guess that idea then carried forward to the work I did with Maya Lin at the Cleveland Public Library, where I had the figures pick up the garden gate itself. It has been a continuing process of trying to give this Mighty Mouse strength to small bronzes, and this was the first step in picking up something literal in the "real" world. *Feats of Strength* would have been a completely different work at any other site on Western's campus. The original site was a fascinating design with the blend of the artificial and the natural and this representation in miniature of a larger context around Bellingham, around Western Washington.

I used to have a studio practice that was very independent from public work. It had sexual content that was more overtly problematic. Because of my own interests my public work gradually has become the center of my studio practice. The challenge I think is to carry the same kind of eccentric, personal needs that an artist has about making work, to carry that into public commissions and to find a way to bring that together with all these other contextual problems that come to you with a commission, such as the locale, the regional sensibility or aesthetic. I often do a subject-specific work that tries to make subject matter specific to the site where the work will be. So, it becomes a wild collaboration, sometimes a surrealist collage among committee members, federal judges, myself, politicians, or the situation itself. A commission brings into my studio these unexpected avenues and subjects, even wilder than the ones I might have dreamed up on my own. <<

(Interview and revisions, March 11, 2002)

nature—in this case, various kinds of rocks—as well as the ongoing feats and the hopeful intelligence of man.

When Western's sculptures are placed in new contexts, entirely new narratives can be read. In Haskell Plaza, Otterness' sculpture exists together with Pepper's wedge-shaped sculpture and Hamrol's ramps. Turning all the way around, the viewer can see the past in geologic history, the primitive tool, and the primary log structure. He can see the present referenced by the inhabitation of the region and islands, both the real and the miniature version; and he can see the future in the intertwining of natural and man-made resources on this University campus.

CONCLUSION: THE RENEWED CAMPUS

Architects and landscape architects have also responded to the history of our buildings and sites, carefully considering the future potential of the site and the refinement of the campus master plan. Their solutions have taken into account regional landscape, from Bassetti's Craftsman-style Ridgeway Complex on a treed hill with ceramic animal figurines to Campbell & Campbell's understanding of our campus geology as well as the geology beyond. This means the relationship of art, architecture, and landscape is evolutionary and ongoing, allowing for the give and take of public space and, most importantly, the additional layers of meaning and texture. Each work is one point of view that assists us in this overall construction of many possibilities. And so, for example, FitzGerald and Abakanowicz have given us our trees. Our mountains are found in Hamrol's log eruption and Nauman's white jagged steps at night. Our islands appear in the bird sanctuary on the Old Main lawn as well as being seen from Trakas' viewing station. They occurred in McCafferty's now vanished berms and Aycock's "island of rose apple trees" as well as the populated version of the San Juans by Otterness. Our fountains, begun by FitzGerald, have been continued by Morris and Aycock and by the constant play of water and mist in the Pacific Northwest. The result is that we have many different types of walkways and "rooms" that reflect an interdisciplinary field of operation in a campus known for its art, architecture, and landscape.

Future Projects

Western Washington University occupies a 190-acre hillside site overlooking Bellingham Bay, the city of Bellingham, the San Juan Islands and the north Cascade mountains. The University opened its doors as a teacher training academy in September 1899 and now enjoys a national reputation as one of the finest master's-granting institutions in the West. More than 12,000 students pursue studies in fine and performing arts, arts and sciences, business and economics, education, the environment, and interdisciplinary self-designed majors.

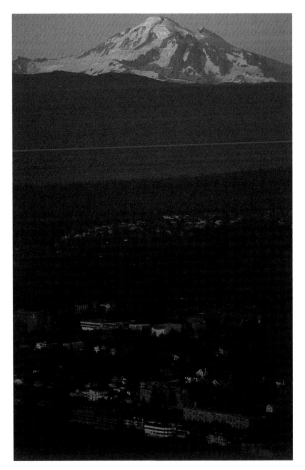

The Outdoor Sculpture Collection Advisory Board actively seeks partnerships with private donors, foundations, and state and federal agencies to provide a wide range of art. David Ireland, a native son of Bellingham and prominent Bay Area artist whose installations extend to the east coast, British Isles, and Europe, has recently been selected to make a proposal for a sculptural work. Continuing into the future, these sculptural proposals and completed projects will enhance our campus as a thriving site for intellectual pursuits as well as bring further excellence to our regional and national art communities.

Notes

1. For characteristics, see Planning, Facilities & Operations, "Western Washington University Character Study Charrette Summary" (Bellingham: Western Washington University, January 2000): 9; Jack Petree and Brett Bonner, "Making the Grade," *Washington CEO Magazine, Supplement* (January 2000): 3.

2. In 1966 Western had won first place for Fred Bassetti's Ridgeway Complex in the competition on college housing from the U.S. Housing and Urban Development Department; the dorms were also highlighted in *Fortune Magazine*. In 1969 the State Arts Award was given to Western for its "high quality of campus planning, architecture and sympathetic incorporation of works of art as integral parts of the plan." In 1969 Western installed Isamu Noguchi's *Skyviewing Sculpture*. Barney Goltz, director of campus planning, prepared an official statement on the university's program in 1970 to the American Institute of Architects in Seattle. When the percent-for-art law was discussed at the state level and passed in 1974, Senator Barney Goltz was instrumental in demonstrating Western's model.

3. Barney Goltz, outgoing director of student activities, had championed the student's work. Although the architect Fred Bassetti had also chosen some student work for the interior of the Humanities building, support for permanent student work died down after the erection of the Noguchi sculpture.

4. For Morris' speech, see Robert Morris, "Keynote Address," in *Earthworks: Land Reclamation as Sculpture* (Seattle: Seattle Art Museum, 1979). Participating in the Earthworks Symposium were: Peter Harvard from Jones and Jones Architects and Landscape Architects; Richard Haag from Bassetti and Co., Seattle; Grady Clay, Editor, *Landscape Architecture*.

5. For the Campbell & Campbell controversy, see Vernon Mays, "The Tale of Two Campuses," *Landscape Architecture* (October 1997): 92–99. Campbell & Campbell not only wanted to place boulders around the base of the Pepper sculpture but they also suggested other places for the Otterness sculpture, such as the corner or far entrance walkway to the plaza between Parks Hall and the Biology building. If there was to be other art in the plaza, they wanted to select their own artist, such as a well-known glass artist for the light fixtures. The letter to the landscape architects was crafted by the Curator of the Outdoor Sculpture Collection, the Dean of the College of Fine and Performing Arts, and the Provost; see Outdoor Sculpture Collection Archives for correspondence during March and April 1997.

6. For quote on art walk, see Mays: 96.

7. Quote from author's interview with artist, July 3, 1991.

8. Caro's sculpture at Western is in a brick-paved courtyard surrounded by roses; the brick pavers are built up so as to slightly raise the sculpture from the ground in order to deter visually impaired viewers from running into it. For references to Michael Fried's analysis of Caro's figuration and syntax, see, for example, Christopher Andreae, *Anthony Caro: The York Sculptures* (Boston: Museum of Fine Arts, 1980): 11–14; and David Cohen, "The Last Modernist," *Sculpture* (January/February 1995): 26.

9. Caro has consistently spoken about these issues with Phyllis Tuchman; see Phyllis Tuchman, "An Interview with Anthony Caro," *Artforum* (June 1972): 56–58; Tuchman, "Sculpting Space," *Sculpture* (October 1997): 23. See also Cohen: 30; and "Anthony Caro—A Discussion with Peter Fuller," in *Anthony Caro,* by Dieter Blume, Catalogue Raisonné, Vol. III (Cologne, Germany: Galerie Wentzel, 1980): 32, 44; Michael Corris, "Sir Anthony Caro and His Critics," *Artforum* (March 1992): 65. The clearest revisionist statement on Caro and architecture is Paul Moorhouse, *Anthony Caro. Sculpture towards Architecture* (London: Tate Gallery, 1991).

10. Hilton Kramer, "Art: Anthony Caro Adds New Forms," *New York Times,* May 6, 1977. *India* was on the cover of the brochure for this André Emmerich Gallery exhibition.

11. For quotes, see Tuchman, *Artforum* (June 1972): 58; Diane Waldman, *Anthony Caro* (New York: Abbeville Press, 1982): 104; Karen Wilkin, Text, in *Caro* (Munich: Prestel Verlag, 1991); Lilly Wei, "The Prime of Sir Anthony Caro," *Art in America* (September 1994): 96.

12. For quote, see Donald Judd, "21 February 93," in *Donald Judd—Large Scale Works* (New York: Pace Gallery, 1993): 9.

13. Judd's work had been seen earlier in 1971 at the Western Gallery in an exhibition *Contemporary Sculpture from Northwest Collections* (also work of Caro, di Suvero, and Morris). This exhibition also included *Fifteen Planes* by David Smith. This work was placed outdoors for a short period during 1971 on loan from the Virginia Wright Fund; Virginia and Bagley Wright subsequently lent Tony Smith's *Wandering Rocks* from 1975 to 1981.

14. For quote on temporal nature, see John Coplans, Interview, in *Don Judd* (Pasadena, CA: Pasadena Art Museum, 1971). For discussion of European rationalism, see Robert C. Morgan, "Rethinking Judd," *Sculpture* (April 2001): 33–34; and Rosalind E. Krauss, "The Material Uncanny," in *Donald Judd: Early Fabricated Work* (New York: PaceWildenstein, 1998): 12. For quote on "existential universe," see Prudence Carlson, "On Judd's Equivocal Objects," *Art in America* (January 1984): 114.

15. Krauss, "The Material Uncanny": 8–10. For Smithson's quote, see Robert Smithson, "Donald Judd (1965)," in *Donald Judd: Early Fabricated Work* (New York: Pace-Wildenstein, 1998): 15.

16. See Lauretta Vinciarelli and Donald Judd, "Courtyard Building for Donald Judd Installations," *Arts and Architecture* (Winter 1981): 37. For relationship to Greek temples, see William C. Agee, "Donald Judd in Retrospect: An Appreciation," in *Donald Judd. Sculpture* (New York: Pace Gallery, 1994): 16. Richard Francis also commented on Judd's relationship to Edens Hall in a letter, December 29, 1995; see Outdoor Sculpture Collection Archives. After leaving his position of contributing editor to *Arts Magazine* (1959–65), Judd continued to write; for Judd's own statement, see Judd, "21 February 93": 13.

17. Maki's first of several major commissions was for the Seattle-Tacoma International Airport (1971–73). The architect Bassetti also made a proposal for this competitive commission. In celebration of its 100th birthday in the year 2000, Western named Maki as one of its significant alumni of the century.

18. For drawings, see *Robert Maki: Sculpture Projects* (Winston-Salem, NC: Southeastern Center for Contemporary Art, 1978): 10.

19. Folke Nyberg, who had earlier worked with Aalto, was part of the design team for Western's dormitories.

20. For quote, see Eric R. Davis, "Extended Vision. Richard Serra Talks about Drawing," *Art on Paper* (May/June 2000): 61.

21. See Carol Rosen, "Sites and Installations. Outdoor Sculpture Revisited," *Arts Magazine* (February 1990): 68. The photograph in Rosen's article was taken before the construction of the Chemistry building.

22. For comment on bouncing ball, see Martin Schwander, "Interview with Richard Serra," in *Richard Serra Intersection* (Düsseldorf: Richter Verlag, 1996): 96. For comment on pragmatism of architects, see Mark Simmons, "Richard Serra. The Coagula Interview," *Coagula Art Journal* (November 1998); and Aruna D'Souza and Tom McDonough, "Sculpture in the Space of Architecture," *Art in America* (February 2000): 86–87.

23. For three of the best essays on this issue, see Douglas Crimp, "Richard Serra's Urban Sculpture: An Interview," *Arts Magazine* (November 1980): 118–19; Crimp, "Serra's Public Sculpture: Redefining Site Specificity," in *Richard Serra* (Stuttgart, Germany: Verlag Gerd Hatje, 1987 and New York: Rizzoli International Publications, 1988): 26–39; and Hal Foster, "The Un/making of Sculpture," in *Richard Serra* (Cambridge, MA: M.I.T. Press, 2000): 175–200.

24. Martha Buskirk, Essay, in *Richard Serra Intersection:* 47–71.

25. For the two best essays on this issue, see Donald Kuspit, "Richard Serra, Utopian Constructivist," *Arts Magazine* (November 1980): 124–29; and Crimp, "Serra's Public Sculpture": 26–39; also in *Richard Serra* (M.I.T. Press): 147–73.

26. Dore Ashton, *Noguchi East and West* (New York: Alfred A. Knopf, 1992): 271.

27. Isamu Noguchi, "Recent Works for Ibsen Nelsen & Associates of Seattle. 'Ibsen Nelsen as a Friend'," *SD (Space Design),* Tokyo (December 1976).

28. Ashton: 165.

29. For development of "cubic pyramid," see Ana Maria Torres De Torre, *Isamu Noguchi. A Study of Space* (New York: Monacelli Press, 2000): 290, 294–99; for work at Yale, see 118–27. For relationship to dance, see Ashton: 54; and Robert Tracy, *Spaces of the Mind. Isamu Noguchi's Dance Designs* (New York: Limelight Editions, 2001): 24–25.

30. Torres De Torre: 27 (figure 8), 268–69, 293. Several models were made for Noguchi's *Skyviewing Sculpture,* which was fabricated by Bakken Iron Company, Mountlake Terrace, north of Seattle. Mary Randlett's photographs of Noguchi's installation at Western were shown at his gallery, Cordier and Ekstrom, New York City, 1970.

31. Isamu Noguchi, *The Isamu Noguchi Garden Museum* (New York: Harry N. Abrams, 1987): 194–95.

32. Avis Lang Rosenberg and Robert Keziere, "Stone Enclosure: Rock Rings," *Vanguard* (February 1979): 23. Ted Castle, "Nancy Holt, Siteseer," *Art in America* (March 1982): 90. Micky Donnelly, "Nancy Holt Interviewed," *Circa. Contemporary Art Journal* (Belfast, Ireland) (July/August 1983): 4–5. Prior to *Rock Rings,* Holt had done *Sun Tunnels* (1973–76) in the Great Basin Desert in northwest Utah. In the summer of 1979 she showed her film on *Sun Tunnels* at the Bellevue Film Festival, Pacific Northwest Arts Fair. In her 1979 show at the John Weber Gallery, New York, she exhibited photographs of her work at Western.

33. For quotes from Poynter and Holt, see Nancy Holt, "Stone Enclosure: Rock Rings," *Arts Magazine* (June 1979): 153–54. Also: Janet Saad-Cook, "Touching the Sky: Artworks Using Natural Phenomena, Earth, Sky and Connections to Astronomy," *Archaeoastronomy* (April 1987): 128.

34. Quote from artist's letter to Daydre Phillips when she was working on the first sculpture brochure, ca. 1978; see Outdoor Sculpture Collection Archives.

35. Hamrol also acted as juror for the 11th Annual National Sculpture and Drawing Competition sponsored by the Western Gallery (1963–74). He and Judy Chicago were also featured in a spring show at the Western Gallery.

36. Best summaries of Trakas' work are Jessica Bradley, *George Trakas: Montreal* (Montreal, Quebec: The Montreal Museum of Fine Arts, 1979); Hugh M. Davies and Sally Yard, "George Trakas. Passion in Public Places," in *Sitings. Alice Aycock, Richard Fleischner, Mary Miss, George Trakas* (La Jolla, CA: La Jolla Museum of Contemporary Art, 1986): 84–100.

37. Annie Dillard, the donor of Keppelman's work, was a scholar-in-residence at Fairhaven College, 1975–78. For quotes, see Dillard, *Pilgrim at Tinker Creek* (New York: Harpers Magazine Press, 1974; Bantam Edition, 1975): 16, 35.

38. Besides the Mercer Island Bridge Tunnel reliefs, Fitz-Gerald was commissioned in 1942 by the Federal Housing Authority to carve murals in Western Red Cedar of scenes of Northwest Coast Native Americans for the Highlands Administration Building (now at Highlands Library, Renton). FitzGerald's later work expressing nature's cycles of birth and death incorporated human and machine fragments that implied a more critical comment on man's destructive qualities; see Tom Robbins, "The Visual Arts: Sculptor Shows Nature in State of Crisis," *Seattle Times,* November 24, 1963: C15; Delores T. Ament, "Unseen Works Reveal New Side of Sculptor," *Seattle Times/Seattle Post-Intelligencer,* October 16, 1988: K7.

39. For this analogy, see Patricia C. Phillips, "Signs of Imperfection," in *Mia Westerlund Roosen: Sculpture and Drawings* (Mountainville, N.Y.: Storm King Art Center, 1994): 12.

40. Irving Sandler, "Mark di Suvero—An Essay," In *Mark di Suvero at Storm King Art Center* (Mountainville, NY: Storm King Art Center; New York: Harry N. Abrams, 1996): 31.

41. For di Suvero's remarks to students, see John Manly, "Artist Defends Work against Student Critics," *Western Front* (WWU), January 24, 1975: 3; and Beth Erickson, "Critics Abound over Sculpture at WWSC," *Bellingham Herald,* January 27, 1975: 2. From his 1962 Green Gallery, New York, exhibition, which included *Ladderpiece,* made with patients of the Institute for Rehabilitation and Research, to his founding of Socrates Park in the eighties, di Suvero has a long tradition of working with the public.

42. For quote, see Sandler (1996): 35. For remarks on technology, see Mimi Weinberg, "Thunder in the Mountains," *Arts Magazine* (February 1986): 42; this comment was made at the same time as Western's work and printed in Barbara Rose's *Readings in American Art* (1975): 275.

43. For discussion of her "arboreals," see Barbara Rose, *Magdalena Abakanowicz* (New York: Harry N. Abrams, 1994): 174–79. In 1980 she represented Poland in a one-person exhibition at *Venice Biennale,* where she returned in 1997 to exhibit *Hand-like Trees* series on Via Sciavone.

44. For "presentness," see Phyllis Tuchman, "Beverly Pepper: The Moline Markers," in *Beverly Pepper: The Moline Markers* (Davenport, IA: Davenport Art Gallery, 1981). For quotes on iron, see Robert Hobbs, "Beverly Pepper: In the *Querencia,*" *Sculpture* (November/December 1994): 23; and Anne Barclay Morgan, "Memory, Monuments, Mystery and Iron," *Sculpture* (April 1998): 36–37.

45. Pepper has acknowledged the axe as a symbol of violence in our own times; see Barbara Rose, *Beverly Pepper: Three Site-Specific Sculptures* (Washington, DC: Spacemaker Press; New York: Watson-Guptill Publications, 1998): 62.

46. For the comparison with medieval altars, see Rosalind E. Krauss, *Beverly Pepper. Sculpture in Place* (Buffalo: Albright-Knox Art Gallery and New York: Abbeville Press, 1986): 123.

47. For reference to memory rooms, see Ronald J. Onorato, "Wonder in Aliceland. Memory and Self in Aycock's Art," in *Sitings* (1986): 51.

48. For quote and reference to photographs, see "Alice Aycock. Reflections on Her Work. An Interview with Jonathan Fineberg," in *Complex Visions. Sculpture and Drawings by Alice Aycock* (Mountainville, NY: Storm King Art Center, 1990): 7–9, 14–15.

49. Previous to Western's steam work, Morris had conceived the idea in 1967 and realized temporary steam pieces for *Earth Art* exhibition at Cornell and his exhibition at Corcoran Gallery, both in 1969. For variations on this theme, see Robert Morris, "Letters to John Cage," *October* (Cambridge, Mass.) (Summer 1997): 71–75; and Branden W. Joseph, "Robert Morris and John Cage: Reconstructing a Dialogue," *October* (Cambridge, Mass.) (Summer 1997): 62–65. In 1972 Morris had a works on paper exhibition at the Western Gallery.

50. Quote from artist's letter to Daydre Phillips in preparation of her 1978 brochure. For analysis of Morris and labor, see Maurice Berger, *Labyrinths: Robert Morris, Minimalism & the 1960s* (New York: Harper and Row, 1989): 14–15.

51. *Site* was first performed with Carolee Schneeman at Surplus Dance Theater in New York. For a description of *Waterman Switch,* first performed at Festival of the Arts, Buffalo, see Maurice Berger, "Remaking Anti-form," in *Robert Morris: The Felt Works* (New York: Grey Art Gallery and Study Center, New York University, 1989): 29–30.

52. For quote, see W. J. T. Mitchell and Robert Morris, "Golden Memories," *Artforum International* (Summer 1994): 89. For a more ominous version of the steam piece, see Morris' proposal for 1969 *Art and Technology Program of LACMA 1967–1971,* in Berger, *Labyrinths:* 125, note 23.

53. Coosje van Bruggen is one of the most articulate on Nauman's work; for quote, see Van Bruggen, *Bruce Nauman* (New York: Rizzoli International Publications, 1988): 107.

54. For story of *slant step,* see Van Bruggen, 107 and note 5.

55. For a similar feeling of being distant from automatic responses, see Nauman's videotape *Slow Angled Walk* (1969); for description, see Coosje van Bruggen, "The True Artist Is an Amazing Fountain," in *Bruce Nauman: Drawings 1965–1986* (Basel, Switzerland: Kunstmuseum Basel and Museum für Gegenwartskunst, 1986): 19.

56. Nauman's work was dedicated during "A Day to Honor Virginia Wright." Typical of student participation, the football team, a marching band, a theater group, and dancers were all involved in celebrating Nauman's work.

57. For toys, see Kenneth Benham, "Architect's Clever New Toy," *Seattle Times,* April 3, 1960: 27. Matthew Kangas noticed a relationship with Noguchi's *Red Cube;* see Kangas, "Isamu Noguchi in the Pacific Northwest," *Sculpture* (December 2000): 27. For Noguchi's garden, see Ashton: 195.

58. See Bassetti's statement in Emmett Watson, "By Design, Seattle Has Some Bright Stars," *Seattle Times,* February 12, 1989: D1. His *Gateway Towers* in Seattle is an elongated hexagon.

59. For quote, see Maarten Van de Guchcte, "A Conversation with Tom Otterness," in *Tom Otterness* (Urbana-Champaign, IL: Krannert Art Museum, University of Illinois, 1994).

Selected Bibliography

Arranged chronologically in sections, with books preceding articles.

* WWU work cited.

WESTERN'S OUTDOOR SCULPTURE COLLECTION

Stearns-Phillips, Daydre. *Western's Outdoor Museum.* Brochure. Bellingham: Western Washington University, 1978 and 1979.

Francis, Richard, and Gard Jones. *Western's Outdoor Museum.* Brochure. Bellingham: Western Washington University, 1983.

Milicic, Vladimir, and Thomas Schlotterback, eds. *Symposium on Western's Outdoor Sculptures.* Bellingham: Western Washington University, 1986.

Francis, Richard. "The Magical Place: Art and Architecture at WWU." Lecture, June 24, 1986. Outdoor Sculpture Collection Archives, Western Washington University.

Kangas, Matthew. "Ceremonial Sculptures at the Nation's Edge: Aycock, McCafferty, Trakas." In *Site-Specific Sculpture Exhibition and Symposium, 1987.* Bellingham: Western Gallery, Western Washington University, 1989.

Clark-Langager, Sarah, and Thom Cathcart, eds. Audiophone Tour for Outdoor Sculpture Collection. Interviews and accompanying text for brochure by Clark-Langager. Bellingham: Western Washington University, 1992.

Mays, Vernon. "A Tale of Two Campuses." *Landscape Architecture* (October 1997): 92–99.

Fairbrother, Trevor. *The Virginia and Bagley Wright Collection.* Essay by Bagley Wright. Seattle: Seattle Art Museum; Seattle and London: University of Washington Press, 1999.*

Clark-Langager, Sarah. "The Outdoor Sculpture Collection: Development of Public Art at Western." In *Perspectives on Excellence: A Century of Teaching and Learning at Western Washington University.* Edited by Roland L. De Lorme with Steven W. Inge. Bellingham: Center for Pacific Northwest Studies, Western Washington University, 2000: 99–133.

Masland, Lynne, and Linda Smeins. "The Campus Beautiful: A Century of Planning and Design at Western." In *Perspectives on Excellence: A Century of Teaching and Learning at Western Washington University.* Edited by Roland L. De Lorme with Steven W. Inge. Bellingham: Center for Pacific Northwest Studies, Western Washington University, 2000: 77–98.

NORTHWEST ART

Architectural Craftsmen of the Northwest. Seattle: American Craftsmen's Council, 1960. See FitzGerald* and Warsinske.

Batie, Jean. "Northwest Annual Has 'Now' Theme." *Seattle Times,* October 6, 1967: 32. See Tibbetts.

"Bellingham Sculptor [C. A. Scott] Wins 'Water Work' Competition." *Seattle Times,* June 2, 1972.

Harrington, LaMar. *Ceramics in the Pacific Northwest: A History.* Seattle: University of Washington Press, 1979. See Eric Nelsen.

Woodbridge, Sally B., and Roger Montgomery. *A Guide to Architecture in Washington State.* Seattle: University of Washington Press, 1980. See Bassetti.

Rupp, James. *Art in Seattle's Public Places.* Seattle: University of Washington Press, 1991. See Beyer, FitzGerald, and Warsinske.

INDIVIDUAL ARTISTS

Magdalena Abakanowicz

Brenson, Michael. *Magdalena Abakanowicz Recent Sculpture.* Providence: Museum of Art, Rhode Island School of Design, 1993.

———. "Magdalena Abakanowicz's Sculpture of Enchantment." In *Magdalena Abakanowicz: Sculpture.* New York: Marlborough Gallery, 1993: 4–9.*

Rose, Barbara. *Magdalena Abakanowicz.* New York: Harry N. Abrams, 1994: 174–86, *Hand-like Trees.*

Heartney, Eleanor. "Magdalena Abakanowicz: Fighting the Crowd." *Sculpture* (September/October 1994): 20–25. *

Abakanowicz. Retrospective exhibition catalogue with texts by Ryszard Stanislawski, Michael Brenson, Jasia Reichardt, and Magdalena Abakanowicz. Warsaw: Centre for Contemporary Art, Ujazdowski Castle, 1995.

Abakanowicz, Magdalena. "About the Nineties." In *Abakanowicz. Recent Exhibitions and Installations.* New York: Marlborough Gallery, 2000.*

Alice Aycock

Osterwold, Tilman, Andreas Vowinckel, and Jonathan Fineberg. Essays. In *Alice Aycock, Retrospective of Projects and Ideas, 1972–1983.* Stuttgart, Germany: Württembergischer Kunstverein, 1983.

La Jolla Museum of Contemporary Art, California. *Sitings. Alice Aycock, Richard Fleischner, Mary Miss, George Trakas.* 1986. Texts by Hugh M. Davies, Ronald J. Onorato, and Sally Yard. Edited by Sally Yard. See also Trakas.

Fineberg, Jonathan, and Alice Aycock. Interview. In *Complex Visions. Sculpture and Drawings by Alice Aycock.* Mountainville, NY: Storm King Art Center, 1990: 7–30.*

Rosen, Carol. "Sites and Installations. Outdoor Sculpture Revisited." *Arts Magazine* (February 1990): 69.* See also Serra.*

Denton, Monroe. "Reading Alice Aycock: Systematic Anarchy." *Sculpture* (July/August 1990): 40–51.

Wacker, Kelly A. "Magic-making in the work of Alice Aycock." *Athanor* (Tallahassee, FL), vol. 16 (1998): 57–63.

Fred Bassetti

Benham, Kenneth. "Architect's Clever New Toy." *Seattle Times,* April 3, 1960: 27.

Richard Beyer

Beyer, Margaret W. *The Art People Love.* Foreword by Fred Bassetti. Pullman: Washington State University Press, 1999.*

Anthony Caro

Tuchman, Phyllis. "An Interview with Anthony Caro." *Artforum* (June 1972): 56–58.

Kramer, Hilton. "Art: Anthony Caro Adds New Forms." *New York Times,* May 6, 1977.*

Andreae, Christopher. Essay. In *Anthony Caro: The York Sculptures.* Boston: Museum of Fine Arts, 1980.

Wilkin, Karen. Essay. In *Anthony Caro: Sculptures.* Mountainville, NY: Storm King Art Center, 1981.

Blume, Dieter. *Steel Sculptures 1960–1980.* Vol. III of *Anthony Caro.* 4 vols. Cologne, Germany: Galerie Wentzel, 1981–1985.*

Waldman, Diane. *Anthony Caro.* New York: Abbeville Press, 1982.*

Tuchman, Phyllis. "An Interview with Anthony Caro." *Art in America* (October 1984): 146–53.

Wilkin, Karen. Essay. In *Caro.* Edited by Ian Barker. Munich: Prestel Verlag, 1991.

Moorhouse, Paul. *Anthony Caro: Sculpture towards Architecture.* Seattle: University of Washington Press, 1992.

Corris, Michael. "Sir Anthony Caro and his Critics." *Artforum* (March 1992): 62–65.

Wei, Lilly. "The Prime of Sir Anthony Caro." *Art in America* (September 1994): 94–98.

Caro, Anthony. "The Sculptural Moment." *Sculpture* (January/February 1995): 28–31.

Cohen, David. "The Last Modernist." *Sculpture* (January/February 1995): 20–31.

Tuchman, Phyllis. "Sculpting Space." *Sculpture* (October 1997): 19–23.

Mark di Suvero

Ratcliff, Carter. "Mark di Suvero." *Artforum* (November 1972): 34–42.

Monte, James. *Mark di Suvero.* New York: Whitney Museum of American Art, 1975.*

Erickson, Beth. "Critics Abound over Sculpture at WWSC." *Bellingham Herald,* January 27, 1975: 1–2.*

David, Douglas. "Egalitarian Sculptor." *Newsweek* (October 27, 1975): 96, 99.

Collens, David, H. Peter Stern, and Phyllis Tuchman. *Mark di Suvero, 25 Years of Sculpture and Drawings.* Mountainville, NY: Storm King Art Center, 1985.

Weinberg, Mimi. "Thunder in the Mountains." *Arts Magazine* (February 1986): 38–42.

Osterwold, Tilman. "Mark di Suvero." In *Mark di Suvero.* Stuttgart, Germany: Württembergischer Kunstverein, 1988.*

Perlein, Gilbert. *Mark di Suvero: Retrospective 1959–1991.* Nice, France: Musée d'Art et d'Art Contemporain, 1991.

Sandler, Irving. *Mark di Suvero at Storm King Art Center.* Mountainville, NY: Storm King Art Center; New York: Harry N. Abrams, 1996.

Moss, Stacey. *Mark di Suvero. The Hands.* Belmont, CA: Wiegand Gallery, College of Notre Dame, 1997.

James FitzGerald

Hills, Gene. "Painters Unveil Portal Plaques." *Seattle Times,* August 19, 1962: Sunday Magazine Section, 18.

Robbins, Tom. "The Visual Arts: Sculptor Shows Nature in State of Crisis." *Seattle Times,* November 24, 1963: C15.

Catherine Viviano Gallery. *FitzGerald.* Exhibition catalogue. New York: Catherine Viviano Gallery, 1969.

Cowles, Charles, and Sarah A. Clark. *Northwest Traditions.* Essay by Martha Kingsbury. Seattle: Seattle Art Museum, 1978.

Ament, Delores Tarzan. "Unseen Works Reveal New Side of Sculptor." *Seattle Times/Seattle Post-Intelligencer,* October 16, 1988: K7.

Lloyd Hamrol

Pasadena Art Museum, California. *15 Los Angeles Sculptors.* 1972. Text by Barbara Haskell.

Prokopoff, Steven. *Four Los Angeles Sculptors.* Chicago: Museum of Contemporary Art, 1974.

Lodato, Peter. *Three L. A. Sculptors: Lloyd Hamrol, George Hermes, Bruce Nauman.* Los Angeles: Los Angeles Institute of Contemporary Art, 1975.

Iskin, Ruth. "Public Art as Identity Reinforcement: An Interview with Lloyd Hamrol." *Journal of the Los Angeles Institute of Contemporary Art* (January/February 1976): 29–33.

Schipper, Merle. "Public Sculpture and Urban Community: Recent Work by Lloyd Hamrol." *LAICA* (September/October 1981): 32–36.

Hopkins, Henry, et al. *Lloyd Hamrol: Works, Projects, Proposals.* Los Angeles: Municipal Art Gallery, 1986.*

Nancy Holt

Holt, Nancy. "Sun Tunnels." *Artforum* (April 1977): 32–37.

"Nancy Holt." In *Born in Boston.* Lincoln, MA: DeCordova and Dana Museum, 1979: 22–23.*

Rosenberg, Avis Lang, and Robert Keziere. "Stone Enclosure: Rock Rings." *Vanguard* (Vancouver, BC) (February 1979): 22–27.*

Holt, Nancy. "Stone Enclosure: Rock Rings." *Arts Magazine* (June 1979): 152–55.*

Castle, Ted. "Nancy Holt, Siteseer." *Art in America* (March 1982): 84–91.*

Donnelly, Micky. "Nancy Holt Interviewed." *Circa. Contemporary Art Journal* (Belfast, Ireland) (July/August 1983): 4–10.*

Beardsley, John. *Earthworks and Beyond: Contemporary Art in the Landscape.* New York: Abbeville Press, 1984. See also Morris.

Marter, Joan. "Nancy Holt's Dark Star Park." *Arts Magazine* (October 1984): 137–39.

Saad-Cook, Janet, et al. "Touching the Sky: Artworks Using Natural Phenomena, Earth, Sky and Connections to Astronomy." *Archaeoastronomy* (April 1987): 124–31; also in *Leonardo* (2/1988): 126–28.*

Jones, Bill. "Stunted Bridges and Fascinating Hardware." *Arts Magazine* (Summer 1990): 56–60.*

Tiberghien, Gilles A. *Land Art.* New York: Princeton Architectural Press, 1995: 126, 147–49, 165–67, 197–203, 235.

Kastner, Jeffrey, and Brian Wallis. *Land and Environmental Art.* London: Phaidon Press, 1998: 14, 32–34, 86–90, 215–19, 227–28, 234, 261, 280.

Donald Judd

Coplans, John. *Don Judd.* Pasadena, CA: Pasadena Art Museum, 1971.

Smith, Roberta. Essay. In *Donald Judd Catalogue Raisonné of Paintings, Objects and Wood-Blocks 1960–1974.* Ottawa: National Gallery of Canada, 1975.

Vinciarelli, Lauretta, and Donald Judd. "Courtyard Building for Donald Judd Installations." *Arts and Architecture* (Winter 1981): 37.

Carlson, Prudence. "On Judd's Equivocal Objects." *Art in America* (January 1984): 114–18.

Foster, Hal. "The Crux of Minimalism." In *Individuals: A Selected History of Contemporary Art 1945–1986.* Los Angeles: Museum of Contemporary Art, 1986: 162–83. See also Aycock, Morris, Nauman, Serra, Trakas.

Judd, Donald. *Complete Writings 1965–1986.* Eindhoven, Netherlands: Stedelijk van Abbemuseum,1987.

Haskell, Barbara. *Donald Judd.* New York: Whitney Museum of American Art and W. W. Norton & Co., 1989.

Indianapolis Museum of Art, Indiana. *Power: Its Myths and Mores in American Art 1961–1991.* 1991. Texts by Holliday T. Day, et al. See also Morris, Nauman, Serra.

Fuchs, Rudi, and Donald Judd. *Donald Judd—Large Scale Works.* New York: Pace Gallery, 1993.*

Agee, William C. "Donald Judd in Retrospect: An Appreciation." In *Donald Judd. Sculpture.* New York: Pace Gallery, 1994.

Krauss, Rosalind E., and Robert Smithson. Essays. In *Donald Judd: Early Fabricated Work.* New York: PaceWildenstein, 1998.

Morgan, Robert C. "Rethinking Judd." *Sculpture* (April 2001): 32–37.

John Keppelman

Dillard, Annie. *Pilgrim at Tinker Creek.* New York: Harpers Magazine Press, 1974; Bantam Edition, 1975.

Kangas, Matthew. Review. *Seattle Sun,* February 21, 1979.

Noah, Barbara. "Review of Exhibitions. Seattle: John Keppelman at Olson Walker." *Art in America* (October 1979): 129.

Connell, Joan. "Artwork Invites Viewer to Be Swept Away." *Bellingham Herald,* May 19, 1983.

Dietz, Diane. "Heart of a Boy. Eye of an Artist." *Bellingham Herald,* December 2, 1988: C1, 3.

Robert Maki

Portland Art Museum, Portland, Oregon. *West Coast Now: Current Work from the Western Seaboard.* 1968. Texts by Rachel Griffin and Henry T. Hopkins. See also Hamrol, Nauman.

Seattle Art Museum. *Robert Maki.* Seattle: Seattle Art Museum, 1973.

Van der Marck, Jan. "Reviews: Portland. Robert Maki at the Portland Center for the Visual Arts." *Art in America* (September/October 1974): 12.

Campbell, Richard M. "Robert Maki and the Concept of Space." *Seattle Post-Intelligencer,* March 14, 1976.

Kangas, Matthew. Essay. In *Robert Maki: Sculpture Projects.* Winston-Salem, NC: Southeastern Center for Contemporary Art, 1978.

———. "Sculpture in Seattle." *Northwest Arts,* May 26, 1978: 4–6.

Glowen, Ron. "Sculptural Purity." *Artweek,* December 22, 1979: 6.*

Kangas, Matthew. "Robert Maki at Richard Hines." *Art in America* (October 1980): 137–38.*

Halper, Vicki. *Documents Northwest: Robert Maki.* Exhibition brochure. Seattle: Seattle Art Museum, 1985.

Reed, Eddie. "Interview with Robert Maki." *Vision* (Seattle) (Fall 1985).

Kangas, Matthew. "Limitless Geometry: Robert Maki." *Sculpture* (October 1998): 8–9.

Michael McCafferty

Garner, R. Bert, and Ann Obery. *6 on Land.* Seattle: and/or, 1978.

Nelson, Maxine. "An Attitude toward Place: Reflections of Michael McCafferty's Work." Exhibition brochure. Seattle: and/or, 1981.

Glowen, Ron. "The Farm Project." *Vanguard* (Vancouver, BC) (October 1981): 10–15.

Lippard, Lucy. *Overlay: Contemporary Art and the Art of Prehistory.* New York: Pantheon Books, 1983: 23, 54, 55.

Hackett, Regina. "Artist Proposes a 'Master Plan' to Heal the Green River." *Seattle Post-Intelligencer,* February 28, 1987: C1–5.

Robert Morris

Leavitt, Thomas A., William C. Lipke, and Willoughby Sharp. *Earth Art.* Ithaca, NY: Andrew Dickson White Museum of Art, Cornell University, 1969.

Michelson, Annette. *Robert Morris.* Washington, DC: Corcoran Gallery of Art and Detroit Institute of Arts, 1969.

Tucker, Marcia. *Robert Morris.* New York: Whitney Museum of American Art, 1970.

Fry, Edward, and Suzanne Delehanty. *Robert Morris/ Projects.* Philadelphia: Institute of Contemporary Art, University of Pennsylvania, 1974.*

Morris, Robert. "Robert Morris Keynote Address." In *Earthworks: Land Reclamation as Sculpture.* Seattle: Seattle Art Museum, 1979. See also "Notes on Art as/and Land Reclamation." *October* (Cambridge, MA.) (Spring 1980): 85–102.

Krauss, Rosalind. "Sculpture in the Expanded Field." *October* (Cambridge, MA) (Spring 1979): 30–44. See also *The Originality of the Avant-Garde and Other Modernist Myths.* Cambridge, MA, and London: M.I.T. Press, 1985: 276–90.

Fineberg, Jonathan. "Robert Morris Looking Back: An Interview." *Arts Magazine* (September 1980): 110–15.*

Krens, Thomas. *The Drawings of Robert Morris.* Williamstown, MA: Williams College Museum of Art, 1982.*

Buchloh, Benjamin. "Conversation with Robert Morris." *October* (Cambridge, MA) (December 1985): 47–54.

Berger, Maurice. *Labyrinths: Robert Morris, Minimalism & the 1960s.* New York: Harper and Row, 1989.

Karmel, Pepe, and Maurice Berger. *Robert Morris: The Felt Works.* New York: Grey Art Gallery and Study Center, New York University, 1989.

Morris, Robert. *Continuous Project Altered Daily: The Writings of Robert Morris.* Cambridge, MA: M.I.T. Press, 1993.

Krauss, Rosalind. *Robert Morris. The Mind-Body Problem.* New York: Solomon R. Guggenheim Museum, 1994: 224–25.*

Rose, Barbara. *Memory in Search of Truth: Robert Morris Works at Villa Celle.* Pistoia, Italy: Fattoria di Celle, 1994.

Mitchell, W. J. T., and Robert Morris. "Golden Memories." *Artforum International* (Summer 1994): 86–92.

Grenier, Catherine, et al. *Robert Morris: Contemporains Monographies.* Paris: Editions du Centre Pompidou, 1995: 119, 242–331.*

Karmel, Pepe. "Robert Morris: Formal Disclosures." *Art in America* (June 1995): 88–95, 117–19.*

Joseph, Branden W. "Robert Morris and John Cage: Reconstructing a Dialogue." *October* (Cambridge, MA) (Summer 1997): 59–69.

Morris, Robert. "Letters to John Cage." *October* (Cambridge, MA) (Summer 1997): 71–79.

Tsouti-Schillinger, Nena. *Robert Morris and Angst.* New York: George Braziller, 2000.*

Bruce Nauman

Livingston, Jane, and Marcia Tucker. *Bruce Nauman: Work from 1965–1972.* Los Angeles: Los Angeles County Museum of Art; New York: Praeger Publishers, 1973.

Lusk, Jennie. Essay. In *Bruce Nauman. 1/12 Scale Models for Underground Pieces.* Albuquerque, NM: The Albuquerque Museum, 1981.

Charters, Cynthia, and L. Price Amerson. Essays. In *The SLANT STEP revisited.* Davis, CA: Richard L. Nelson Gallery, University of California, 1983.

Heynen, Julian. Essay. In *Bruce Nauman: Stadium Piece, Musical Chairs, Dream Passage.* Krefeld, West Germany: Krefelder Kunstmuseum, Museum Haus Esters, 1983.

Ammann, Jean-Christophe, Nicholas Serota, and Joan Simon. Texts. In *Bruce Nauman.* London: Whitechapel Art Gallery, 1986.

Van Bruggen, Coosje, Dieter Koepplin, and Franz Meyer. *Bruce Nauman: Drawings 1965–1986.* Catalogue raisonné. Basel, Switzerland: Kunstmuseum Basel and Museum für Gegenwartskunst, 1986.*

Van Bruggen, Coosje. *Bruce Nauman.* New York: Rizzoli International Publications, 1988.

Simon, Joan. "Breaking the Silence: An Interview with Bruce Nauman." *Art in America* (September 1988): 140–49, 203.

Benezra, Neal, and Kathy Halbreich. *Bruce Nauman.* Edited by Joan Simon. Minneapolis: Walker Art Center in association with Hirshhorn Museum and Sculpture Garden, 1994.

Schjeldahl, Peter. "The Trouble with Nauman." *Art in America* (April 1994): 82–91.

Graw, Isabelle. "Just Being Doesn't Amount to Anything (Some Themes in Bruce Nauman's Work)." *October* (Cambridge, MA) (Fall 1995): 133–38.

Miller, John. "Dada by the Numbers: Bruce Nauman and Walter Benjamin's Notion of Shock." *October* (Cambridge, MA) (Fall 1995): 123–28.

Hoffman, Christine. *Bruce Nauman Interviews 1967–1988.* Amsterdam: Verlag der Kunst, Fundus Bücher 138, 1996.

Kunstmuseum Wolfsburg. *Bruce Nauman Image/Text 1966–1996.* Wolfsburg, West Germany: Kunstmuseum Wolfsburg, 1998.

Simon, Joan. "Bruce Nauman: The Matter in Hand." *The Tate* (Summer 1998): 36–43.*

Chiong, Kathryn. "Nauman's Beckett Walk." *October* (Cambridge, MA) (Fall 1998): 63–81.

Adams, Parveen. "Bruce Nauman and the Object of Anxiety." *October* (Cambridge, MA) (Winter 1998): 96–113.

Snodgrass, Susan. "Bruce Nauman at Donald Young." *Art in America* (September 1999): 132–33.*

Fehrenkamp, Ariane. "Bruce Nauman: *Stadium Piece,* Bellingham, WA." *Sculpture* (November 1999): 14.*

Day, Holliday T. *Crossroads of American Sculpture. David Smith, George Rickey, John Chamberlain, Robert Indiana, William T. Wiley, Bruce Nauman.* Indianapolis: Indianapolis Museum of Art, 2000.

Hoffman, Christine, Michael Glasmeir, et al. *Samuel Beckett. Bruce Nauman.* Vienna: Kunsthalle Wien, 2000.

Schjeldahl, Peter. "Naumanal." In *Bruce Nauman Four Works.* Exhibition brochure. Denver: Denver Art Museum, 2001.*

Isamu Noguchi

Noguchi, Isamu. *A Sculptor's World.* Foreword by R. Buckminster Fuller. New York: Harper and Row, 1968.

———. "Recent Works for Ibsen Nelsen & Associates of Seattle: Ibsen Nelsen as a Friend." *SD Magazine (Space Design)* (Tokyo) (December 1976).*

Friedman, Martin. *Noguchi's Imaginary Landscapes.* Minneapolis: Walker Art Center, 1978.

Hunter, Sam. *Isamu Noguchi.* New York: Abbeville Press, 1978.

Grove, Nancy, and Diane Botnick. *The Sculpture of Isamu Noguchi, 1924–1979: A Catalogue.* New York and London: Garland Publishing, 1980.

Whitney Museum of American Art. *Isamu Noguchi: The Sculpture of Spaces.* New York: Whitney Museum of American Art, 1980.

———. *Isamu Noguchi: A Study of the Sculpture.* New York and London: Garland Publishing, 1985.

Noguchi, Isamu. *The Isamu Noguchi Garden Museum.* New York: Harry N. Abrams, 1987.*

Ashton, Dore. *Noguchi East and West.* New York: Alfred A. Knopf, 1992.

Altshuler, Bruce. *Noguchi.* Modern Master Series. New York: Abbeville Press, 1994.

Apostolos-Cappadona, Diane. *Isamu Noguchi. Essays and Conversations.* New York: Harry N. Abrams, 1994.

Ohno, Bryan. *Isamu Noguchi.* Essay by Sam Hunter. Seattle: Bryan Ohno Editions in association with University of Washington Press, 2000.*

Torres De Torre, Ana Maria. *Isamu Noguchi. A Study of Space.* New York: Monacelli Press, 2000.*

Kangas, Matthew. "Isamu Noguchi in the Pacific Northwest." *Sculpture* (December 2000): 26–31.

Tracy, Robert. *Spaces of the Mind. Isamu Noguchi's Dance Designs.* New York: Limelight Editions, 2001.

Tom Otterness

Robinson, Walter. "Arcadian Hijinks." *Art in America* (December 1985): 94–97.

Shearer, Linda. *Projects: Tom Otterness.* Exhibition brochure. New York: Museum of Modern Art, 1987.

Herrera, Hayden. *Tom Otterness.* Santa Monica, CA: James Corcoran Gallery; New York: Brooke Alexander, 1990.

Museum of Modern Art, New York. *High and Low: Modern Art and Popular Culture.* 1990. Texts by Kurt Varnedoe and Adam Gopnik. See also Nauman.

Brenson, Michael. "Tom Otterness's Wicked World of Human and Beastly Folly." *New York Times,* November 23, 1990.

Kirshner, Judith Russi. *The Tables. Tom Otterness.* Valencia, Spain: IVAM Centre del Carme, 1991.

Van de Guchte, Maarten. "A Conversation with Tom Otterness." In *Tom Otterness.* Urbana-Champaign, IL: Krannert Art Museum, University of Illinois, 1994.

Dreishpoon, Douglas. Interview. In *Tom Otterness. The Frieze.* Greensboro, NC: Weatherspoon Gallery, University of North Carolina, 1996.

Arning, Bill. "Monuments to the Fallen Martyrs of Muddling-Through." In *Otterness.* New York: Marlborough Gallery, 1997.

"Tom Otterness. *Feats of Strength:* Bellingham, Washington." *Sculpture* (May 2000): 16–17.*

Finkelpearl, Tom. "Caught in the Middle." *Public Art Review* (Minneapolis) (Fall/Winter 2001): 8–10.

Tsai, Eugenie. "The Worlds of Tom Otterness." In *Free Money and Other Fairy Tales. Tom Otterness.* New York: Marlborough Gallery, 2002.

Beverly Pepper

Hopkins, Henry. *Beverly Pepper Sculpture 1971–1975.* San Francisco: San Francisco Museum of Art, 1977.

Sheffield, Margaret. "Beverly Pepper's New Sculpture." *Arts Magazine* (September 1979): 172–73.

Tuchman, Phyllis. "Beverly Pepper: The Moline Markers." In *Beverly Pepper: The Moline Markers.* Davenport, Iowa: Davenport Art Gallery, 1981. See also *Bennington Review* (Bennington, VT) (Winter 1982): 41–43.

Krauss, Rosalind E. *Beverly Pepper. Sculpture in Place.* Buffalo: Albright-Knox Art Gallery; New York: Abbeville Press, 1986.*

Hobbs, Robert. "Beverly Pepper: In the *Querencia*." *Sculpture* (November/December 1994): 20–25.

Rose, Barbara. *Beverly Pepper: Three Site-Specific Sculptures.* Washington, DC: Spacemaker Press; New York: Watson-Guptill Publications, 1998.

Morgan, Anne Barclay. "Memory, Monuments, Mystery and Iron. An Interview with Beverly Pepper." *Sculpture* (April 1998): 34–39.

Hobbs, Robert. "Beverly Pepper's Memory Sculptures." *Beverly Pepper Recent Sculpture: Forms of Memory II.* New York: Marlborough Chelsea, 1999: 2–3.

Richard Serra

Weyergraf, Clara, ed. *Richard Serra: Interviews, Etc. 1970–1980.* Yonkers, NY: Hudson River Museum and Archer Fields, 1980.*

Crimp, Douglas. "Richard Serra's Urban Sculpture: An Interview." *Arts Magazine* (November 1980): 118–23.*

Kuspit, Donald. "Richard Serra, Utopian Constructivist." *Arts Magazine* (November 1980): 124–29.*

Bois, Yve-Alain, Dominique Bozo, Rosalind Krauss, and Alfred Pacquement. Texts. In *Richard Serra.* Paris: Musée National d'Art Moderne and Centre Georges Pompidou, 1983.

Krauss, Rosalind, et al. *Richard Serra: Sculpture.* Edited by Laura Rosenstock. New York: Museum of Modern Art, 1986.

Crimp, Douglas. "Serra's Public Sculpture: Redefining Site Specificity." In *Richard Serra.* Stuttgart, Germany: Verlag Gerd Hatje, 1987; New York: Rizzoli International Publications, 1988: 26–39, 77.

Van Vlack, et al. *Richard Serra.* New York: Harry N. Abrams, 1990.

Zweite, Armin. *Richard Serra Running Arcs (For John Cage).* Düsseldorf: Kunstsammlung Nordrhein-Westfalen, 1992.

Griffith, Nathan Paul. *Richard Serra and Robert Irwin: Phenomenology in the Age of Art and Objecthood.* Ph.D. Dissertation. Ann Arbor, MI: University of Michigan, 1993.*

Serota, Nicholas, and David Sylvester. Interview. In *Richard Serra. Weight and Measure 1992.* Düsseldorf: Richter Verlag; London: Tate Gallery, 1993.

Serra, Richard. *Writings-Interviews.* Chicago: University of Chicago Press, 1994.

Krauss, Rosalind, et al. *Richard Serra Props.* New York: D.A.P./Distributed Art Publishers; Düsseldorf: Richter Verlag, 1995.*

Schwander, Martin, ed. *Richard Serra Intersection.* Essay by Martha Buskirk. Düsseldorf: Richter Verlag, 1996.

Ferguson, Russell, Anthony McCall, and Clara Weyergraf-Serra, eds. *Richard Serra: Sculpture 1985–1998.* Essay by Hal Foster. Los Angeles: The Geffen Contemporary at The Museum of Contemporary Art, 1998.

Simmons, Mark. "Richard Serra. The Coagula Interview." *Coagula Art Journal* (November 1998).

Foster, Hal, et al. *Richard Serra.* Cambridge, MA: M.I.T. Press, 2000.

D'Souza, Aruna, and Tom McDonough. "Sculpture in the Space of Architecture." *Art in America* (February 2000): 84–89.

Davis, Eric R. "Extended Vision. Richard Serra Talks about Drawing." *Art on Paper* (May/June 2000): 60–65, 102.

George Trakas

Linker, Kate. "George Trakas and the Syntax of Space." *Arts Magazine* (January 1976): 92–94.

Kardon, Janet. *George Trakas: Columnar Pass.* Philadelphia: Philadelphia College of Art, 1977.

Art Gallery of Ontario, Toronto. *Structures for Behavior: New Sculptures by Robert Morris, David Rabinowitch, Richard Serra and George Trakas.* 1978. Texts by Roald Nasgaard, et al.

Bradley, Jessica. *George Trakas: Montreal.* Edited by Normand Thériault. Montreal: Montreal Museum of Fine Arts, 1979.

Davies, Hugh M. *George Trakas: Log Mass: Mass Curve.* Amherst, MA: University Gallery, University of Massachusetts, 1980.

Institute of Contemporary Art, University of Pennsylvania, Philadelphia. *Connections: Bridges, Ladders, Ramps, Staircases, Tunnels.* 1983. Texts by Hal Foster and Janet Kardon. See also Aycock, Nauman, Serra.

Cleveland Center for Contemporary Art. *Artists and Architects: Challenges in Collaboration.* 1985. Text by Joyce Schwartz. See also Aycock, Holt.

Fuller, Patricia. *Five Artists at NOAA: A Case Book on Art in Public Places.* Seattle: Real Comet Press, 1985.

Yard, Sally. *George Trakas: Constructions, Wall Pieces, Drawings.* La Jolla, CA: Quint-Kirchman Projects, 1992.

Von Bismarck, Beatrice, Diethelm Stroller, Astrid Wege, and Ulf Wuggenig, eds. *Christian Philipp Müller. Branding the Campus. Universitate Luneburg.* Düsseldorf: Richter Verlag, 2001.*

Norman Warsinske

"Aluminum Art Piece in Place." *Seattle Times,* March 30, 1961: 1.

Mia Westerlund Roosen

Chandler, John N. Essay. In *Mia Westerlund: Recent Work/Sculpture and Drawing.* Vancouver, BC: Vancouver Art Gallery, 1978.

Prince, Kathy. "Mia Westerlund Breaking the Form." *Vanguard* (Vancouver, BC) (October 1978): 3–6.*

Gumpert, Lynn. *Mia Westerlund Roosen.* New York: New Museum of Contemporary Art, 1985.

Viney, Jill. "Interview: Mia Westerlund Roosen. Sculpture with a Life Force." *International Sculpture* (September/October 1985): 7, 34–35.

Feinberg, Jean. "Evocative Abstraction: The Sculpture of Mia Westerlund Roosen." *Arts Magazine* (October 1986): 18–20.

Ratcliff, Carter. Essay. In *Mia Westerlund Roosen.* West Hartford, CT: Joseloff Gallery, University of Hartford, 1989.

Phillips, Patricia C. "Signs of Imperfection." In *Mia Westerlund Roosen: Sculpture and Drawings.* Mountainville, NY: Storm King Art Center, 1994: 10–21.

FUTURE PROJECTS

Tsujimoto, Karen. *The Art of David Ireland.* Oakland: Oakland Museum of California and the University of California Press, 2003.

Index